*The Best of Photojournalism, 5*

# The Best of *Photojournalism, 5*

## PEOPLE, PLACES, AND EVENTS OF 1979

*Introduction by Tom Brokaw*

NATIONAL PRESS PHOTOGRAPHERS ASSOCIATION

UNIVERSITY OF MISSOURI SCHOOL OF JOURNALISM

The 37th Annual Pictures of the Year Competition,

upon which this book is based, is supported

by an educational grant from Nikon, Inc.

*University of Missouri Press*
*Columbia & London, 1980*

Copyright © 1980 by The Curators of the University of Missouri
Library of Congress Catalog Card Number 77–081586
Printed and bound in the United States of America
University of Missouri Press, Columbia, Missouri 65211

The photographs appearing in this book have been used
with the permission of the holders of rights thereto
and may be the subject of separate copyright.

Library of Congress Cataloging in Publication Data
    National Press Photographers Association
    The Best of Photojournalism / 5
    Index
1.Photography—Worldwide. 2. Photojournalism
3. 37th Annual Pictures of the Year Competition.
Library of Congress Card Number 77–081586
ISBN 0–8262–0321–3

For information concerning the Pictures of the Year
Competition, contact Charles Cooper, Executive
Secretary of the National Press Photographers
Association, Box 1146, Durham, N.C. 27702

The Reporters' Committee for Freedom of the Press
would like to extend its deepest appreciation to
Mr. Brokaw for donating to the Committee the
honorarium provided to him by the University of
Missouri Press for his introduction to this book.
The gift will be used to further the Committee's goal
of defending the First Amendment and freedom-of-
information rights of the news media.

# Contents

# Introduction

*by Tom Brokaw*

This is not an easy assignment, for I have long believed that the enduring appeal of a photograph is that it speaks for itself. Occasionally, it requires a simple, one-line description of who, what, or where. More often than not, however, a photograph, even a bad one, will stand on its own — without even that one line. Indeed, the unspoken eloquence of a great photograph is sometimes so compelling that I react by thinking, "Damn, I wish I had said that."

However, it is not just my fascination with the descriptive language of photographs that draws me to them. They long have been windows on a world beyond my immediate reach. When I was growing up in South Dakota, newspaper and magazine photographs stirred my curiosity and nurtured my intellect as they transported me far beyond those broad, flat prairie horizons. They were seminal forces in my decision to become a journalist.

This is a book celebrating photojournalism, a demanding craft that has many forms. One of its functions is to tell a story, often shocking. You may hear or read, "A television cameraman was killed today when debris from a car crash in a drag race bounced across the infield and knocked the victim from his camera platform." That is a routine account of another random death. In a world so conditioned to random death, that description would have little impact. Now look at the photographs taken at the National Hot Rod Association U.S. Nationals in Indianapolis. You are at the race. You gasp in horror as the crash begins and you want to shout, "Look out!" as the menacing debris heads for the cameraman. You are sickened by the sight of the cameraman flying off the platform. Finally, you have a greater understanding of the fragility of life and the cruelty of fate.

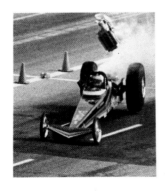 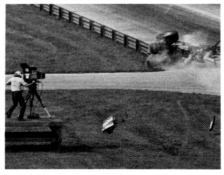 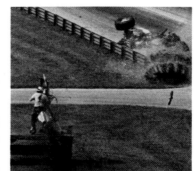 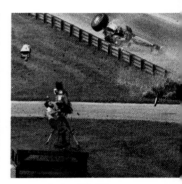

*see pp. 80–81*

Those photographs represent photojournalism at its most fundamental. There are other pictures in these pages that are much more complicated. Some may at first appear to be merely a record of an event, planned or otherwise. However, a longer examination widens their meaning.

It is impossible to summarize the Iranian revolution with a single photograph, but that remarkable picture of the firing squad is a suitable symbol for much of what has been happening in that embattled country. First, it is clearly Iranian against Iranian, an aspect of the revolution many Americans suppressed as a result of their understandable preoccupation with the fate of the American hostages. It represents the undisciplined violence and furious passion of the revolution. It is, then, a great photograph not merely because it records the moment of death but because it does so much more than that.

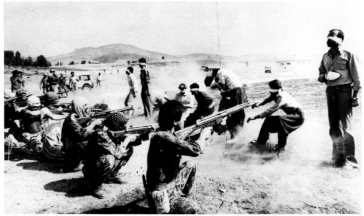

*see p. 19*

There are other, less violent but no less truthful symbols in these pages. Some are prophetic. The picture of President Carter, Israeli Prime Minister Begin, and his former Foreign Minister Dayan fumbling their papers reflects the awkward relationship between the administrations. President Carter is the victim of another painful photographic symbol, as his collapse in the six-mile run at Catoctin Mountain National Park is vividly, agonizingly portrayed. These are pictures that only reinforce the critics who say he is not up to the job and that he too often sets out on a course without being prepared for the consequences. Even President Carter's admirers may find these pictures to be an uncomfortably strong antidote to their best arguments defending his courage and determination.

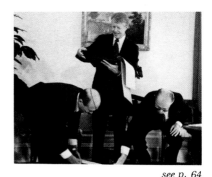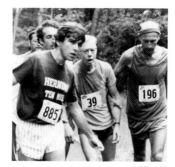

*see p. 64*       *see pp. 62–63*

Apart from their symbolic value, press photographs have many strengths. One is their ability to capture the inner spirit of a subject. Remember all those Hollywood films where jungle tribes refuse to be photographed because they fear the camera will capture their spirit? Those tribes were on to something. After all, a great photograph is more than a one-dimensional reflection made permanent by the right combination of

chemicals, elements, and light. It is, instead, a lasting vision of the many dimensions of the subject. The familiar face below plainly belongs to Ayatollah Khomeini. We see more than his face, however. We see a medieval mind accented by vengeful eyes. The photograph expands our perception of this peculiar man. Contrast the eyes of the Ayatollah with the eyes and expression of the Cambodian child in the refugee camp at Sa Kaew, Thailand. Here a single photograph communicates the desperate condition of helpless, powerless victims trapped in still another political struggle. This is a picture I will carry in my mind as I carry pictures of my own children in my wallet. The difference, of course, is in the emotion with which I bring them forth. The pictures of my children I will unfold with a sense of unalloyed pride and joy. The picture of this Cambodian child will emerge from my subconsciousness with a sense of frustration, pity, and anger.

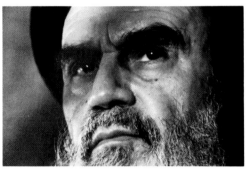
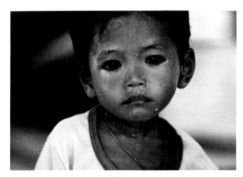

see p. 21

see p. 39

Still another kind of spirit has been captured in the picture of Deborah Harry, surly star of the New Wave group Blondie. The contempt, arrogance, and mystery of this grown-up punk show through.

While Deborah Harry may have been manufacturing that expression, look at the spontaneous reaction in the exceptional photograph of the young woman with the blood-streaked face at the Fiesta Parade in San Antonio. It is the personification of fear and panic. We do not need to see the sniper to know that he is there and at work. If we have not personally experienced the prospect of instant death from an unknown assailant, with this picture we know the terror it brings.

We know, too, the real meaning of cowardice as we look into the eyes of the hooded Ku Klux Klansman at a gathering in Louisville. For me, this photograph is one that strips away the Klan's bold proclamation of strength and noble purpose.

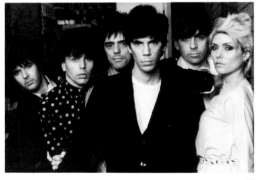
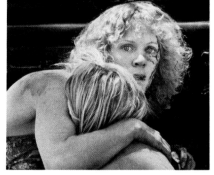
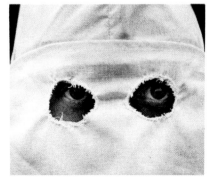

see p. 47

see p. 79

see p. 151

Introduction / 9

For some subjects a single photograph is inadequate. The series on Washington State Prison and Wade Scott in the World Understanding category permit us to use the camera as a guide. We are taken through these fascinating and yet unfamiliar surroundings a frame at a time so that the many parts become, ultimately, greater than the whole. Each story instructs us in its own way about our ability to adapt and prevail even in the most trying circumstances. I was particularly struck by two photographs, each with a distinctly different message. One shows the narrow, windowless passageway of peeling paint and worn steps leading to the Washington State Prison gallows. Capital punishment is a raw form of death, and its trappings are no more elegant. The other picture celebrates life and courage. It is the picture of Wade kicking the soccer ball at the end of his tortuous rehabilitation. It is truly a happy ending, made more meaningful by the experience we have shared through the pictures of the earlier phases of therapy.

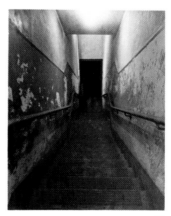

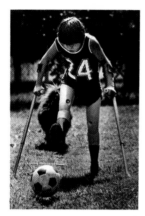

*see p. 99*          *see p. 112*

This book also reminds us that photojournalism is a record of the moment and a reminder of the past. It documents rites of passage. Patty Hearst in these pages is wearing a T-shirt that reads "Pardon Me." That picture triggers in our mind's eye another picture of Patty, this one of Patty as Tanya, Symbionese Liberation Front revolutionary.

Patty was just one of many women who commanded our attention in 1979. Indeed, the most commanding figure was not a single specific member of that sex. It was, instead, Woman. The vastly expanded role and influence of women at almost every level of society may be the most historic development of these times. Again, it is a story difficult to tell with a single photograph, but doesn't the picture of the woman at the head of the military column provide a vivid commentary on the changing sex roles?

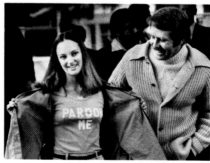

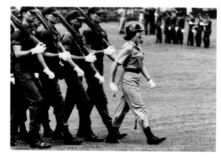

*see p. 85*

*see p. 85*

Now, consider photography as an art form. After all, a picture can tell a story and satisfy an aesthetic need as well. The picture of the Moslem woman framed by the oversize photograph of the Ayatollah Khomeini is no less than a riveting piece of abstract art. Similarly, the grain elevators photographed amid the wheat fields of Saskatchewan have the hard edge of realism and the soft touch of impressionism.

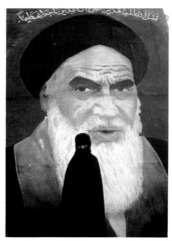 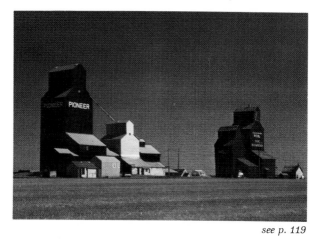 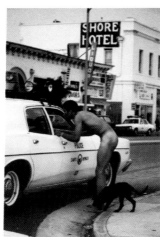

see p. 35

see p. 119

see p. 123

It is tempting on occasions such as this to take photography and our attitudes toward it too seriously. This is a book of humor as well as a book of history, commentary, and art. A picture can be an 8 x 10 banana peel, catching us off guard, providing unexpected laughter in the midst of unrelieved gloom. The picture of the naked man talking calmly to a police officer is at once funny and poignant. Indeed, a picture can be sympathetic while it is being funny. That sequence of photographs depicting "A Nasal Battle" touches at the same time nerves, humor, and sympathy. It teaches us to laugh at our common condition.

see p. 245

Finally, I want to say something about the people behind these photographs. Some I know personally. Others I feel I know through their work. What I find particularly appealing about all of them is their dedication and their individuality, even when they are part of a crowd of photographers. These rumpled bundles of concentration, energy, and devotion live a kind of guerrilla life-style, constantly on the move, ready to shoot from any position at a moment's notice. They have an extraordinary feel for life in so many forms, and they have a vision that permits them to see what too many ordinary journalists overlook. In this book they share their touch and they lend us their eyes. We should be grateful.

It seems that the memory of one crisis is lost in the presence of another. While the Vietnamese boat people commanded so much American sympathy, the plight of the Cambodian refugees was at least as serious. And the plight of the masses of starving Southeast Asians faded from recollection when over sixty American citizens were taken hostage by Iranian students in Tehran.

But a review of the photographs that were chosen from the Pictures of the Year competition graphically renews the memory of all these events. It also dramatizes the powerful impact of the decisions made by a relatively small number of people. These photographs record the events in ways that words never could, in ways that put the events before us in all of their original immediacy.

The early months of 1979 were months of instability for the population of Cambodia. The fall of the Pol Pot government and the invasion by Vietnamese troops left thousands homeless. Being uprooted from home and livelihood is an experience that most Americans cannot begin to comprehend. The photographs of children in Cambodian refugee camps portray an aspect of life that is completely foreign to most of us. This year's competition had more than its share of pictures of starving and dying children. Perhaps this part of the Cambodian tragedy is the one that is hardest to cope with. The first few photographs in the book portray a nation subject to the kind of change that it was powerless to control. The photograph of the ten-year-old Khmer Serai soldier (p. 16) is at least evidence of a people fighting back and, in the context of the sequence of pictures, is almost a sign of hope.

If the Cambodians have been completely uprooted from their homeland, the Iranian revolution provided an entirely different set of opportunities for photojournalists. While the Iranian government is another example of instability, there is a certain dynamism in the pictures. The opulence of Shah Mohammed Reza Pahlevi's quarters before his fall in January created a combination of Persian and Western values that must be intriguing. The religious fervor of Moslem zealots is shown in so many instances—their way of imposing some sort of control over their own lives. The dark mystery that cloaks the Ayatollah Khomeini and the rabid anti-American sentiment that has accompanied his rise to power are curious phenomena to our Western culture. The magazine pictorials of the rich Moslem culture bring the whole epic to life by setting before us the forms and textures of life in Tehran.

The Russian invasion of Afghanistan had far-reaching implications for U.S. foreign policy. But for journalists, forbidden entrance sparked a determination to uncover the Afghans' story. A photographer disguised as a deaf-and-dumb Patha tribesman—the scenario could have been lifted from a paperback novel. But the cloak-and-dagger situation necessitated an inventiveness on Steve McCurry's part.

International news in 1979 certainly provided unusual opportunities for photographers. The year should be remembered for its intensity, and the visual portrayals in these photographs will be an essential element in that record.

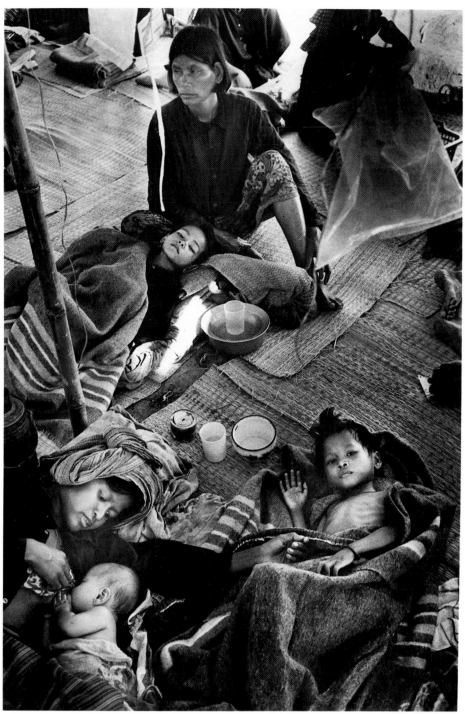

In January 1979, the Cambodian government of Pol Pot fell to Vietnamese forces and Cambodian rebels, and thousands of refugees began to flee the country. In Sa Kaew, Thailand, Eddie Adams photographed these children inside a field hospital. According to doctors there, many of the children had not eaten in so long that when food entered their stomachs it was painful, many spit the food out or vomited, others went into shock or even died.

In the Cambodian camp of Nang Mak Moon, a Khmer Serai soldier stands guard. The residents of this camp consider themselves the last bastion of free Cambodians and steadfastly refuse to leave Cambodia for Thailand, where soldiers like this boy would have to give up their weapons and abandon all hope of returning to their homes.

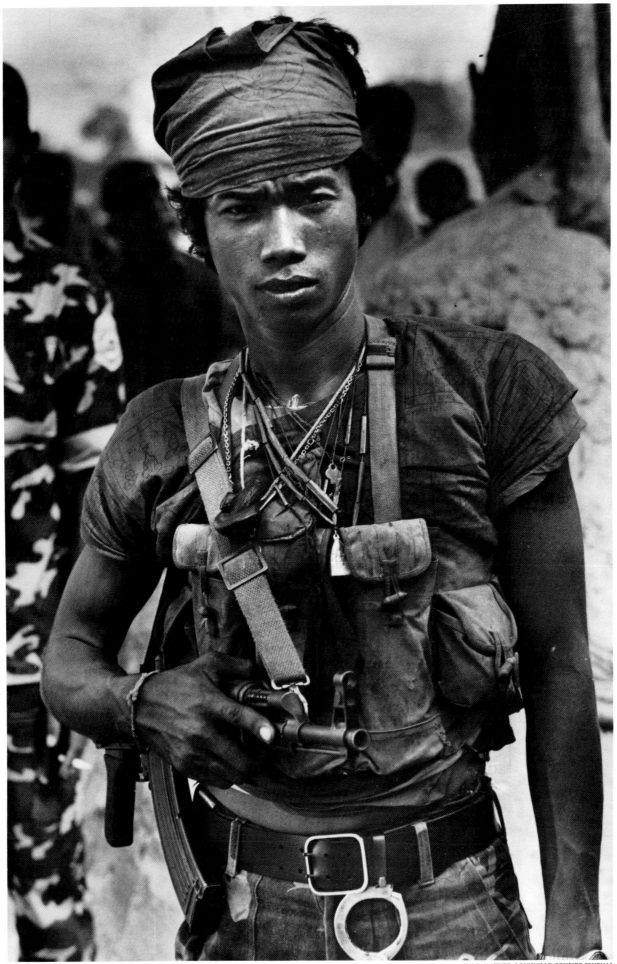

JAY B. MATHER, LOUISVILLE COURIER-JOURNAL

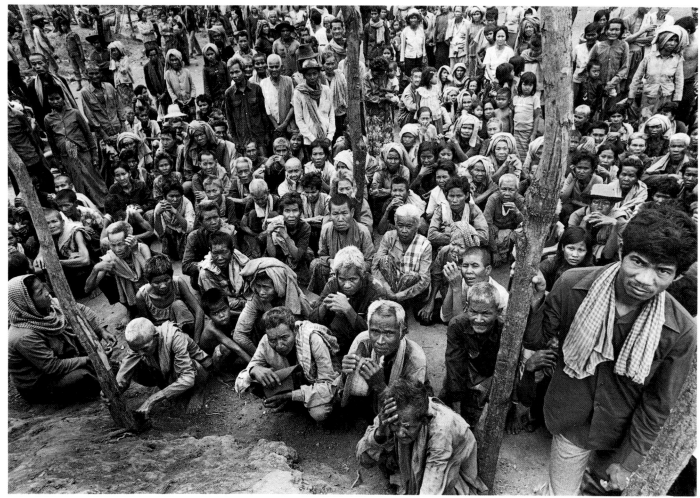

JAY B. MATHER, LOUISVILLE COURIER-JOURNAL

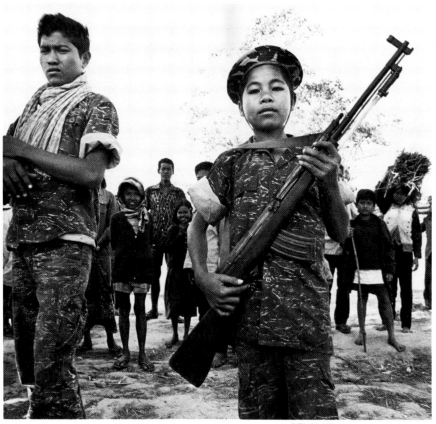

RICHARD OLSENIUS, MINNEAPOLIS TRIBUNE

In November, refugees in the Cambodian camp of Samet Meanchey gathered in silent protest of a proposal by world relief organizations to move them into Thailand, where they could receive more aid. The Cambodians were afraid of being attacked by Thai soldiers and also of being put into the same refugee camp as their former enemies, the Khmer Rouge soldiers.

At Camp 007 on the Cambodian-Thai border, a ten-year-old Khmer Serai soldier poses with his weapons. The Khmer Serai, the "free Cambodians," were the last Cambodians to fight both the Khmer Rouge forces of former President Pol Pot and the Vietnamese forces then ruling the country.

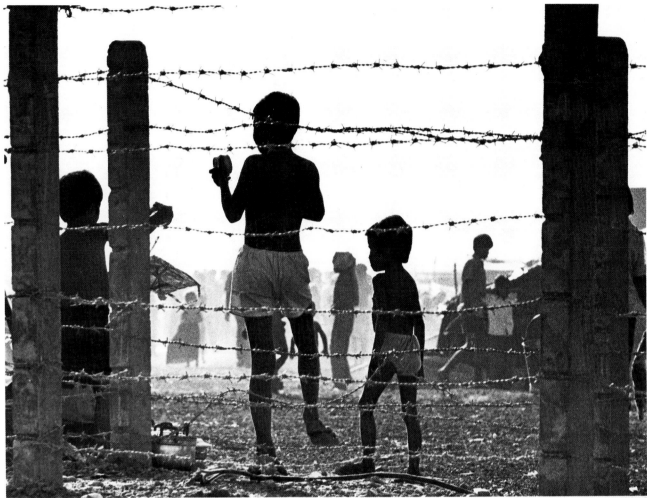

RICHARD OLSENIUS, MINNEAPOLIS TRIBUNE

In the refugee camp of Sa Kaew, Thailand, children seemed to be the major victims of the fighting in Cambodia. Richard Olsenius photographed children playing in their home of barbed wire, while Jeff Robbins took this picture of a young Cambodian mother holding her baby in her arms as she waited in line outside a hospital in the camp. The young child had died by the time the mother reached the medical help inside.

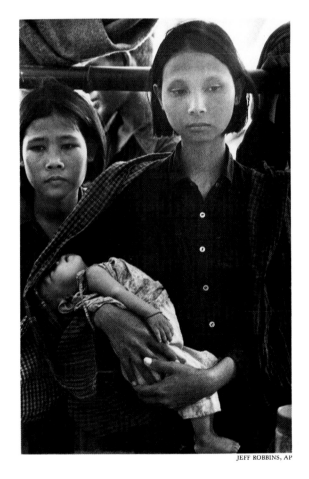

JEFF ROBBINS, AP

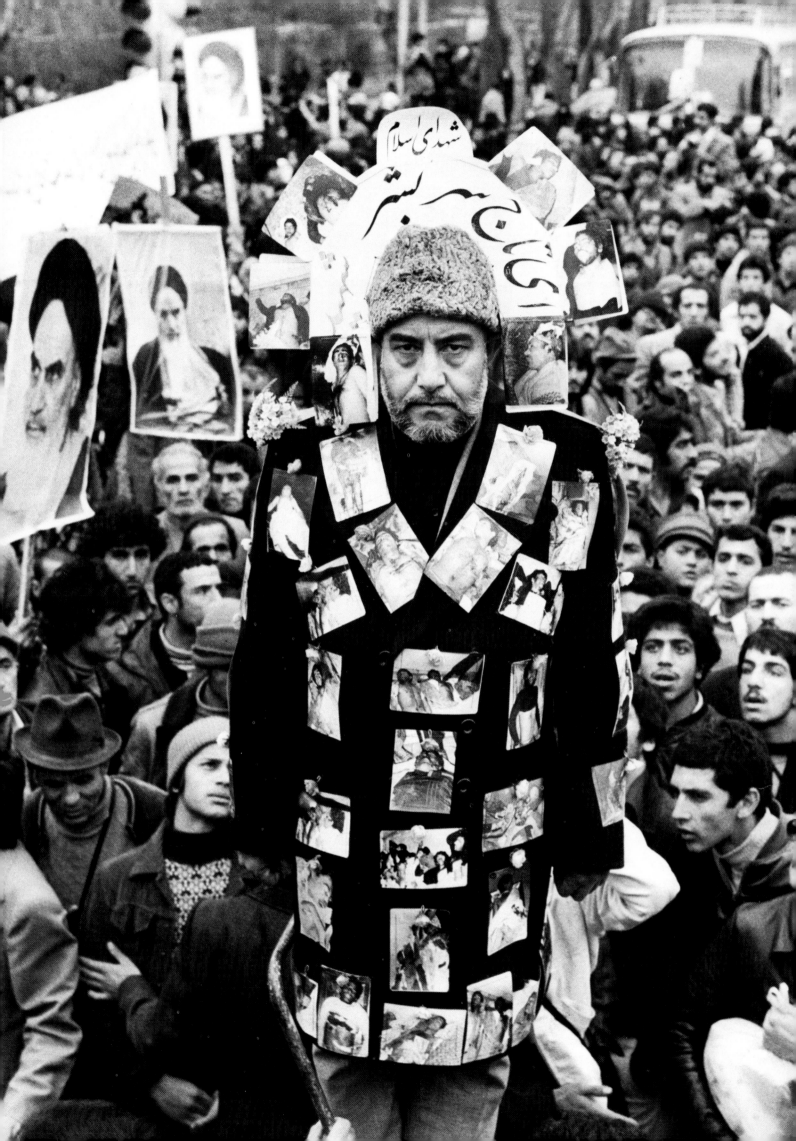

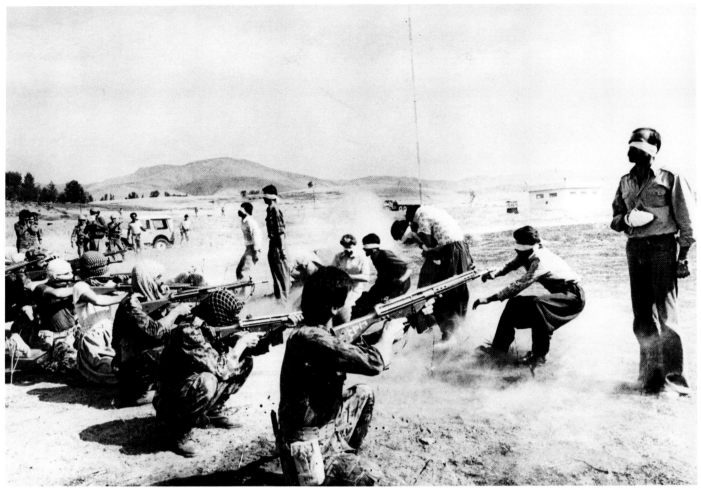

ANONYMOUS, UPI (SPOT NEWS, FIRST PLACE, NEWSPAPER)

In August, the government of Ayatollah Khomeini executed nine Kurdish rebels and two former police officers of the deposed Shah in an attempt to dramatize the futility of guerrilla fighting and to encourage Iran's 4 million Kurds to help root out the guerrillas among them. Instead, the Kurds, who had previously been waging their war for political autonomy against the Shah's government, swore to kill one Khomeini loyalist for each rebel executed and vowed to continue their fight against the Khomeini government. This dramatic photograph has also won the Pulitzer Prize.

In Iran, Shah Mohammed Reza Pahlevi was forced on January 16 to flee the country he had ruled for thirty-seven years. During the next few weeks, millions of Iranians gathered in Tehran to cheer the Shah's departure and to demonstrate for the return of the Ayatollah Khomeini. In a graphic, albeit somewhat eccentric, demonstration of the atrocities committed by the Shah, one man covered his body with pictures of persons slain by the Shah's government.

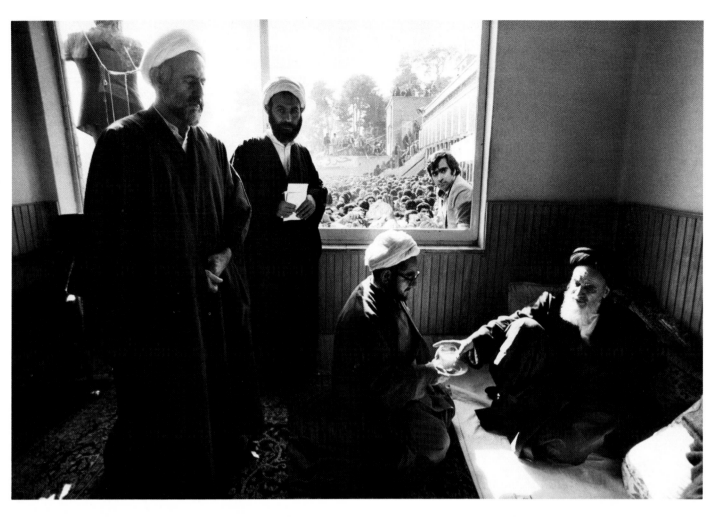

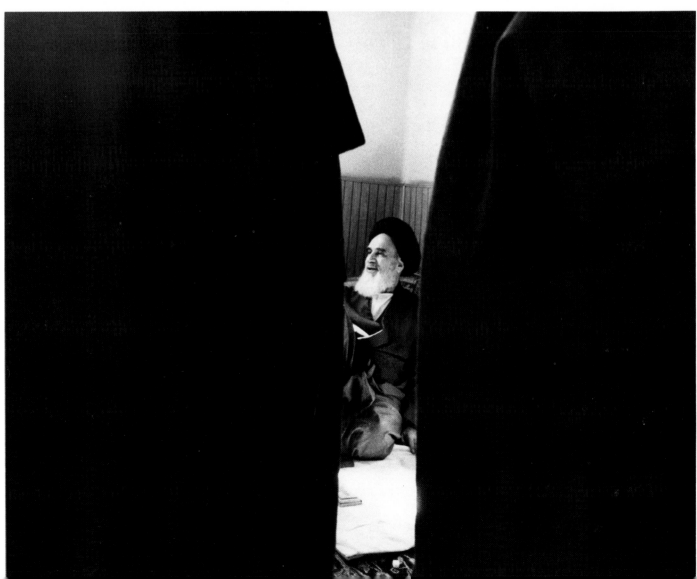

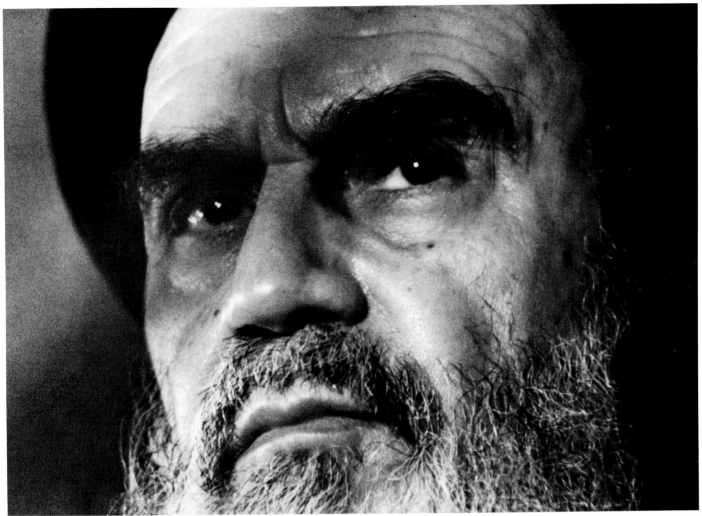

The Ayatollah Khomeini had returned to Iran in early February, ending an exile of fifteen years. Soon after the Ayatollah's return, David Burnett took these photographs of him at his temporary headquarters in the Refa School in Tehran, as the Ayatollah took a break from greeting the crowd gathered to cheer his return (top left) and met with the mullahs, or Moslem priests (bottom left). The striking portrait (above) was taken during a press conference held during this period.

THIERRY CAMPION, AP (SPOT NEWS, HONORABLE MENTION, NEWSPAPER)

Two Iranians used the American flag to carry garbage from the U.S. embassy in Tehran on November 5, the day after sixty-two Americans were taken hostage inside the embassy by Iranian militants. The militants demanded the extradition of the Shah from the United States, where he had gone for medical treatment, and vowed to hold the Americans until the Shah was returned to Iran to stand trial.

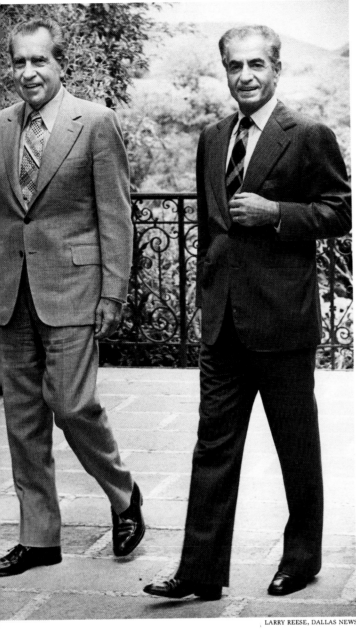

LARRY REESE, DALLAS NEWS

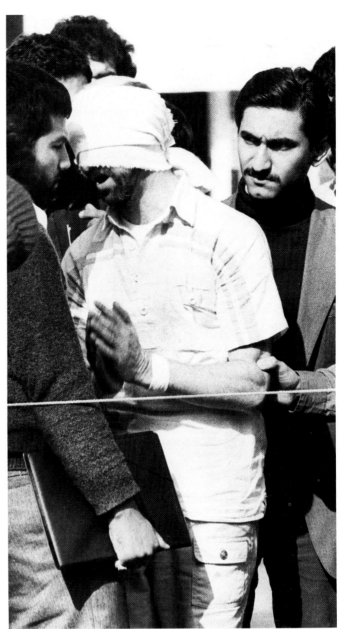

THIERRY CAMPION, AP

While on vacation in Cuernavaca, Mexico, Larry Reese was asked to try to get a picture of former President Richard Nixon's meeting with the deposed Shah of Iran. After spending two days in front of the Shah's residence and being detained by the Secret Service, Rees managed to take this picture by climbing on a chair and holding his camera over the heads of the Mexican photographers.

In a scene frequently repeated during the first days after the capture of the American embassy, one of the American hostages was blindfolded and led outside the embassy wall to be displayed to the crowds gathered there. A few of the American hostages were released shortly after their capture, but for fifty of them this was just the beginning of a term of captivity that would last longer than anyone had expected.

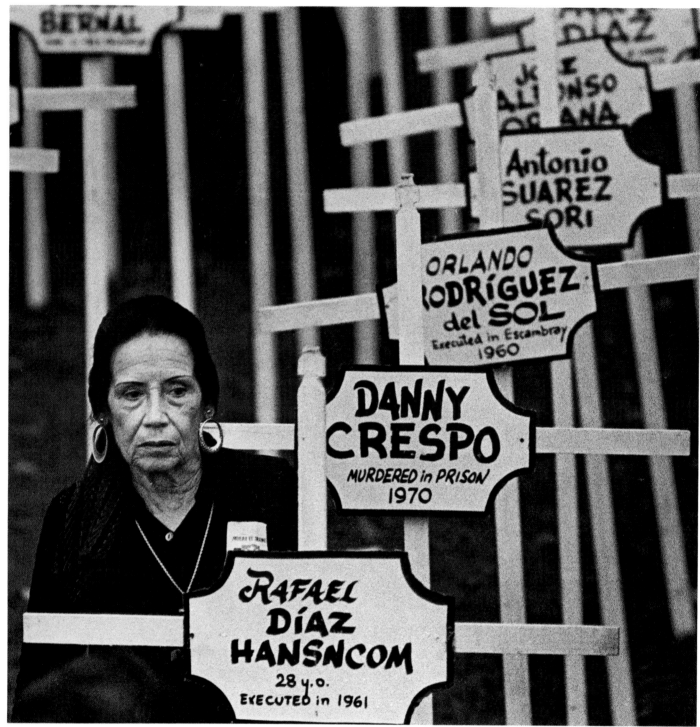

In October, President Fidel Castro of Cuba spoke at the United Nations as a representative of the nonaligned nations, requesting resources for developing the poorer nations of the world.

In Miami, the wife of a Cuban political prisoner stood among 824 crosses bearing the names of men who have been killed in Cuba during Castro's twenty-year regime. The crosses were erected by the more than two thousand Cuban exiles who gathered in Miami's Bayfront Park to protest the presence of Castro in the United States.

In July, after a seven-week civil war that left 10,000 dead and 500,000 homeless, rebels of the Sandinist National Liberation Front took over Managua, the capital of Nicaragua, and a five-man junta took control of the government. The next day, a sixteen-year-old boy, the last of four sons, was shot by gunmen from a passing car while standing in front of a church. Here, friends and relatives stand guard over his body.

In the first weeks of the civil war, two of the homeless tried to relax in the sweltering midday heat of one of Managua's refugee centers. Because of the overcrowding, many of the refugees, like these two girls, had to sleep in fly-infested areas such as this.

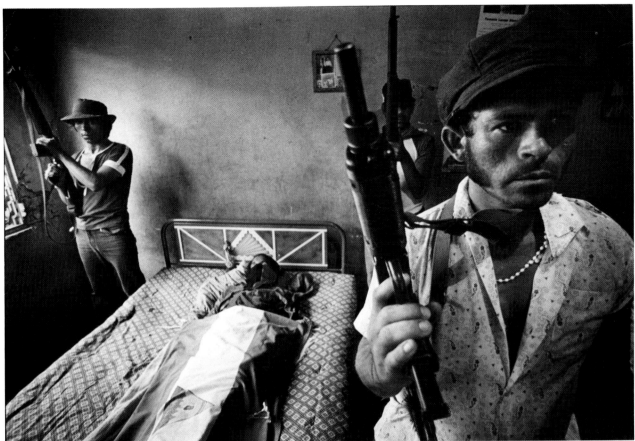

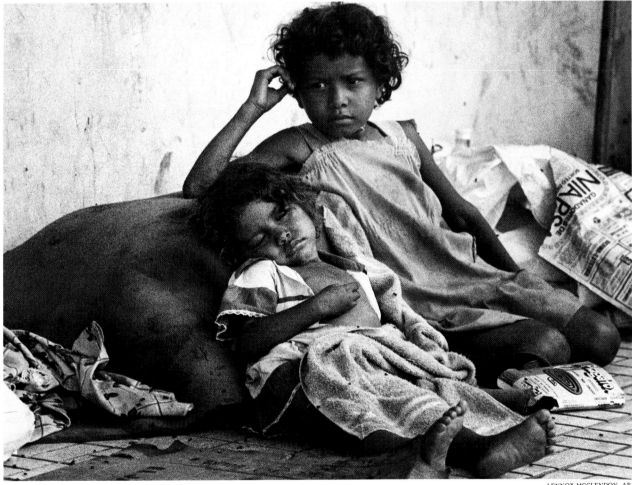

International News / 25

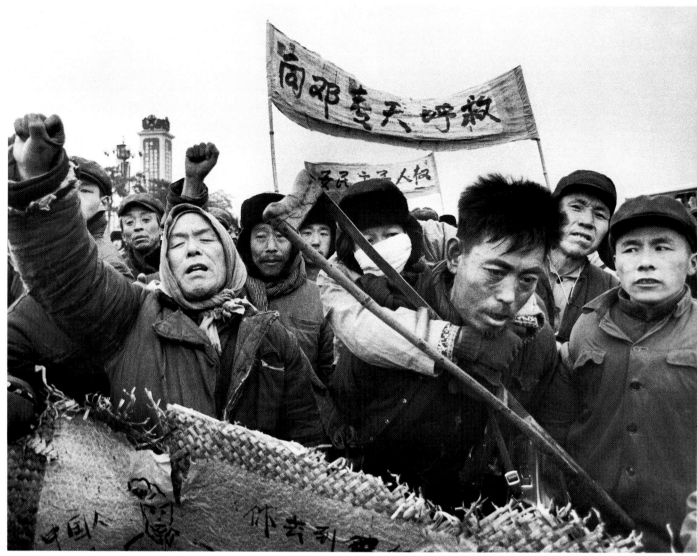

NEAL ULEVICH, AP

In Peking, a group from Shantung province staged a demonstration in late January to protest alleged violations of rights in their province. The group marched from Ti'en An Men Square to the Communist party headquarters nearby, as police redirected traffic to clear a path for the group. The banners appeal to Premier Teng Hsiao-ping for human rights and democracy.

In June, Bob Hope visited China in order to film a television special and thus became the first American entertainer to visit that country. Photographed here in front of Democracy Wall in Peking, Hope's tenuous smile suggests his reaction to not being recognized by anyone.

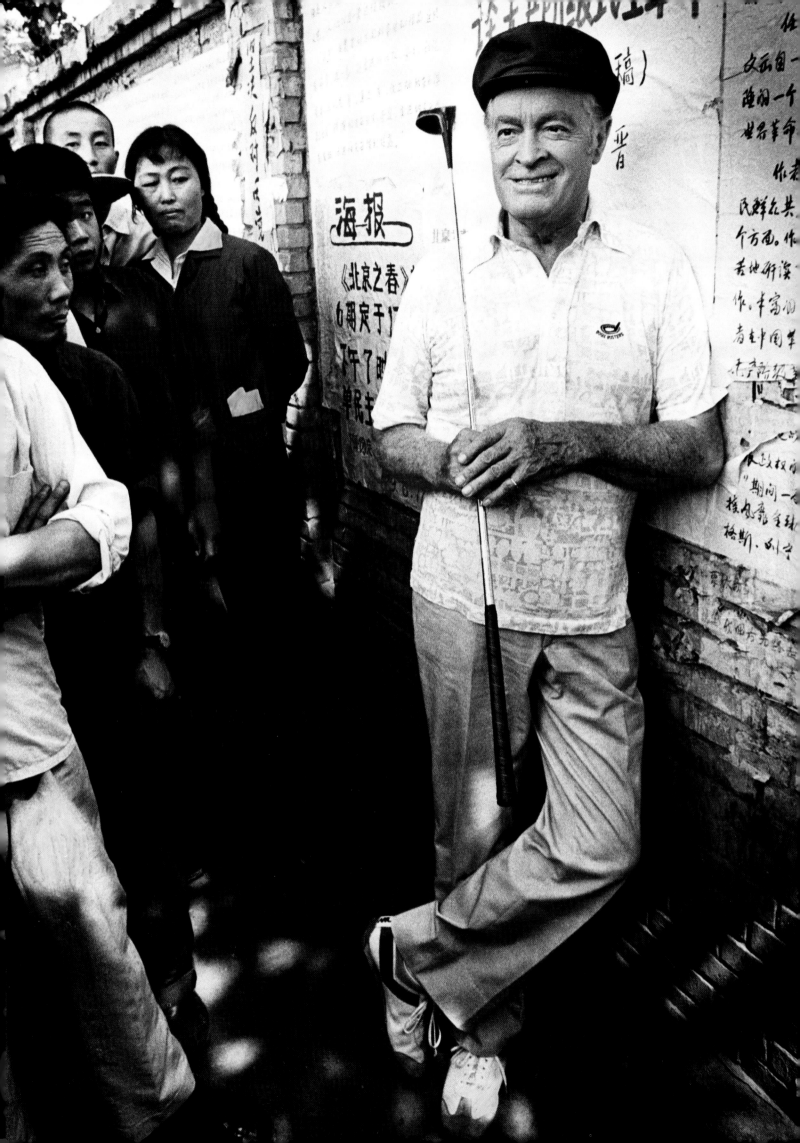

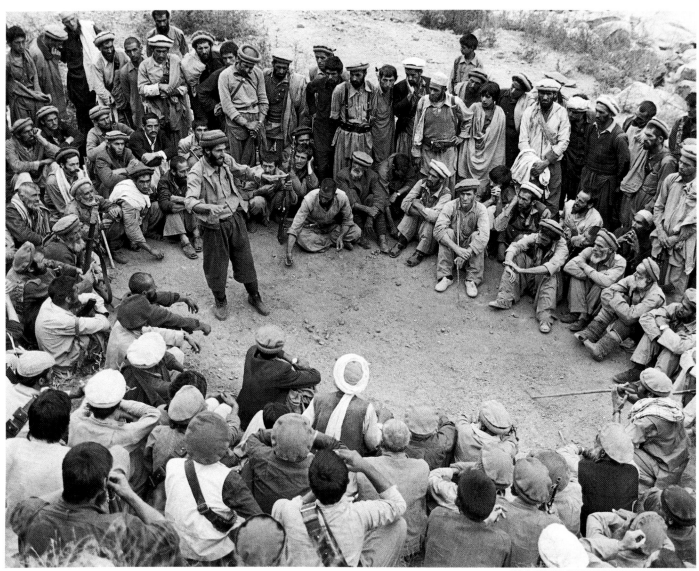

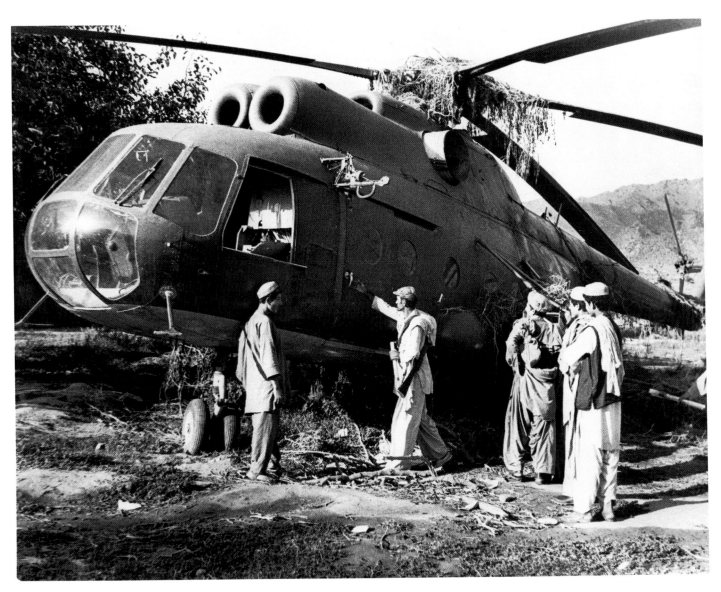

In September, two months before the Russian invasion of Afghanistan, photographer Steve McCurry, disguised as a deaf-and-dumb Patha tribesman, spent a month traveling with a band of rebel Moslem fighters. For two years, these Moslem rebels, or Mujahadeens, have been struggling against the Communist-supported central government in Kabul. With them, McCurry trekked through some of the most rugged terrain in the world—the Hindu Kush.

In Kumar Province, a rebel commander listened to the opinions of his men, allowing each man to speak his piece. They disagreed on many things, but to a man they agreed that they would fight to the death against the Russians.

Near Asmer, a small group of Mujahadeens, using only obsolete and captured Soviet weapons, managed to down this Soviet helicopter.

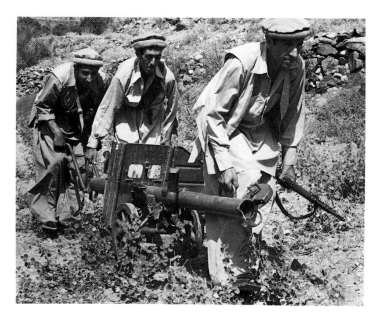

Three Mujahadeens carried a captured Soviet 82-millimeter rocket launcher of World War II vintage over a narrow and rocky trail.

Another three rebel snipers kept watch on a cliff overlooking a government base near Barikote.

To these Mujahadeens, this is *Jihad* or holy war. These Moslems believe there is more merit in fighting this war than in making a pilgrimage to Mecca. They abhor the Communists for their lack of belief in any god. Even in war, however, these Mujahadeens pray five times a day to Allah, always facing Mecca.

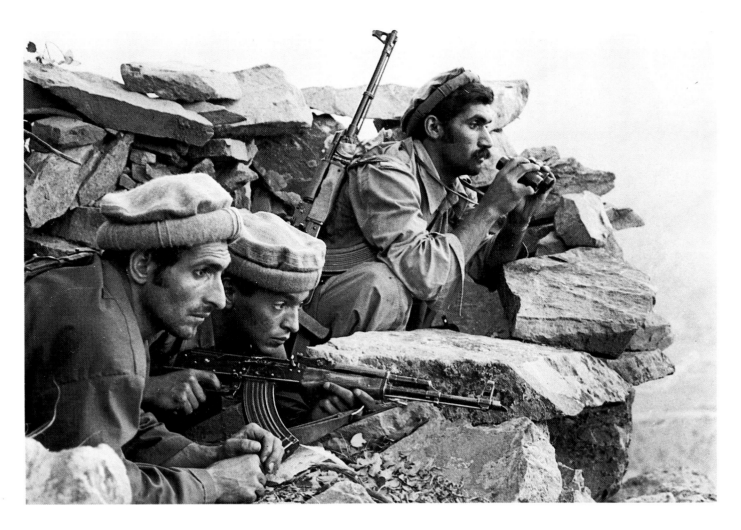

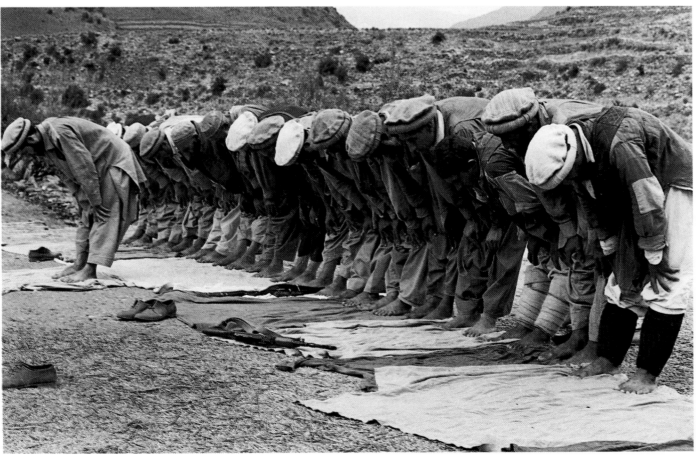

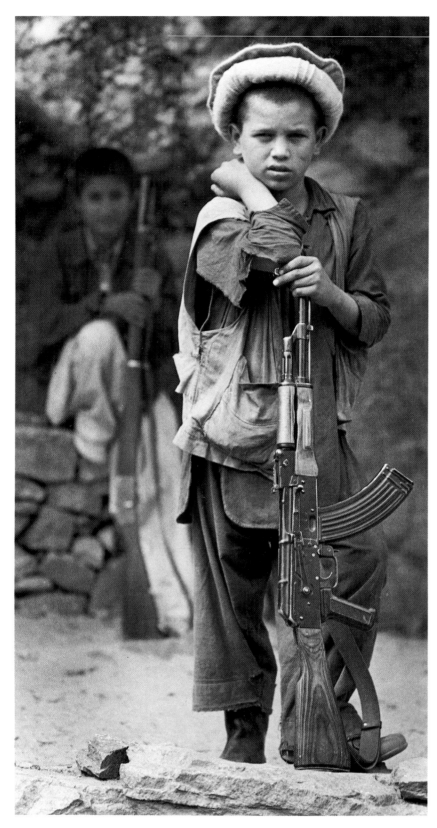

This young rebel helped the Mujahadeens by carrying
weapons from one area to another and baking bread to sneak
to the hideaways in the hills.

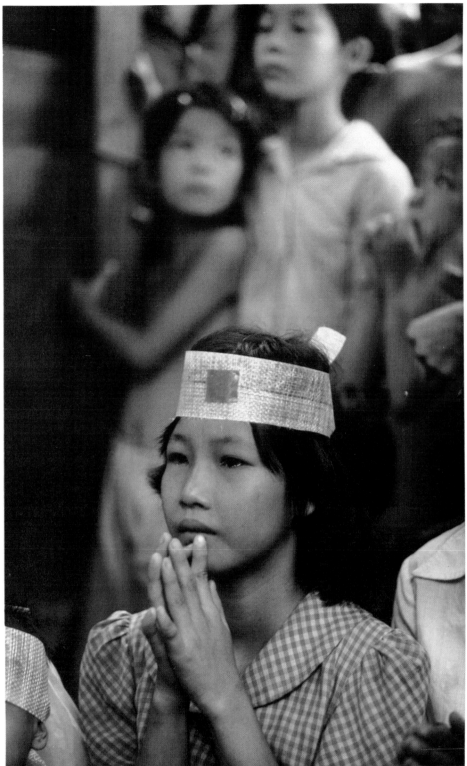

Uninhabited until August 1978, by September 1979 Pilau Bidong, a mile-square island off the eastern coast of Malaysia, was the home for 35,000 Vietnamese boat people. Crowded into a camp only forty-three acres large, these refugees were waiting to learn whether they would be allowed to join the 85,000 of their countrymen who had already emigrated to the United States and other Western nations.

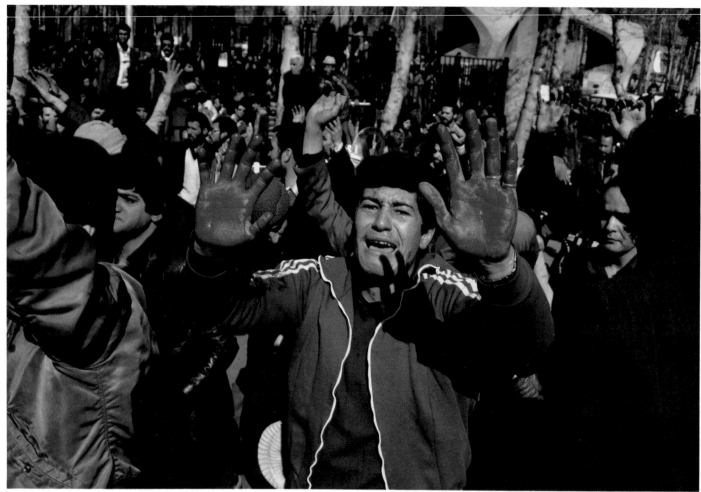

On January 31, the day before the Ayatollah Khomeini returned to Tehran, Prime Minister Shahpur Bakhtiar staged a show of force by parading his army past Tehran's university. All was calm until soldiers in the last truck fired into the crowd, killing and wounding half a dozen students. Outraged, demonstrators soaked their hands in the blood of the martyred students to protest the actions of the government.

An Iranian woman in traditional Moslem dress stands in front of a poster-portrait of Ayatollah Khomeini. Soon after his return to Iran, the Ayatollah ordered that Moslem women "must be clothed according to religious standards," a dictum that angered many, both male and female.

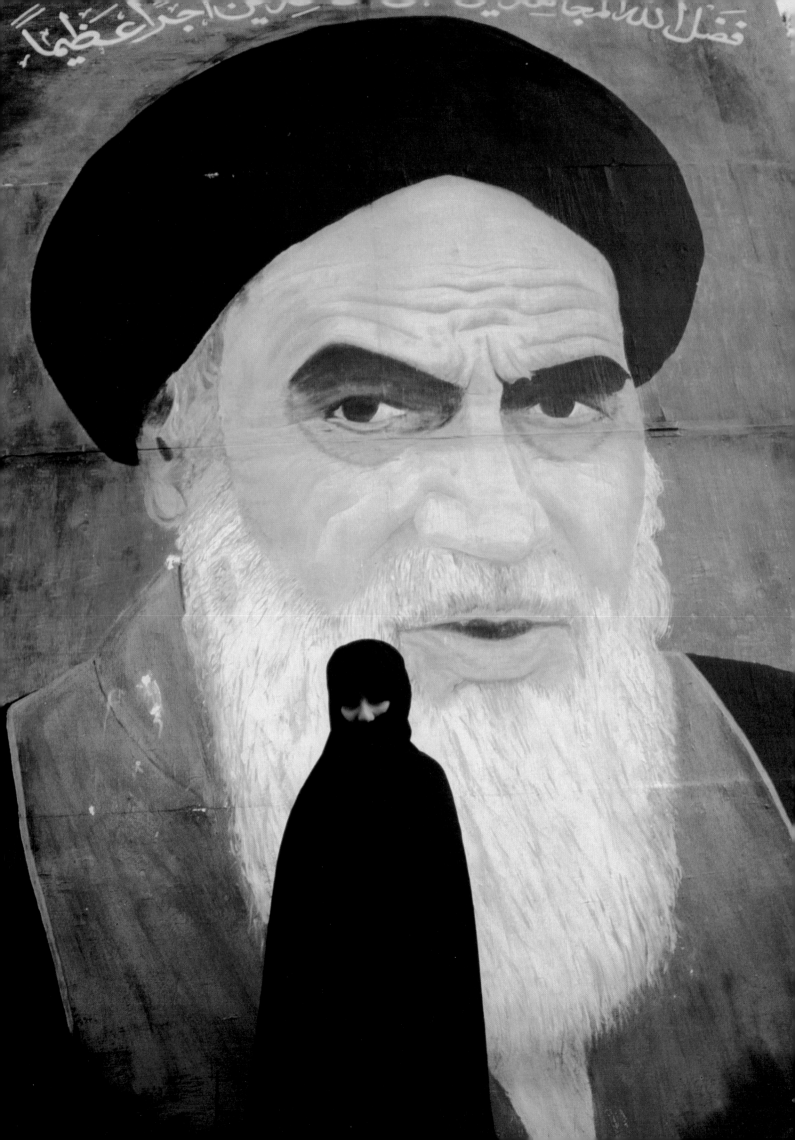

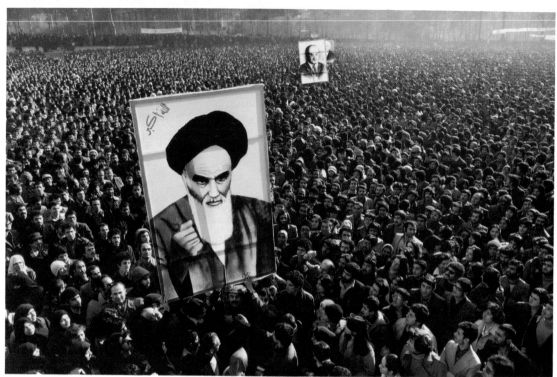

PHOTOS ON PP. 36-37 BY DAVID BURNETT, CONTACT PRESS IMAGES, INC.

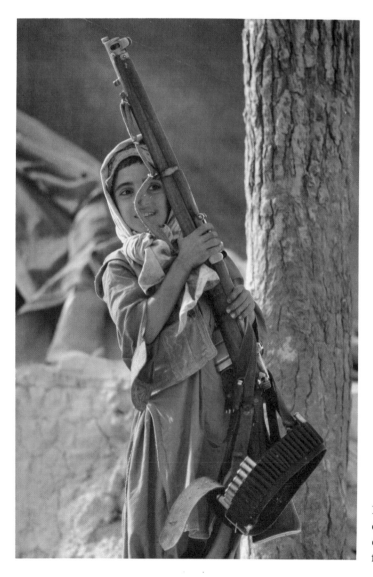

At the university in Tehran, on the day it reopened in February after having been closed for several months, students rallied to show their support of the Ayatollah Khomeini.

After the departure of the Shah from Iran, a revolutionary soldier stood guard at one of the Shah's former homes, the Galestan Palace in Tehran.

In Afghanistan, a young boy at the camp of the Beluchi Liberation Front carries the gear of one of the freedom fighters.

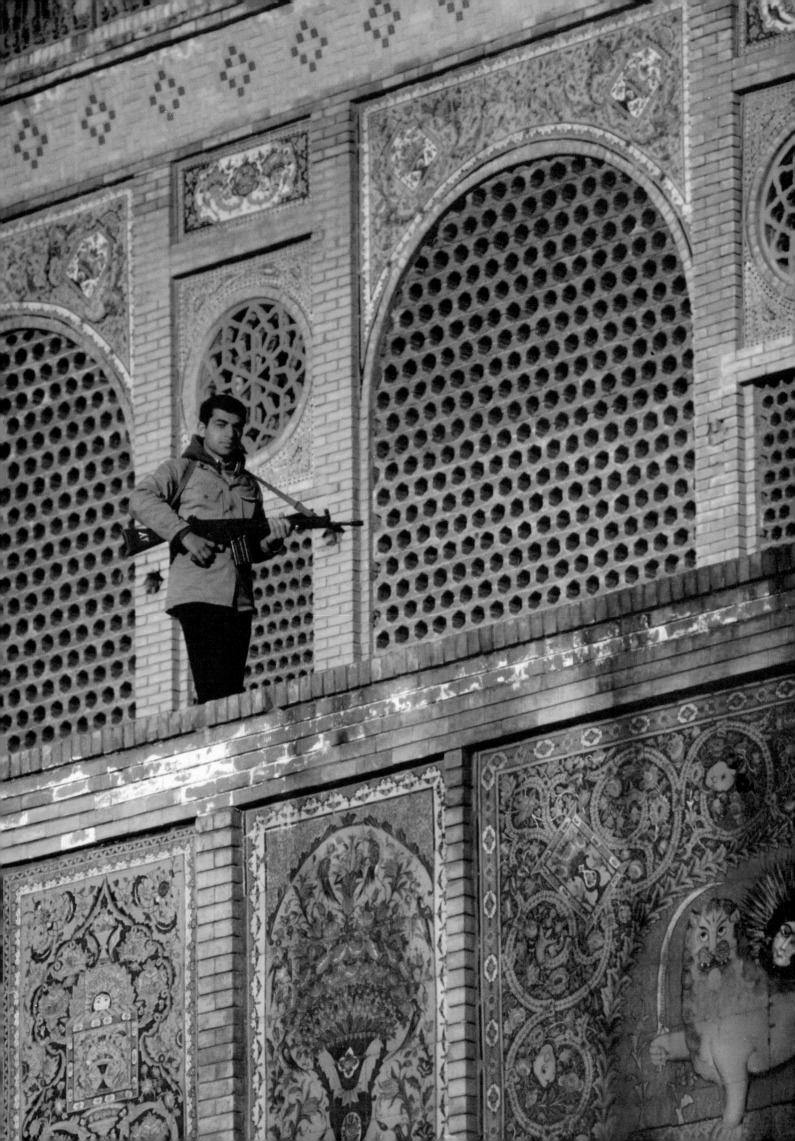

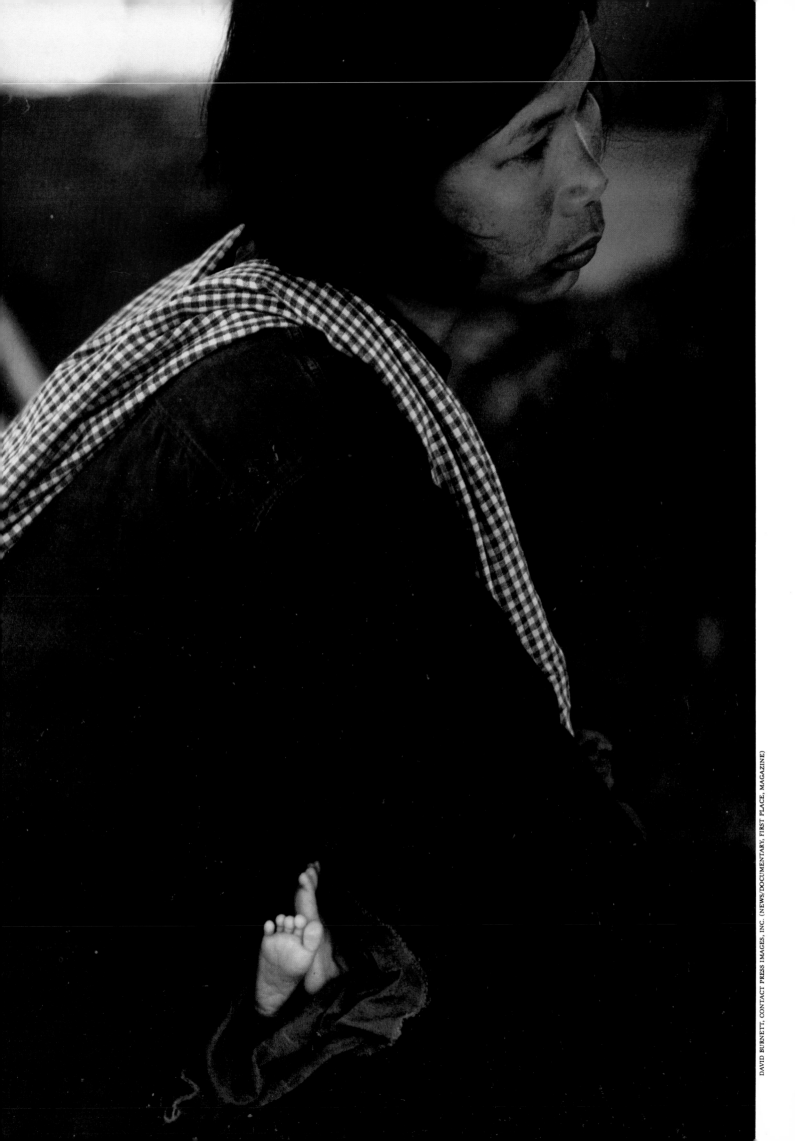

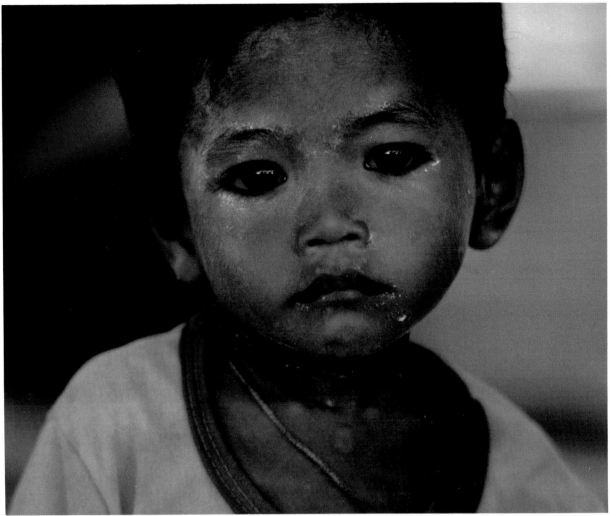

DAVID BURNETT, CONTACT PRESS IMAGES, INC. (PORTRAIT/PERSONALITY, THIRD PLACE, MAGAZINE)

The faces of a mother with her child and of another young child in the Sa Kaew refugee camp in Thailand reflect the despair felt by many of the Cambodians forced to flee their homes and their country. At one time, as many as fifty residents a day in this camp were dying of starvation or disease.

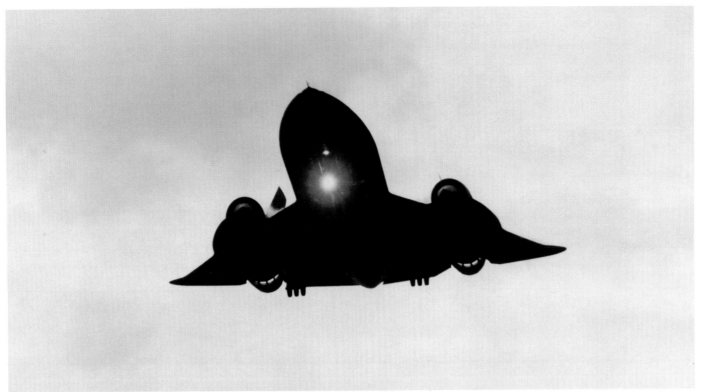

Early in 1979, Co Rentmeester was allowed to photograph two of the United States' most sophisticated aircraft. The helmeted man at left is aboard the navy's F-14 Tomcat. This carrier-based plane can fly at twice the speed of sound at a height of 55,000 feet for a distance of 2,000 miles. Above are two views of the air force's SR-71 spy plane. Although most of the statistics on this plane are top secret, it is known that it holds the world's record for absolute speed—it can fly 2,200 miles per hour—and for sustained altitude—at about 85,000 feet.

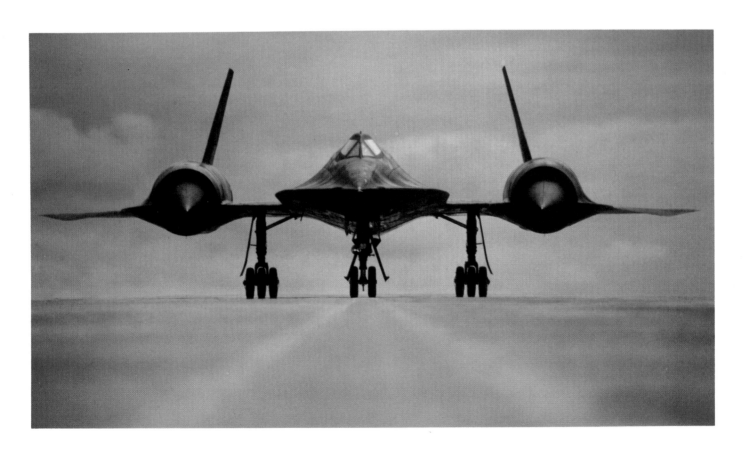

In Rangoon, Burma, David Burnett was intrigued by the shadows that fell on this woman's face as she stood in the local marketplace.

Also in Rangoon, Burnett surprised this Burmese worker by snapping his picture while the worker was showering in the street under the water falling from a pipe.

At Grande Rivière in Martinique, the afternoon sun spreads a glow over the fishing boats of the Carob Indians. Named gommiers for the gum trees from which they are hewn, these boats enable the fishermen to travel as far as twenty miles offshore in their search for the tuna, king mackerel, and dolphin from which they make their livelihood.

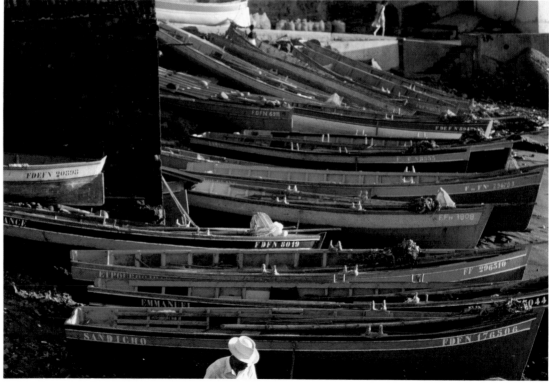

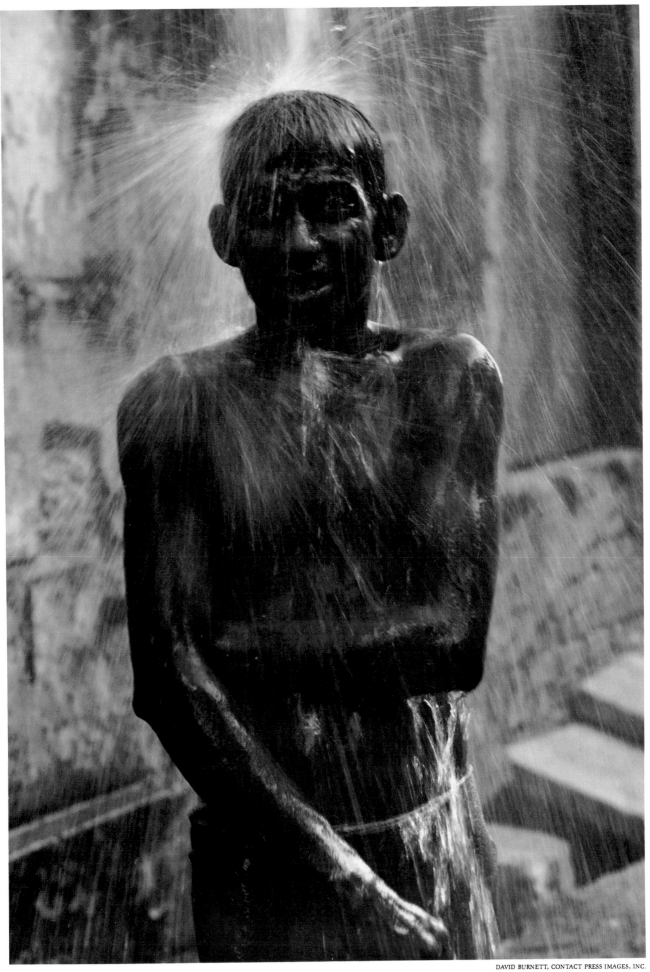

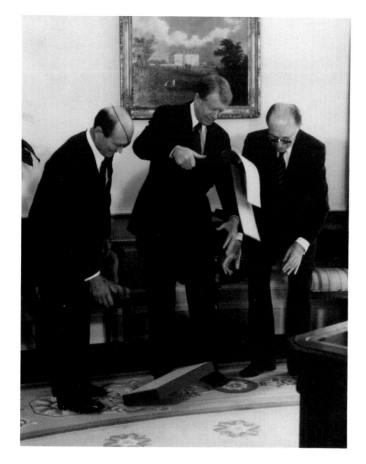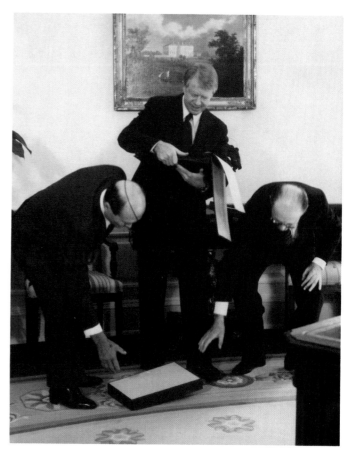

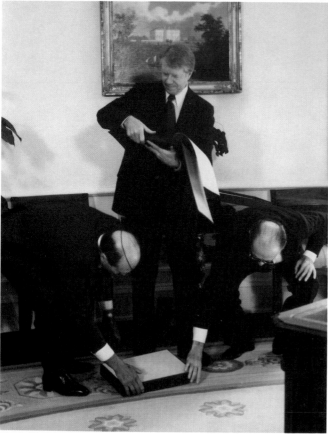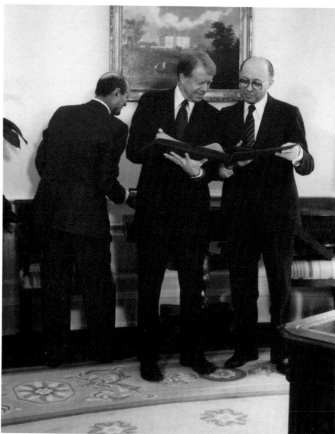

ROBERT A. CUMINS, FREELANCE (NEWS/DOCUMENTARY PICTURE STORY, THIRD PLACE, MAGAZINE)

Protocol in high places. Early in the morning of March 26, the day these world leaders were to sign the Israeli-Egyptian peace treaty, President Carter was presented with a photo album of his recently completed trip to Israel. As the president opened the album, the bottom cover fell, and in a respectful gesture both Foreign Minister Moshe Dayan and Prime Minister Menachem Begin stooped to retrieve it.

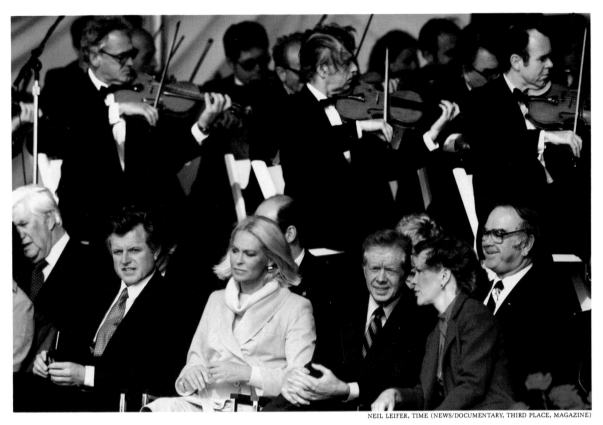

A rare occasion for the Kennedys and Carters to get together—the opening ceremony of the John F. Kennedy Library.

You may recognize their faces, but their names won't ring a bell. These folks make a living just by looking famous. Strolling on Sunset Boulevard in Hollywood are doubles of Shirley Temple, Gerald Ford, Candice Bergen, Henry Kissinger, Raquel Welch, and Jimmy Durante.

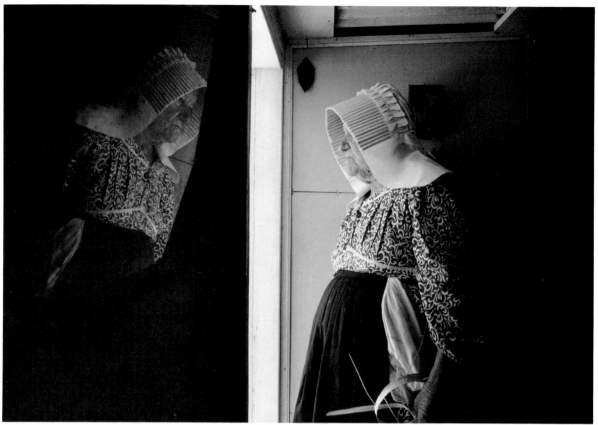

Still living in the ways of the past, a woman of St. Barts—wearing a traditional bonnet—
pauses from her weaving to look out the front door. She is a descendant of the fishermen
who left Normandy and Brittany in France to settle on the tiny Caribbean island.

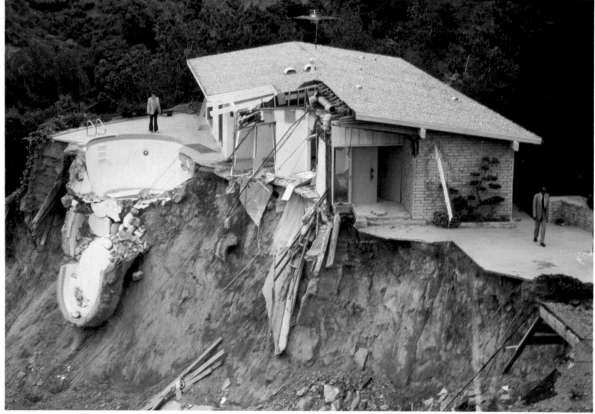

Alternating periods of drought and rain have forced this Los Angeles house to take a
quick dip in value from approximately $200,000 to zero.

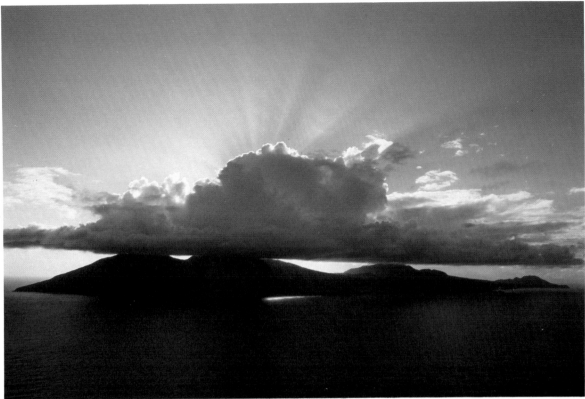

Low-hovering clouds crown the volcanic peaks of Montserrat, one of the islands in the British West Indies.

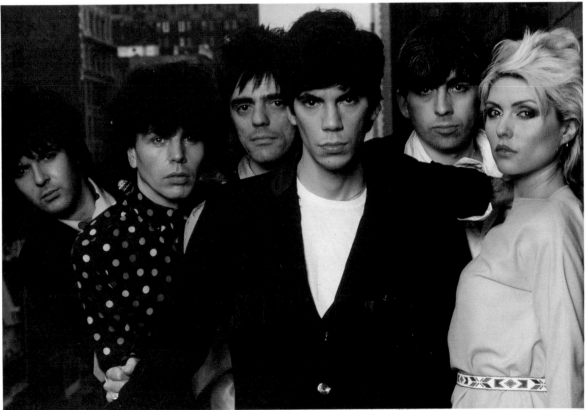

Who's a punk? Having tossed aside the standard paraphernalia used by punk rockers, the group Blondie posed here at the Chelsea Hotel in New York for a recent album cover. Lead singer Deborah Harry, whose striking yellow tresses inspired the group's name, shows her new image as a grown-up sex symbol. One of a new breed of innovators in the rock 'n' roll business, Blondie is the most commercial of the New Wave groups since its hit song "Heart of Glass" sold 1.6 million copies in 1979.

# National News

A great proportion of national news is reported and photographed in unexciting places for newspapers whose primary concern is to serve a local populace. Even in an age when we are bombarded by centralized electronic media, hundreds of small towns support individualized local print media. These are audiences that cannot be reached by more expensive forms of communication, but that are willing to support coverage of local events in a limited form.

Many of us are aware of the major news events through television news coverage. While there are many advantages to presenting news in this condensed form, TV images are fleeting and quickly forgotten. Newspaper and magazine photographs give the reader an opportunity for reflection. And periodicals, especially, "save" the news for us by presenting it in a permanent, portable form.

While in every year there are major events that have far-reaching implications, such as the nuclear accident at Three Mile Island, most of what occurs has happened many times before. The names change, the faces change, but the events remain similar. The photographers represented in "National News" are presenting accounts to people about their own surroundings. These photographers must endlessly meet the challenge of presenting events in a fresh, objective way. A few seconds' lapse can mean the difference between a good photograph and one that is outstanding. It is especially the province of the local newspaper photographer to be continually aware of these subtleties, since there is no other source for this sort of presentation.

How many solar eclipses have been photographed? But that does not diminish a reader's interest in seeing another version. Fires can be the most dramatic kind of disaster, but the number does not release the photographer from his obligation to be on hand with his camera.

Constituencies own the lives of their political leaders, and they somehow expect the photojournalists to record every aspect of them for posterity. Pictures like the sequence of President Carter faltering in the footrace in Catoctin Mountain National Park somehow bring the frailties of public leaders into perspective.

There will always be a certain fascination with the violation of the law. People seem to feel the need to be aware of when the law is broken—whether it is by protesters who are adamant about a political ideal or a sniper who has crossed the line between sanity and insanity during a local celebration, or a convicted murderer facing the very human fact of death by electrocution. Photographic accounts remind us of the less civilized, less controlled side of our society.

Natural disasters always have an especially awing effect. While the nuclear accident and all of the potential side effects that may have resulted from it were precipitated by the minds of men, it is sobering to be reminded of the enormous powers over which men have no control. Every year some locale suffers at the whim of hurricanes, tornadoes, floods, or fire damage during drought. The photographs continue to remind us of our vulnerability long after men have cleared the rubble and rebuilt in its place.

The pictures in the national news category show how newspaper and magazine photographers portray us to ourselves. They reflect the way in which we see ourselves as a nation.

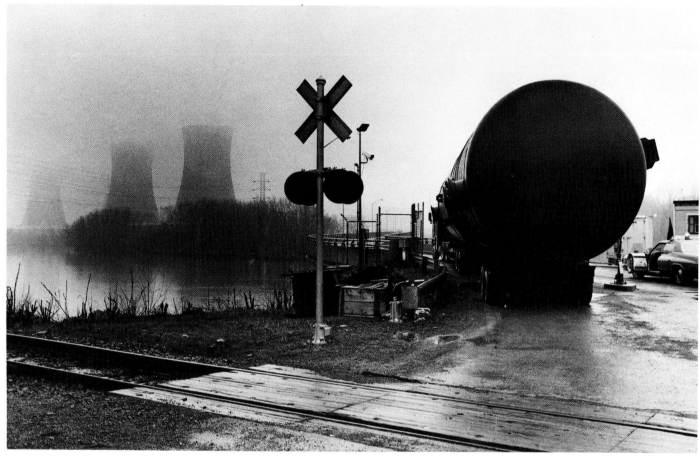

A few days after the Three Mile Island nightmare, this tank truck was supposed to ferry out the radioactive water from the malfunctioning reactor, while a security guard, gaining a false sense of security from the gas mask over his gun, stands at the main observation deck across the Susquehanna River.

All pregnant women and preschool children within five miles of the plant were urged to evacuate, and residents farther away were urged to stay indoors. A little boy, too young to understand what has happened, plays at the evacuation center while his mother pensively looks on (top right). Another mother and child sit in front of their home (less than a half-mile away from the plant) after posting one of the first antinuke signs.

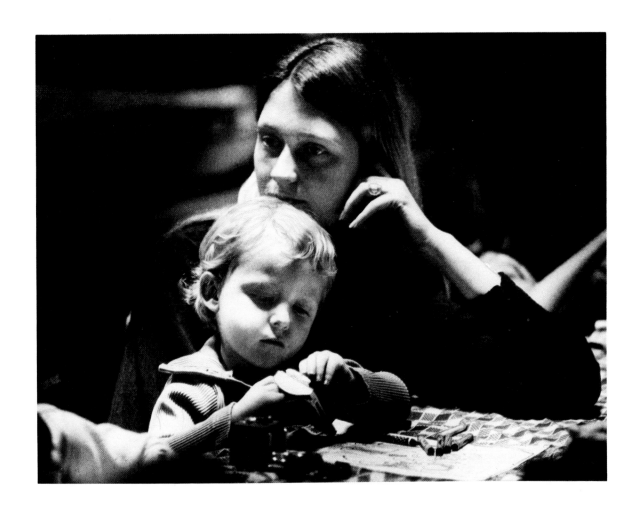

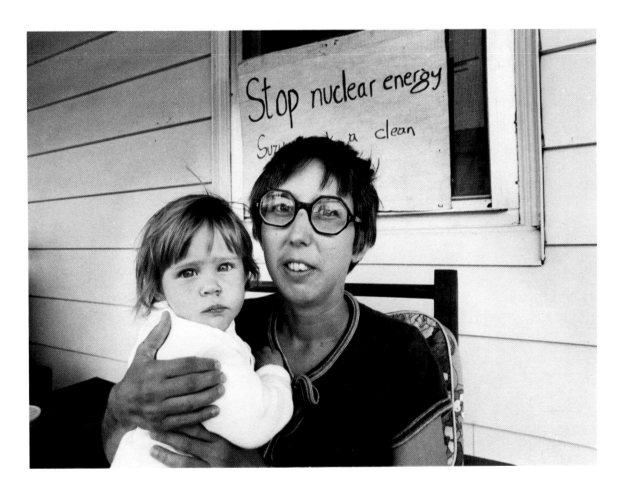

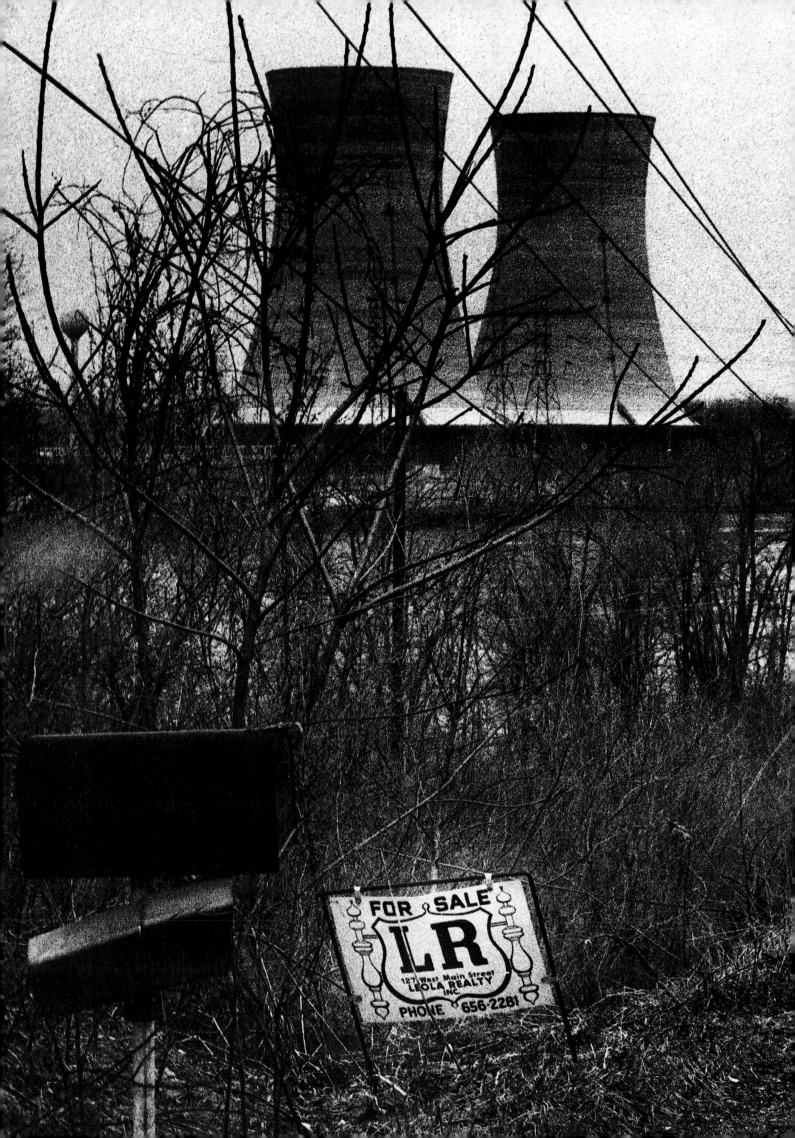

FOR SALE
LR
127 West Main Street
LEOLA REALTY
INC.
PHONE 656-2281

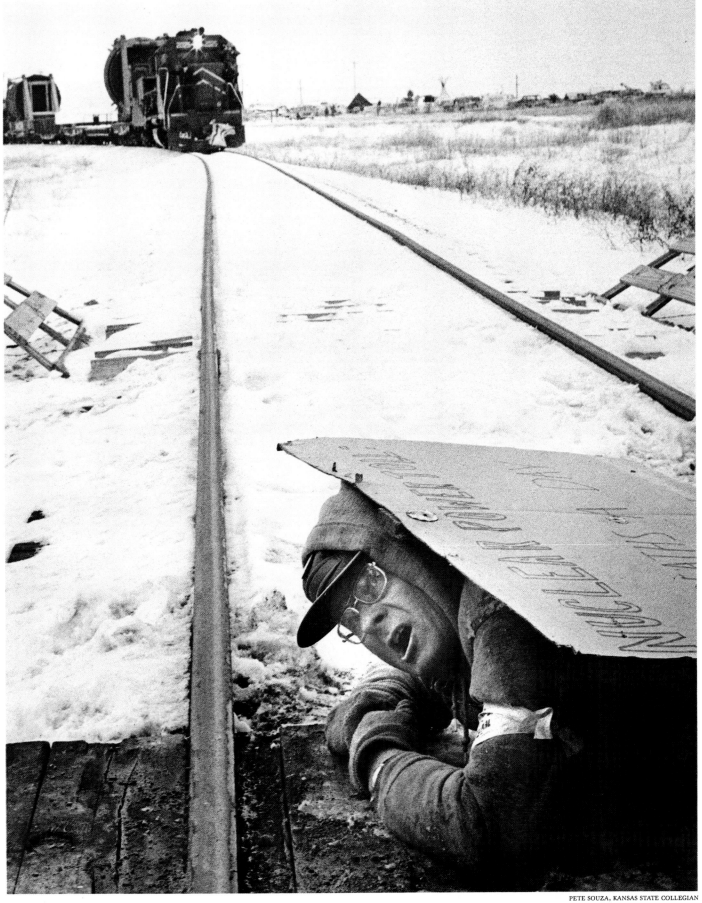

Francis Blaufass of Burlington, Kans., tries to block the passage of a train carrying a nuclear reactor to the Wolf Creek Nuclear Power Plant. He was later arrested along with thirty-six other antinuke demonstrators for criminal trespassing.

Anyone Want to Buy a Nuclear Power Company? What bank would want to take a risk on this investment?

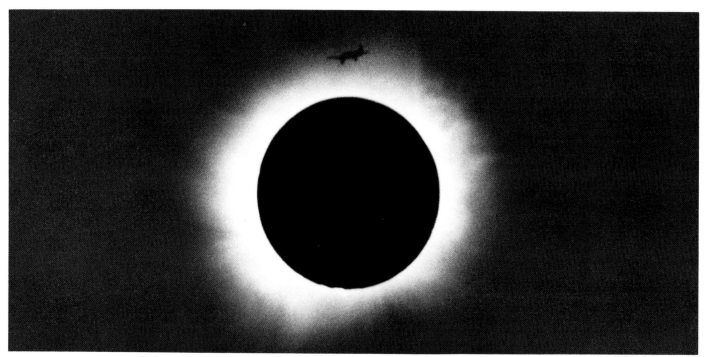

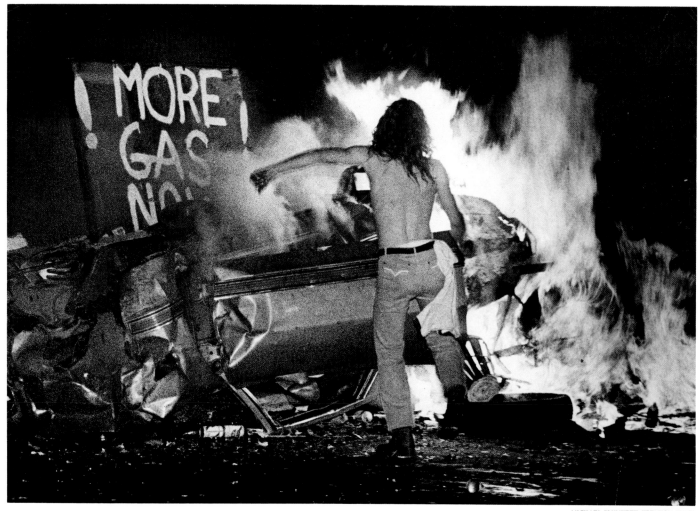

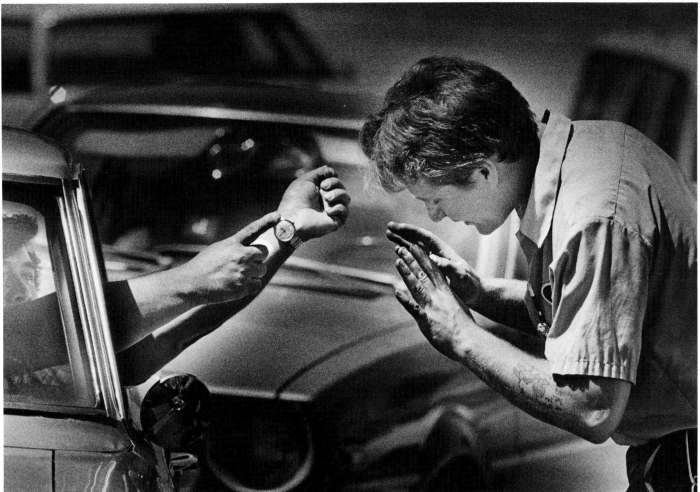

A gas-station attendant in California tries to calm an irate customer during the oil crisis. The customer had discovered that the attendant had cut off the waiting line at the point where he could close at noon. The driver was in line before the noon hour but was beyond the cutoff point.

Appearing as a silhouette, a plane passes through the sun's corona during the February 26 total eclipse of the sun, the last that will be seen over North America in this century. On this day, the sky around Lewiston, Idaho, was quite overcast. Many photographers were flown to a nearby clear spot in the sky, but this photographer happened to photograph this plane in an intriguing position.

On Sunday night, June 24, in Levittown, Pa., rioting followed a demonstration begun by independent truck drivers, who were protesting the high cost and short supply of diesel fuel and gasoline. The protestors burned a car and vandalized nearby gas stations.

This was the second day of protesting for two thousand residents, in which thirty-four communities sent police reinforcements.

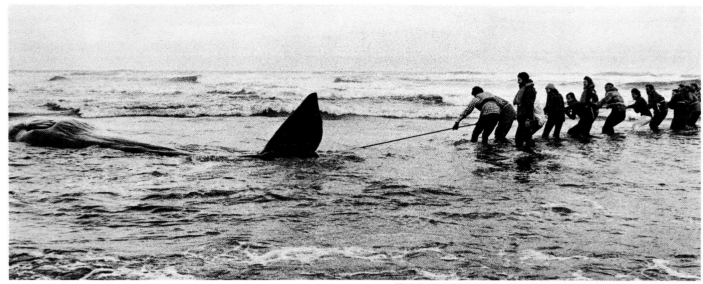

CHARLIE NYE, EUGENE REGISTER-GUARD (NEWS PICTURE STORY, SECOND PLACE, NEWSPAPER)

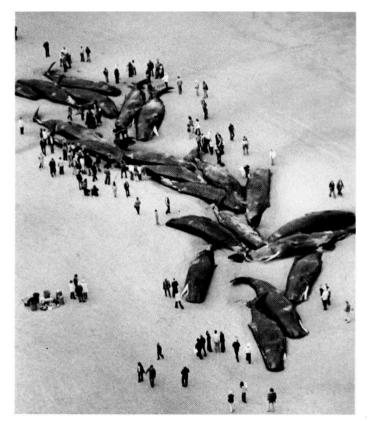

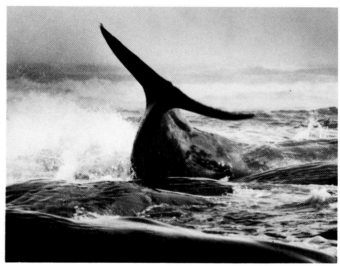

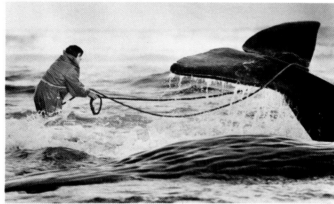

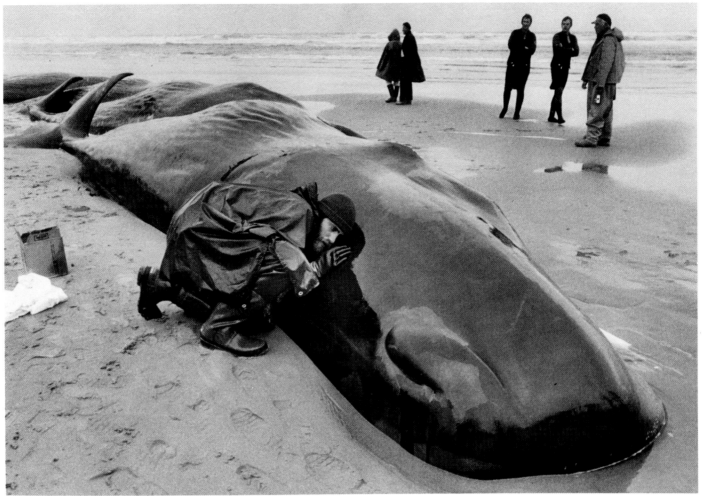

CHARLIE NYE, EUGENE REGISTER-GUARD (SPOT NEWS, THIRD PLACE, NEWSPAPER)

On June 16, forty-one sperm whales beached themselves on the shore of the Oregon coast, fifty-five miles west of Eugene. This rare occurrence attracted hundreds of onlookers and also a team of scientists, and almost everyone knew that the whales would not survive.

But a dozen members of Greenpeace from the Portland and Eugene areas traveled through the night to try to save the whales from their fate. Attempting to use manpower to pull the whales back out to sea, they looped ropes around the whales' flukes and heaved. The whales, weighing from six to twenty-five tons each, could not be budged. Most of them died slowly, their lungs collapsing from the weight of their own bodies.

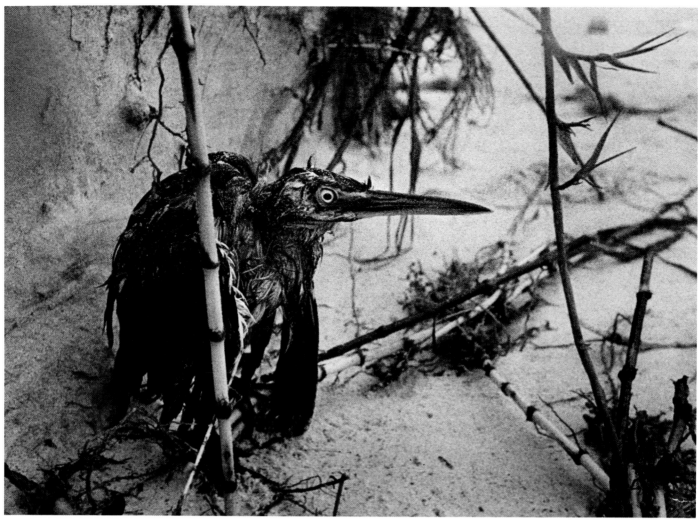

One of Hurricane David's many victims, a young green heron, after being blown from its nest by devastating winds, sits dying in the shelter of redistributed sand dunes near St. Augustine, Fla. By the time the hurricane had finished its eight-day rampage during the month of September, more than eleven hundred people had died.

Residents flee a raging brushfire that threatened their homes in Claremont, Calif. (right). One house was reported to have been damaged.

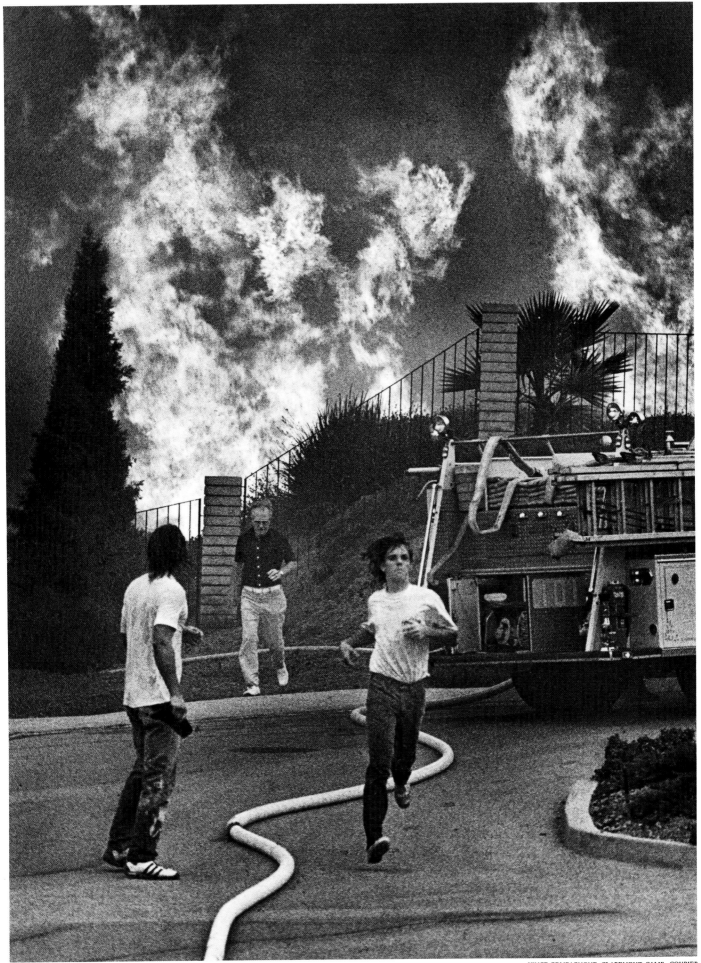

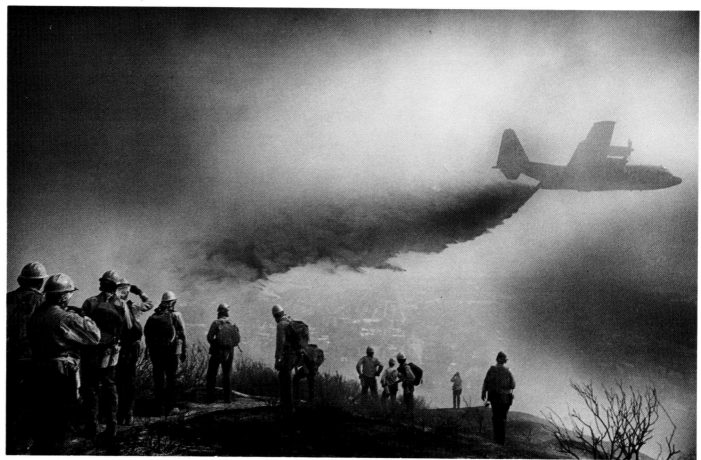

TOM KASSER, SAN BERNARDINO SUN TELEGRAM (NEWS PICTURE STORY, HONORABLE MENTION, NEWSPAPER)

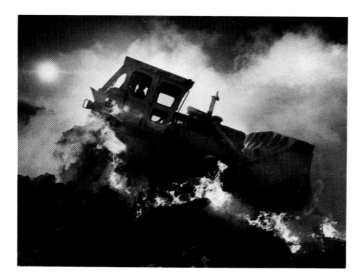

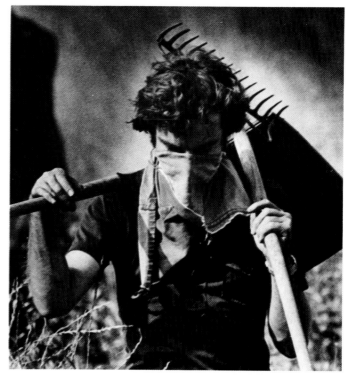

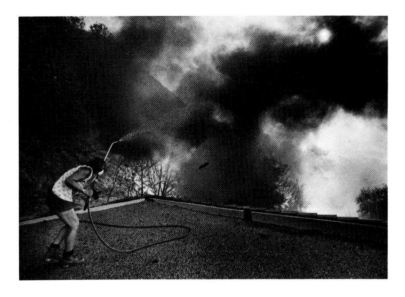

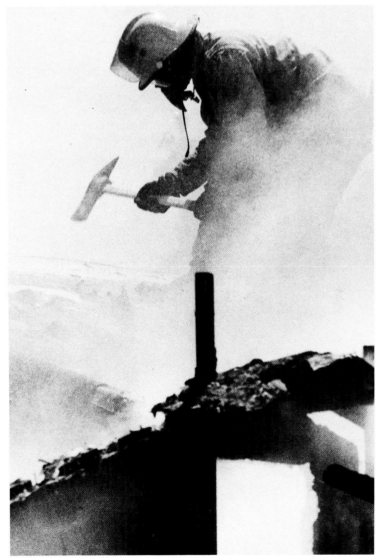

The summer of 1979 was a summer of fiery war in Southern California. Dozens of brushfires blackened a half-million acres of brushland, killed an undetermined number of animals, and destroyed a hundred homes. As big C-130 air tankers bombarded the flames with sticky, red fire retardant, fire fighters—using bulldozers and axes—fought to gain the upper hand on the uncontrollable flames, and many homeowners, such as Dorothy Nimocks (top right), tried to protect their homes from the advancing fires with hoses and rakes.

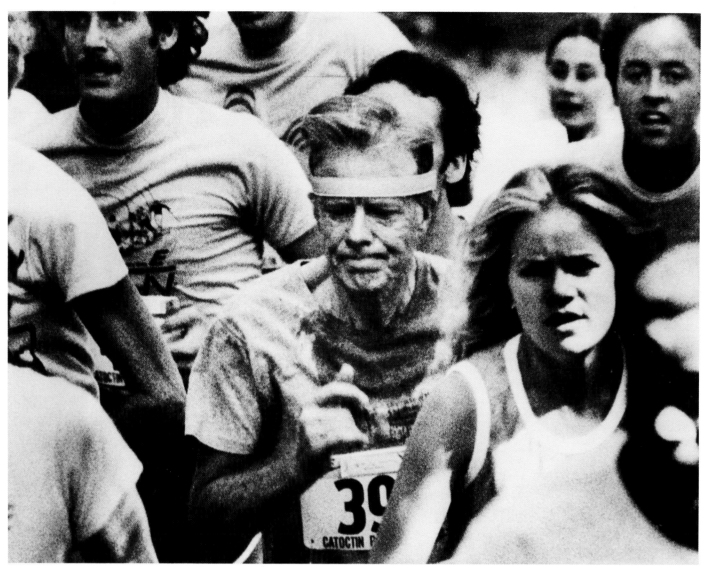

LARRY DOWNING, UPI (GENERAL NEWS/DOCUMENTARY, FIRST PLACE, NEWSPAPER)

A grimacing President Carter makes his way up a steep hill during the 6.2-mile footrace—a standard ten-kilometer race—through the back woods of the Catoctin Mountain National Park, Md.

Carter, an avid jogger, struggles to keep pace with the other runners until, wobbling, moaning, and pale with exhaustion, he is forced to drop out after the 3.5-mile mark.

To keep the president from totally collapsing, security guards took a firm grip of his arms and led him to a waiting car.

The president apparently suffered no lasting ill effects.

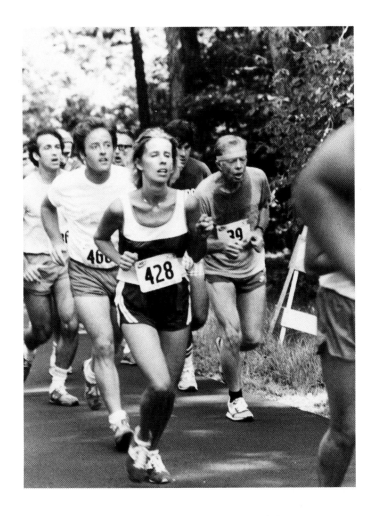

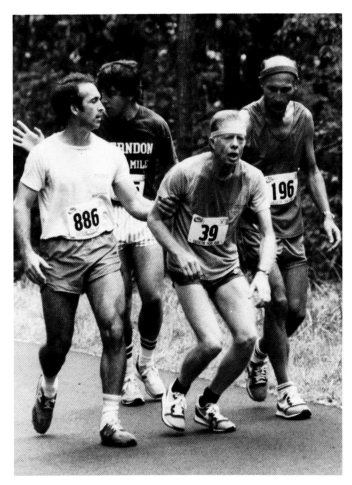

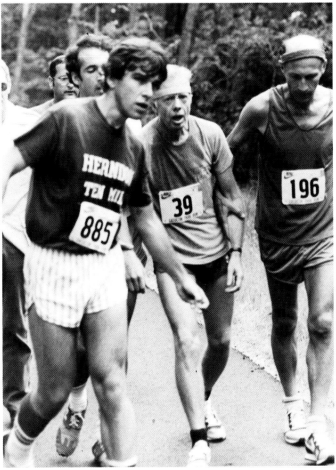

PHILIP B. STEWART, RUNNING TIMES (NEWS PICTURE STORY, HONORABLE MENTION, NEWSPAPER)

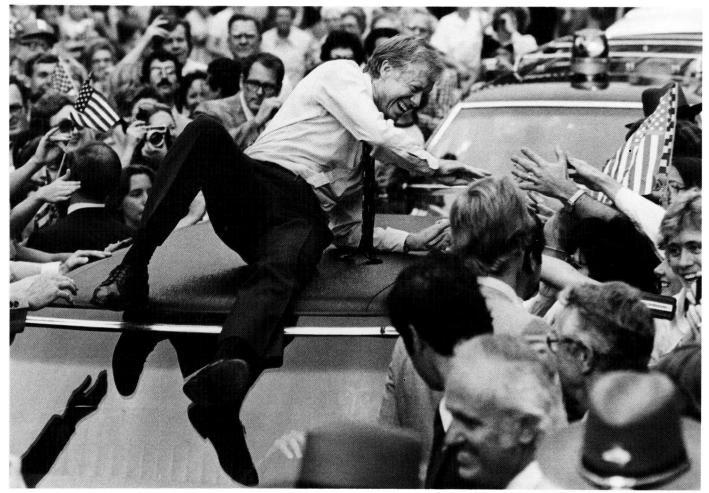

ROBERT DAUGHERTY, AP

President Carter, leaning across the roof of his car, vigorously shakes the hands of his supporters along a parade route through Bardstown, Ky., while campaigning there in July. The president climbed on top of his car as the parade moved through the town to the high-school gym, where a town meeting was held.

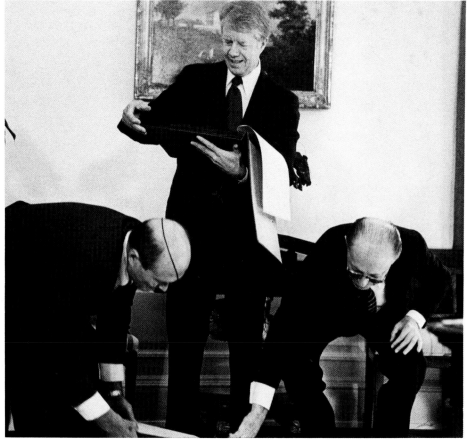

LARRY DOWNING, UPI (GENERAL NEWS/DOCUMENTARY, THIRD PLACE, NEWSPAPER)

While President Carter continues to look through a photo album of his recently completed trip to Israel, both Israeli Prime Minister Begin and Foreign Minister Dayan are found in a situation that photographer Larry Downing has entitled "fumbled diplomacy."

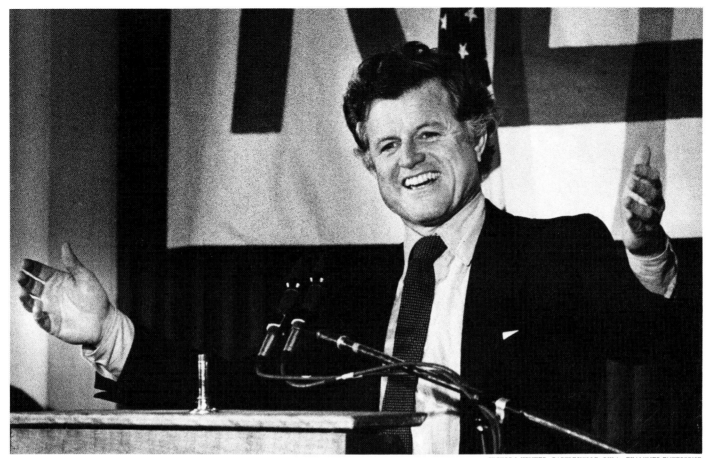

An exuberant Sen. Edward Kennedy greets Oklahoma University students at a rally the day after officially announcing his intentions of becoming a presidential candidate.

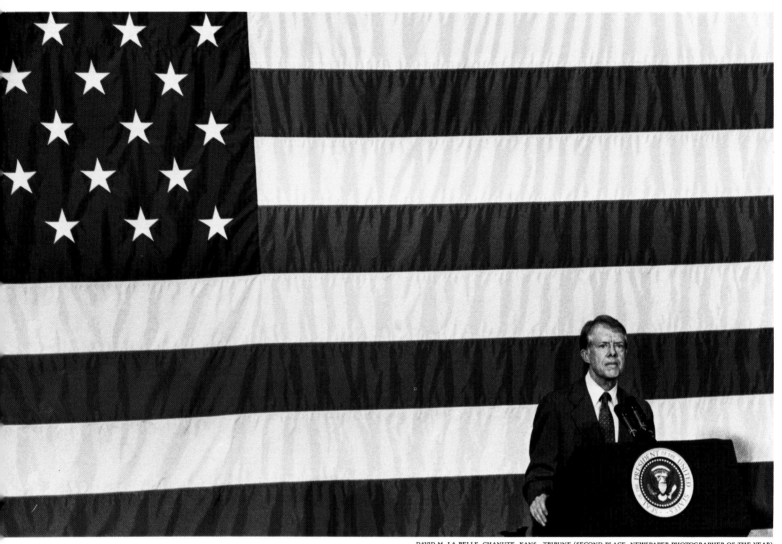

DAVID M. LA BELLE, CHANUTE, KANS., TRIBUNE (SECOND PLACE, NEWSPAPER PHOTOGRAPHER OF THE YEAR)

President Carter, looking troubled and solemn, listens to questions asked by an audience in Elk City, Okla. Quite a contrast to the famous smile of a few years ago.

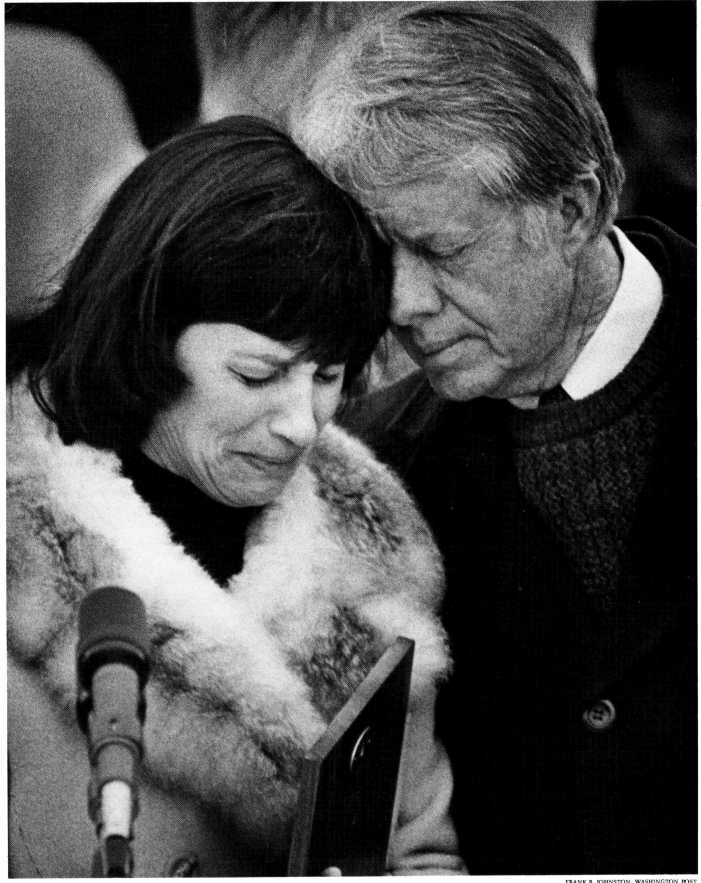

FRANK B. JOHNSTON, WASHINGTON POST

President Carter comforts the widow of Adolph Dubs during memorial services. Dubs, the former U.S. ambassador to Afghanistan, was abducted February 14 in Kabul by Afghani Moslems who were demanding the release of Moslem prisoners held by our government. He was killed during the exchange of fire between the abductors and government security men.

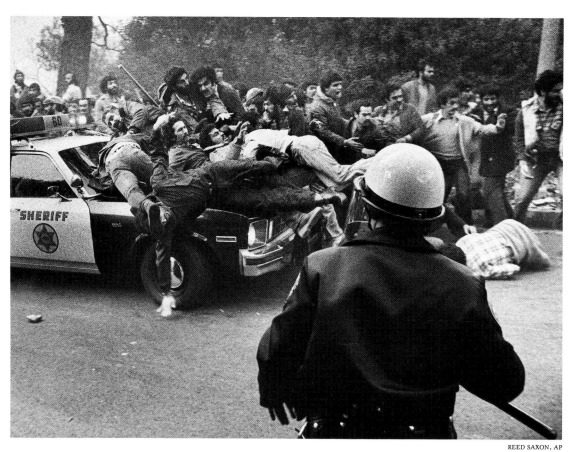

A sheriff's patrol car drives through a group of Iranian anti-Shah demonstrators near the house of the Shah's sister in Beverly Hills, Calif., on January 2. The demonstrators set fires, overturned cars, and attacked officers in their efforts to get to the Shah's relatives, who were staying in the house.

Enraged that fifty American citizens were being held hostage in Iran, students angrily confront a Communist spokesman during campus demonstrations at the University of Washington.

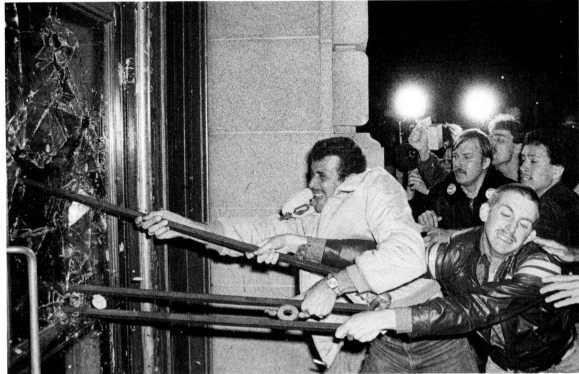

On May 22, gay demonstrators smashed the glass out of the front door of the San Francisco City Hall in protest of the voluntary manslaughter conviction of Dan White, a former San Francisco supervisor, who was indicted for the fatal shooting of Mayor George Moscone and Supervisor Harvey Milk on November 17, 1978.

Gainesville police apprehend a man during a scuffle with members of the African People's Socialist party, who marched in support of the Iranian seizure of the American embassy. Two hundred officers protected the black protestors from an outraged crowd of American whites waving the American flag.

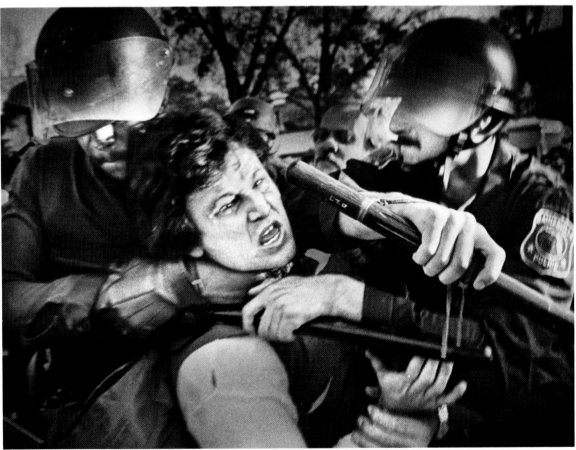

National News / 69

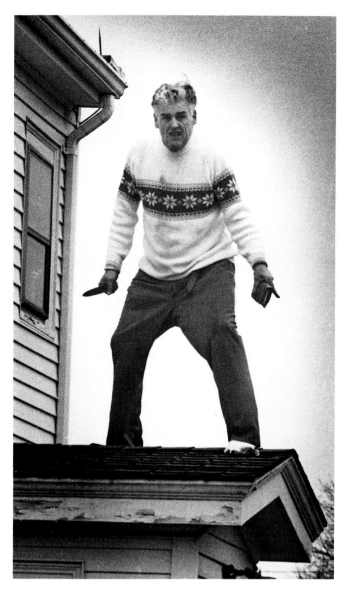

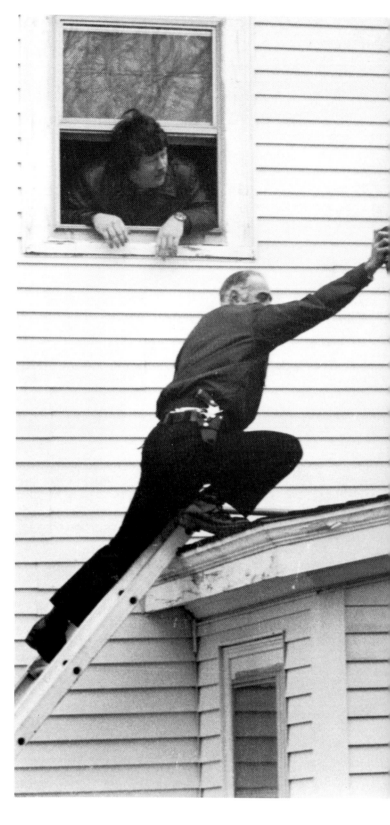

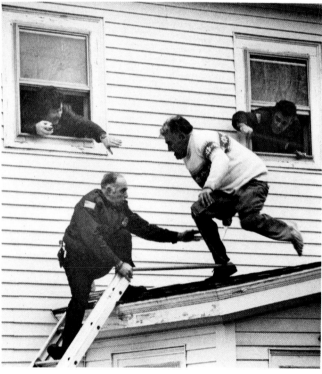

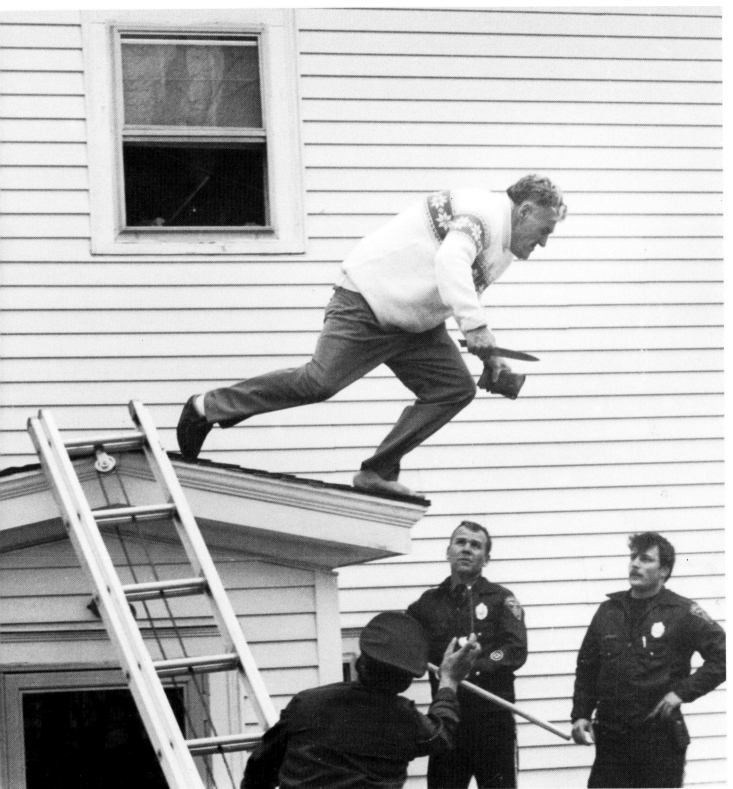

NORMAN A. SYLVIA, PROVIDENCE JOURNAL-BULLETIN (NEWS PICTURE STORY, FIRST PLACE, NEWSPAPER)

Having just climbed onto a twelve-foot entryway roof of his apartment, a forty-eight-year-old man, armed with a kitchen knife, screams at no one in particular for no apparent reason. Several officers, leaning out the second-story windows in the rear of the building, try to talk to him, while another attempts to coax him down before being stabbed in the shoulder. Shortly after Mace was sprayed in his direction, the man jumped off the roof, fracturing his leg and breaking his ankle.

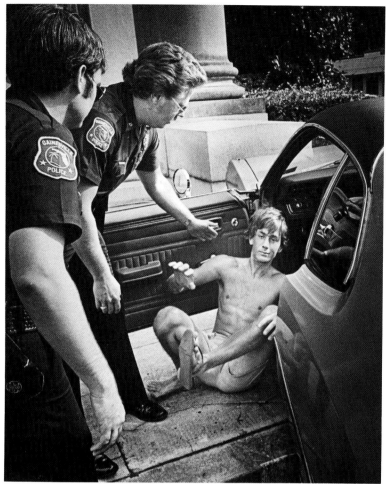

A not-so-happy landing. Ken Jamir's run-in with the Gainesville, Fla., post office was soon followed by a run-in with the law. He was charged with driving while intoxicated and driving with an invalid driver's license.

BILL WAX, GAINESVILLE SUN

Firemen count the wreckage of the DC-10 disaster. On May 25 shortly after takeoff from Chicago's O'Hare International Airport, an American Airlines jetliner lost its left engine and plunged to the ground, killing all 272 passengers aboard plus 3 persons on the ground. This was the worst disaster in the history of U.S. aviation.

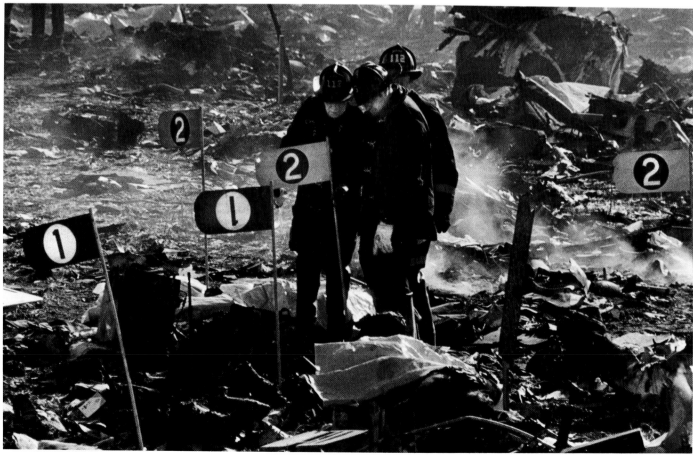

DAVE TONGE, ARLINGTON HEIGHTS, ILL., DAILY HERALD

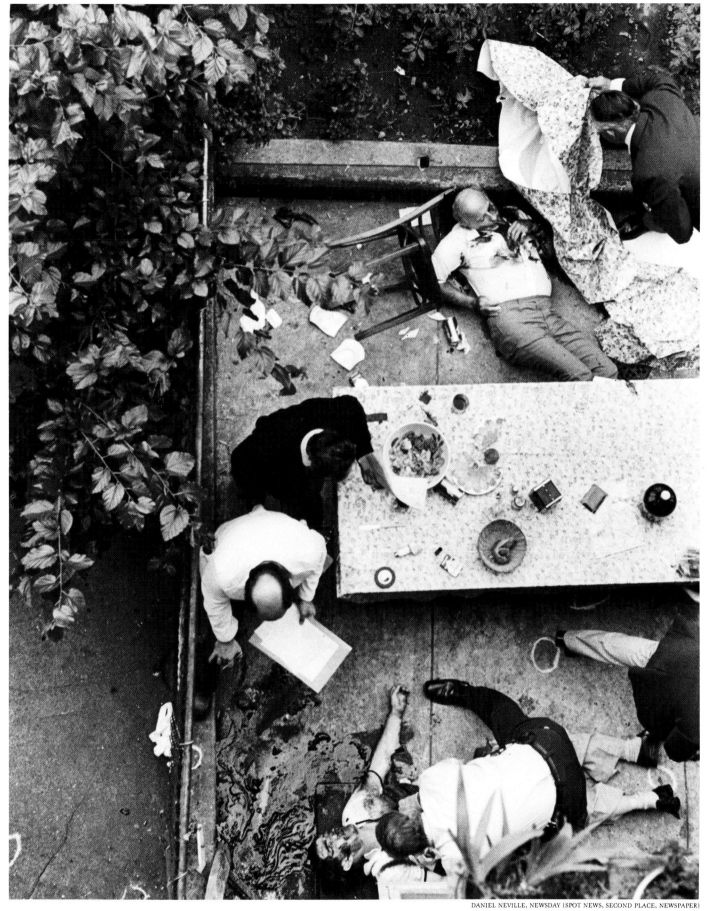

DANIEL NEVILLE, NEWSDAY (SPOT NEWS, SECOND PLACE, NEWSPAPER)

A bloody scene of a gangland murder. Police examine the bodies of sixty-nine-year-old mob chieftan Carmine Galante (with cigar still in his mouth) and of his bodyguard, who were gunned down in a Brooklyn, N.Y., cafe in an apparent underworld showdown on July 12.

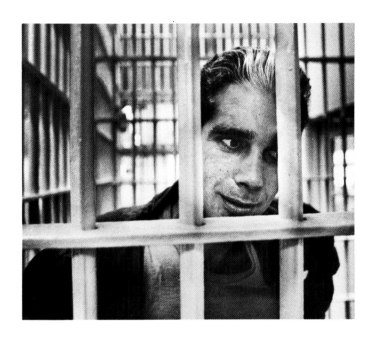

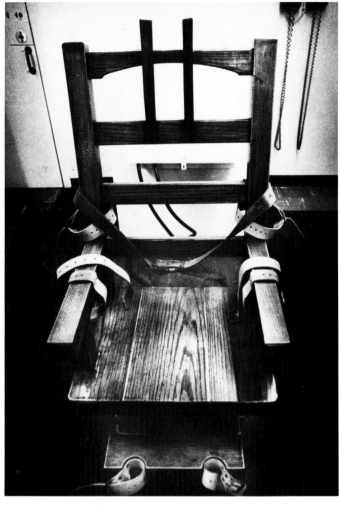

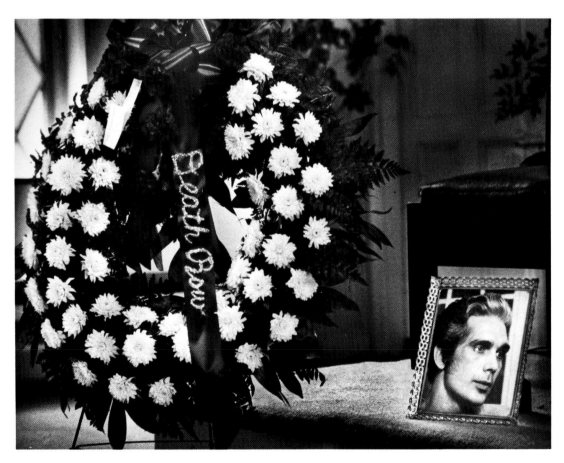

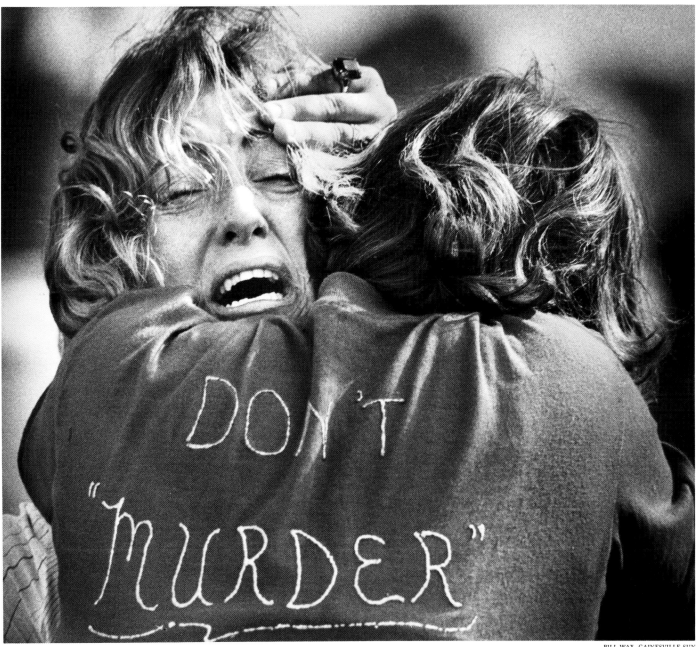

On May 25, John Spenkelink became the first person in our nation since 1967 to be executed legally against his will. He was convicted and sentenced to die for the 1973 death of his traveling companion Joseph Syzmanski, who was murdered in a Tallahassee, Fla., motel room.

"Old Sparky," the electric chair used in the execution, had not been used since 1964. The chair was handcrafted by prisoners at the Florida State Prison from an old oak tree.

The day after the execution, the remaining 133 convicts on Death Row sent a wreath to a memorial service in the Tallahassee church frequented by the man who doomed Spenkelink's life, Florida Governor Robert Graham.

Sharon Perry was comforted by a friend when it was announced that Spenkelink would indeed be executed. She grieved with good reason: her brother is on Death Row.

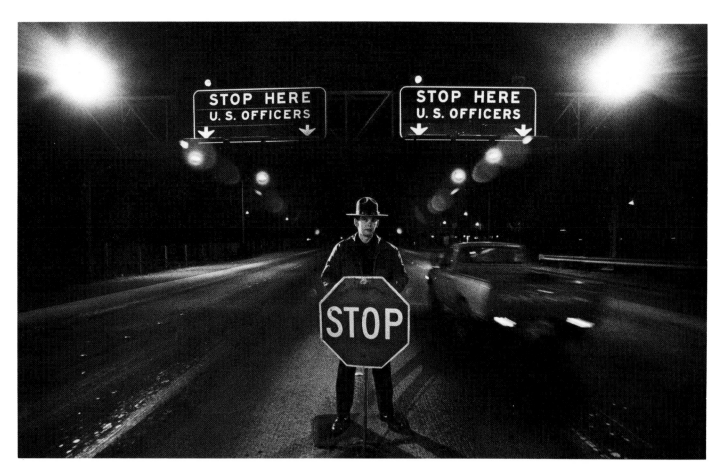

U.S. border patrol agents search for illegal aliens at the San Onofre checkpoint fifty miles north of the Mexican border. Many of these aliens are smuggled in the trunks of cars. Once the aliens are apprehended, they are processed to be returned to Mexico.

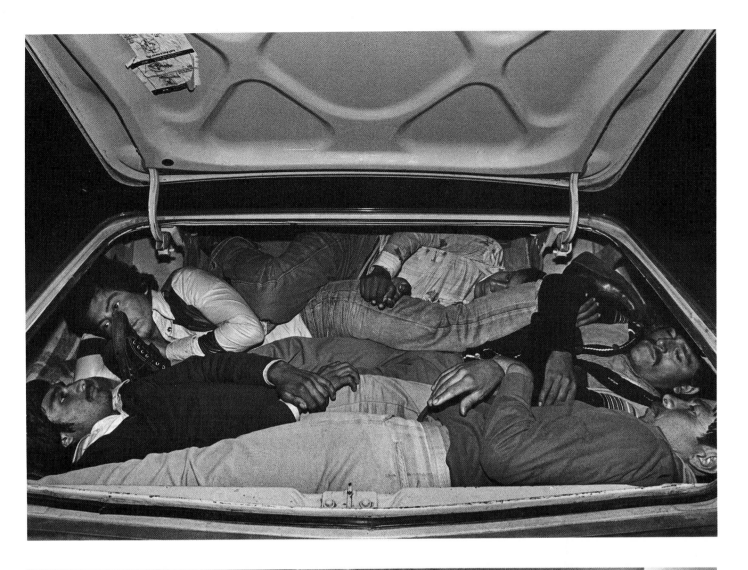

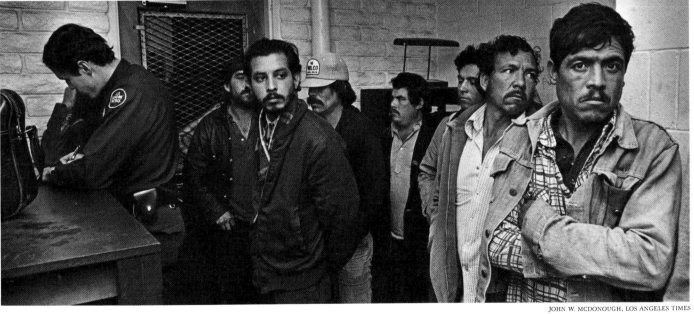

JOHN W. MCDONOUGH, LOS ANGELES TIMES

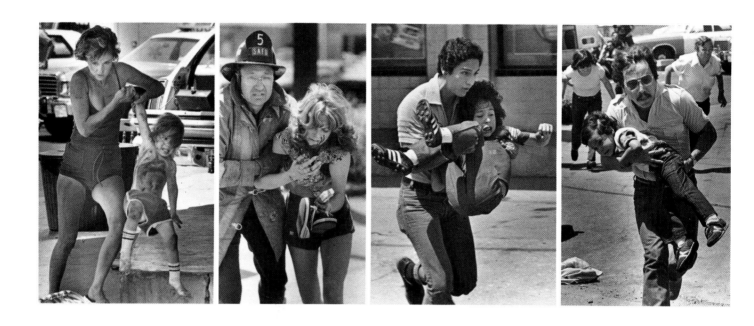

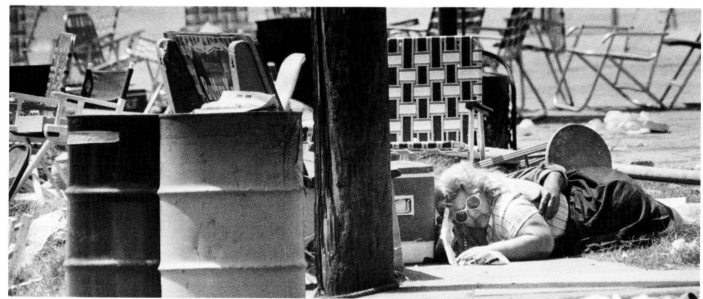

STEVE CAMPBELL, SAN ANTONIO EXPRESS & NEWS (NEWS PICTURE STORY, THIRD PLACE, NEWSPAPER)

The annual Fiesta Parade, which commemorates the Battle of the Flowers, was held on April 27 in San Antonio, Tex. About 300,000 people attended the event, and everyone seemed to be enjoying themselves when suddenly shots were fired into the crowd from a nearby trailer, sending spectators for any available cover.

Police, firemen, paramedics, and volunteers worked quickly to evacuate hundreds of people who were pinned down hiding from the sniper's fire.

Dianne Wick, who had traveled from St. Louis to San Antonio for the parade, heard the shots and cried, "Is this for real?" Both Wick and her sister were hit, but only slightly injured. As the shooting continued, Wick comforted her terrified nephew.

After thirty minutes, fifty persons were wounded, including six policemen, and two people were dead. The shooting finally stopped when the sixty-four-year-old sniper took his own life.

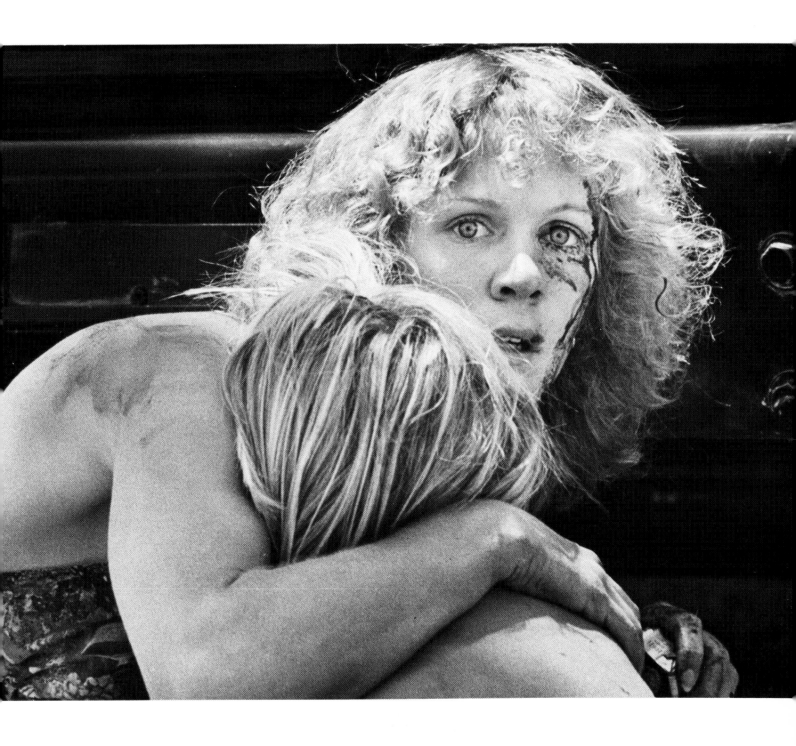

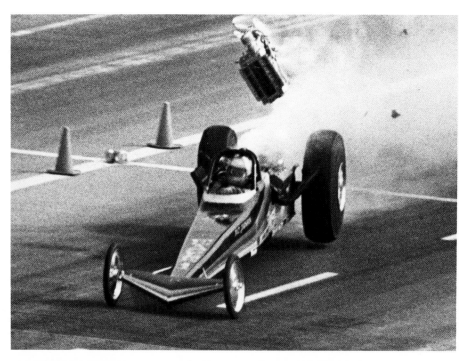

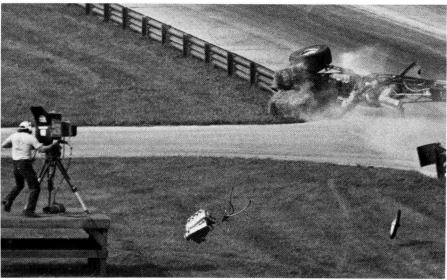

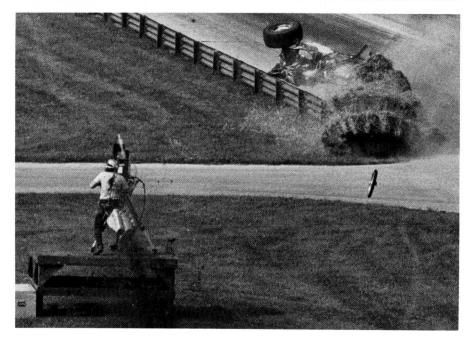

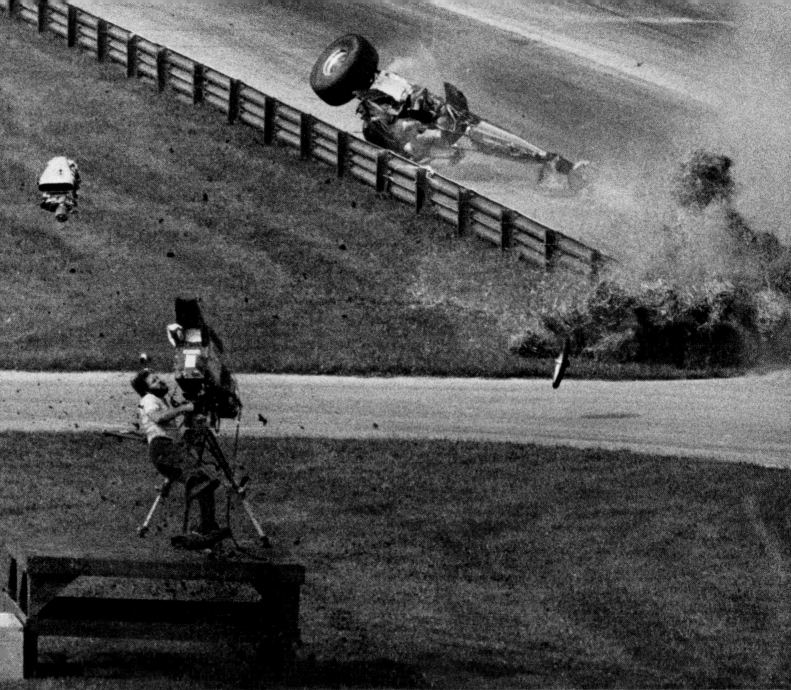

When cameraman Joe Rooks of Bowling Green, Ohio, attended the National Hot Rod Association U.S. Nationals in Indianapolis on September 1, little did he know of the tragedy that would befall him.

When the drag race began, a top fuel dragster driven by Frank Rupert of Carritos, Calif., blew the supercharger off the engine. The dragster turned over several times before it finally hit the guardrail, while the heavy blower bounced 250 yards down the track toward Rooks, knocking him flat. Rooks died en route to the hospital, and Rupert suffered a broken leg and some internal injuries.

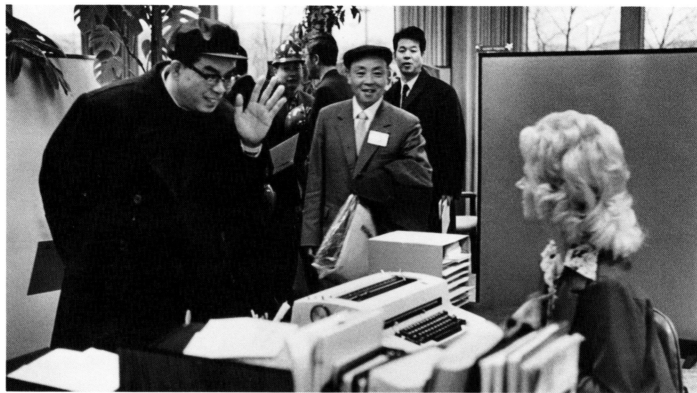

CHARLIE NYE, EUGENE REGISTER-GUARD (GENERAL NEWS/DOCUMENTARY, SECOND PLACE, NEWSPAPER)

"Hi there, Blondie." When a delegation from the People's Republic of China toured the Weyerhauser lumber mill in Eugene, Ore., they were pleasantly charmed by the company's secretaries and quickly responded with smiles and cheery hellos. The trade group was in the United States to learn about the American way of processing lumber.

Even the Pope couldn't keep the rain away when he arrived at Battery Park, New York City, on October 2, his second day in the United States. On that day, he addressed the United Nations, visited some of the slums in the city, and then celebrated mass for eighty thousand people in Yankee Stadium.

The next day, a multitudinous crowd gathered at St. Patrick's Cathedral to hear the special message of the Pope. He later addressed a gathering of nineteen thousand teenagers at Shea Stadium.

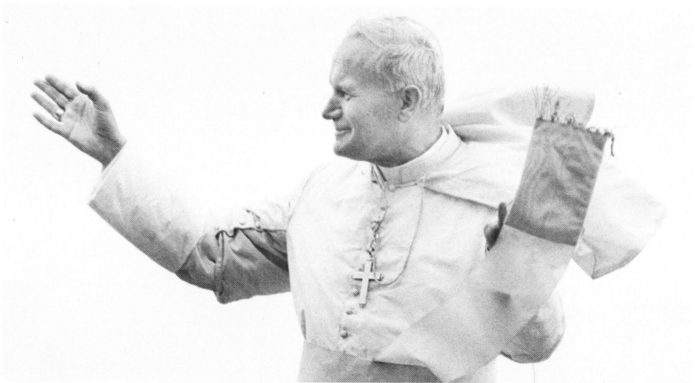

DAVID BURNETT, CONTACT PRESS IMAGES, INC.

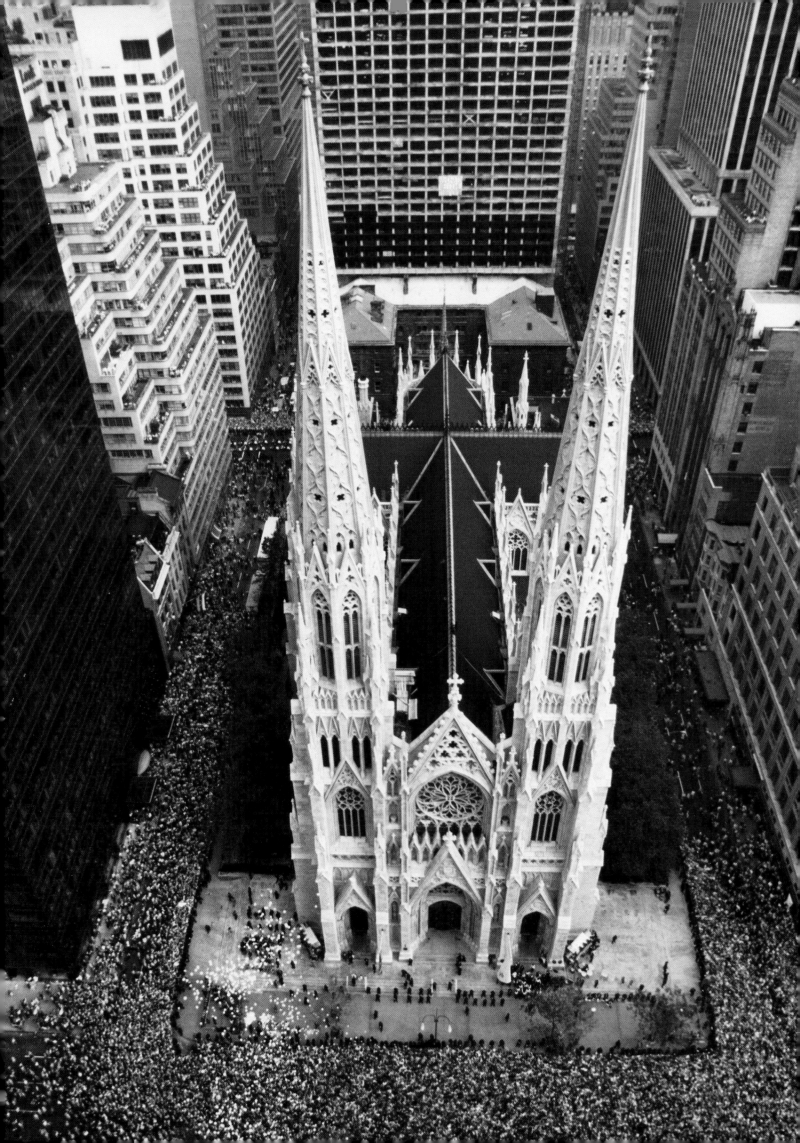

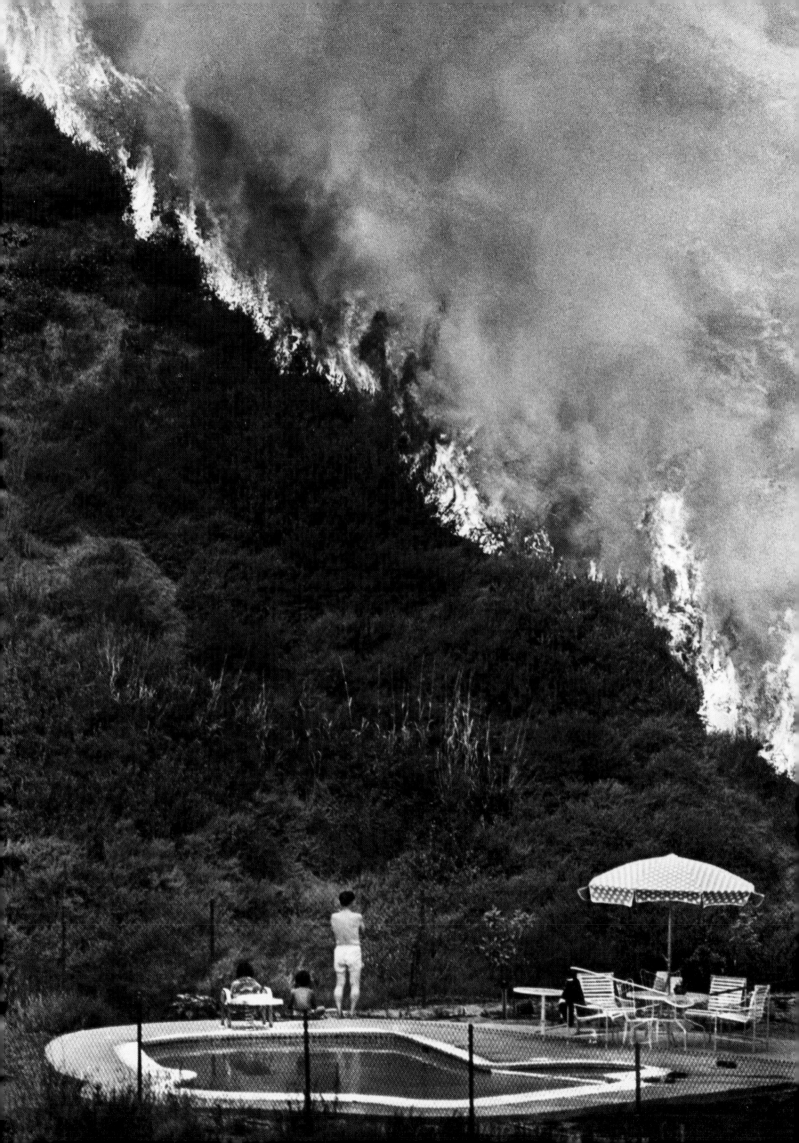

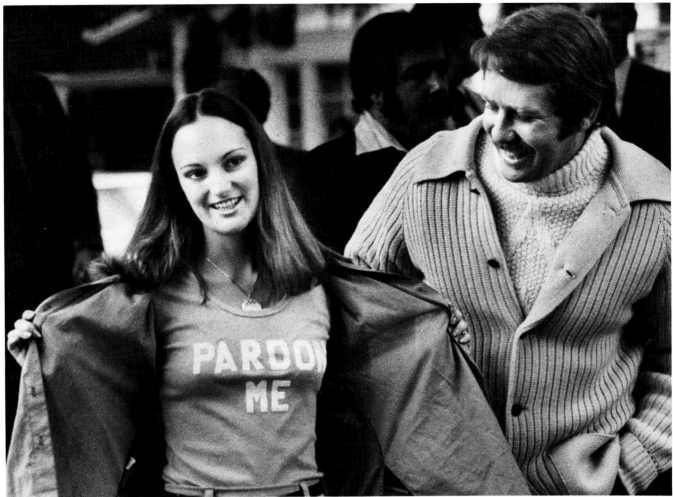

Patty Hearst shows off her T-shirt the morning she was released from a federal prison, as Bernard Shaw, her fiancé, grins in approval. After serving twenty-two months of a seven-year sentence for bank robbery, Hearst was granted freedom on February 1 under an executive clemency order from President Carter.

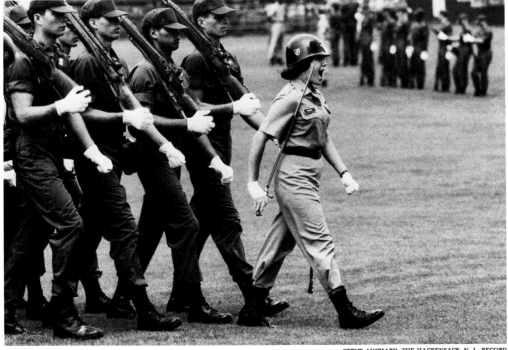

She's come a long way. A woman cadet and graduate of para-trooper training takes charge of a platoon of West Point plebes.

A sudden brushfire destroyed one hundred acres near the plush homes of La Jolla, Calif. No homes were damaged.

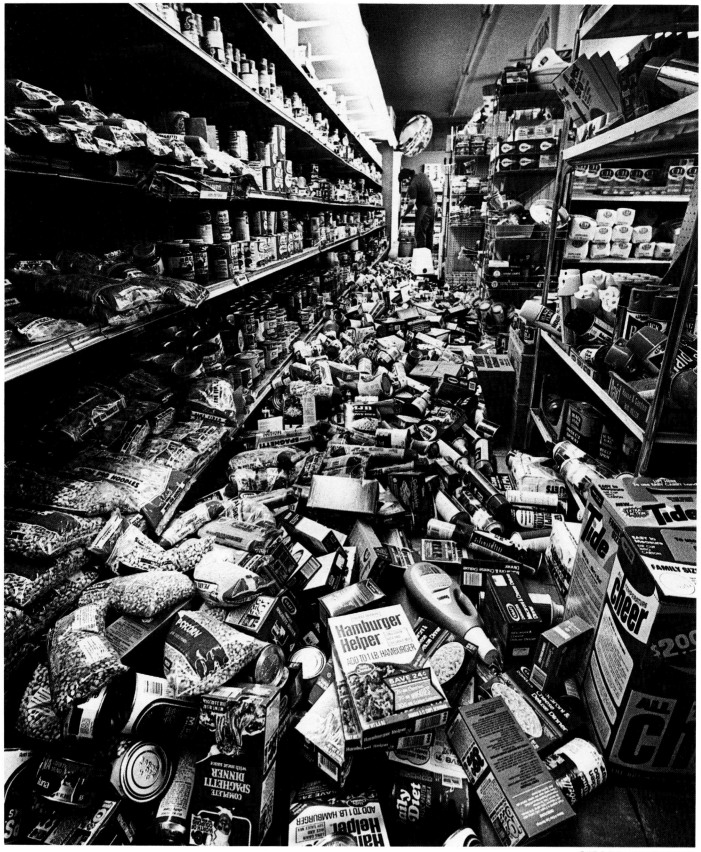

On October 15, a quake that registered 6.4 on the Richter scale shook the earth in the town of El Centro, Calif. More than a hundred people were injured, and the resulting damage was estimated to be well over 15 million dollars.

# Nikon World Understanding Award

In 1972, an educational grant to the University of Missouri School of Journalism from Nikon, Inc., established the Nikon World Understanding Award. Each year, the award is given to the photographer whose work the judges feel best serves "the common purposes of mankind," in other words, whose work shows an understanding of man and of man's problems that transcends differences of race, religion, language, and nationality. This year's Nikon World Understanding Award is given to Ethan Hoffman, whose thoughtful, touching, and sometimes horrifying treatment of life inside a prison brings the realities of prison life a little closer to all of us.

Hoffman's investigation into prison life began in 1977, when he and reporter John McCoy, then both of the *Walla Walla Union-Bulletin,* were assigned to cover the Washington State Prison in Walla Walla.

Hoffman and McCoy first entered the prison while on their beat in the summer of 1977, while the penitentiary was undergoing the last stages of its reform experiment. The experiment was originated in 1969 to prepare the inmates at Walla Walla for a life outside prison walls. Therefore, the inmates acquired certain rights such as the right to privacy, freedom of speech, and the right to make significant decisions. Mail censorship ended. Phone calls were permitted. Work was no longer obligatory. Inmates were guaranteed fair hearings before they could be subjected to any punishment. Dress and hair codes were lifted. Visiting family and friends were not separated from the inmates by glass partitions and screens. On occasion, the inmates were even allowed to visit their homes and to work outside the prison.

For a while, prison life went well. But with a lot of free time on their hands, inmates, bored, found new ways of entertaining themselves. Drugs became more commonplace at Walla Walla than on the streets. Violence increased. Soon, subgroups began to arise in the form of clubs: The Black Prisoners Forum Unlimited; Brotherhood of American Indians; Prison Motorcycle Association; Men against Sexism; Lifers with Hope; and so on. Club members began to battle for control of drugs, extortion, and gambling.

The reforms initiated at Walla Walla were not successful because the basic problems of the prison—such as a physical plant that was built before 1900; overcrowding of the inmates; unavailability of jobs for most inmates; lack of counseling and educational facilities; and a rural, undereducated guard force confronting a young, urban, streetwise population of inmates—were all ignored.

In the summer of 1978, chaos came to a head. One security guard was killed in an explosion; another died while breaking up a fight between inmates. Four inmates were stabbed, and finally a riot broke out, which ended in a three-week lockdown: Inmates were locked in their cells and not allowed to leave them for any reason.

After quitting their jobs at the *Union-Bulletin* in 1978, McCoy and Hoffman decided to do an in-depth story of life inside prison walls. From September 1978 to January 1979, Hoffman spent every day of his four months after the lockdown with "no escort" at Walla Walla, and in his own words: ". . . was free to roam the prison as I chose. I entered the prison to explore and explain what life behind bars is like today.

"I was welcomed by the inmates who felt their story was not being told. A story of empty hours and mindless days. As one inmate told me, 'Life in here is hours and hours of boredom punctuated by moments of sheer terror!'

"Some people may be repelled by prison life in Walla Walla. But I hope by communicating the chaotic and troubled experience of life in prison people on the outside will gain a greater understanding of this minority of American citizens."

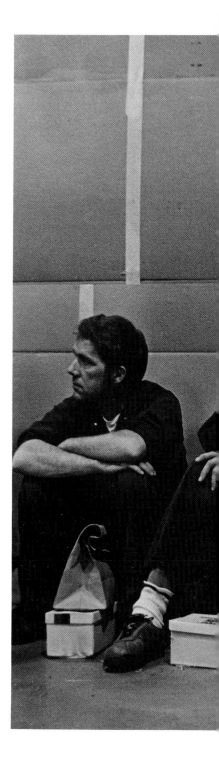

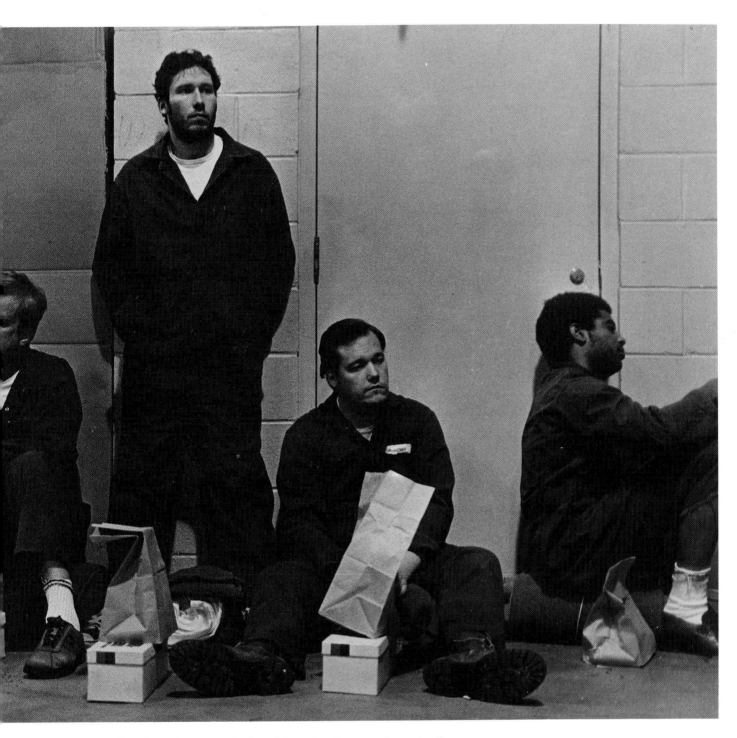

On a snowy Wednesday afternoon, Fred and twenty other new inmates (known as fish) are dropped off at Washington State Prison in Walla Walla, after eight hours of riding in an armored bus from Seattle.

Fred doesn't remember killing a stranger one night at a party after hours of drinking and taking drugs. Until now, he has never had a record of any kind.

Upon arrival, Fred is unhooked from a chain that is shackled at the wrists, feet, and waist, and locked to twenty-five other prisoners, as an armed guard closely watches every move.

Later, Fred (standing) and other fish wait for further instructions.

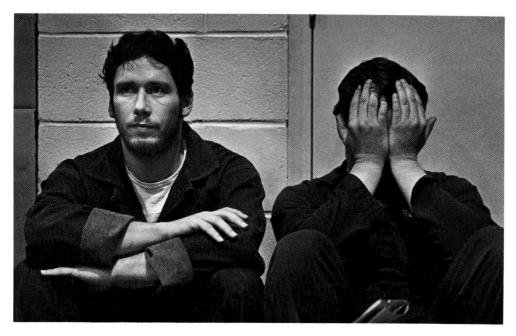

Waiting for his cell assignment, Fred recalls the advice he had been given: "Steer clear of lifers and niggers. Don't fuck around with drugs until you know people. If you talk to cops stay at least ten feet away or you'll be pegged for a snitch."

Mentally disturbed inmates are assigned to private cells in 4-wing, away from everybody else. Photographer Ethan Hoffman tried to talk with this man (lower left) and all that the man could say was, "Convicts are created on Saturn by Satan and angels wing them down to earth."

The shower in 8-wing, built in 1888, is used by 450 men of that wing. It is open three hours every day and after each use floods into the wing.

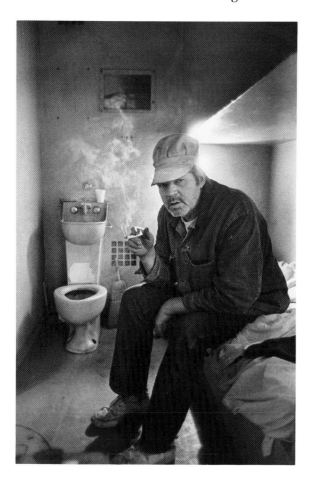

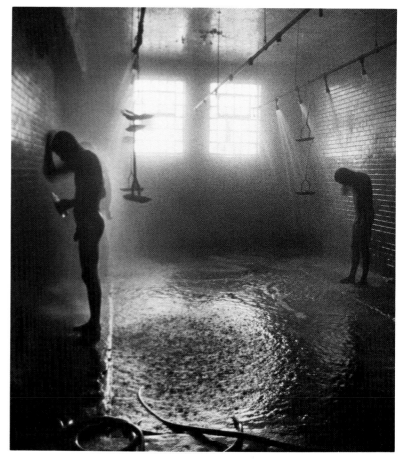

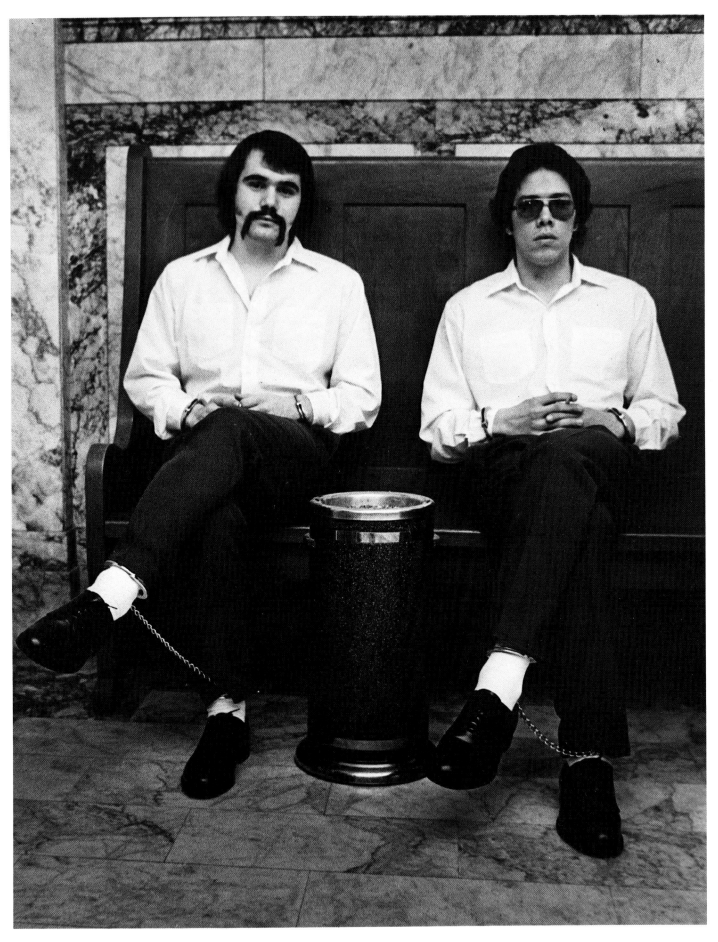

Because of an attempt to escape from Walla Walla, Kenny (right) and another inmate wait to be tried. As president of the largest club in prison—Lifers with Hope—Kenny has become the most powerful man in prison.

Having unusual influence and authority, Kenny enjoys the right to negotiate with the administration to get his fellow inmates out of segregation and meets with the warden whenever he pleases.

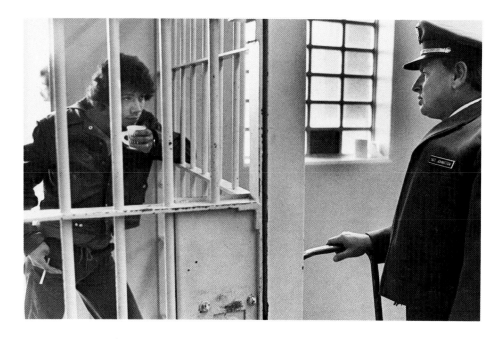

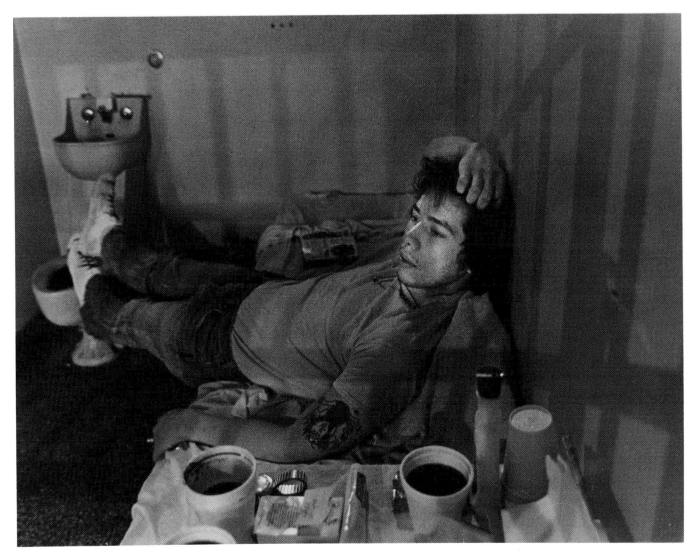

Kenny alone in his cell.

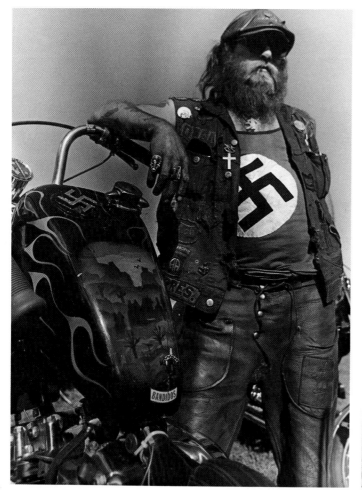

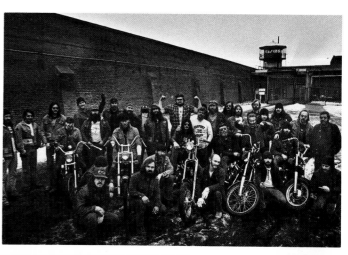

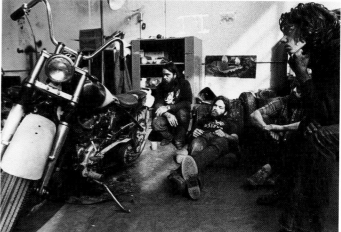

The Bikers, perhaps the most controversial club in Walla Walla, started with official approval as a training class in motorcycle maintenance.

The members of this club keep busy by flaunting their life-styles on Friday afternoons when they all get stoned in anticipation of their weekly cruise around the recreation yard. Their emblem—the swastika; their motto, "Fuck the World."

Shying away from prison politics and power, the Bikers stay close to each other and their Harley choppers.

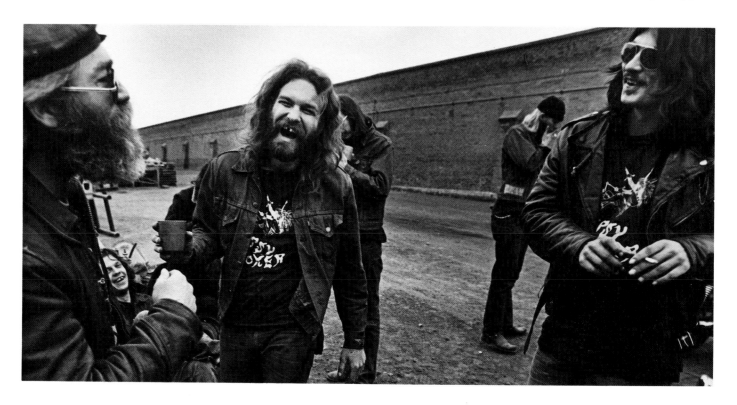

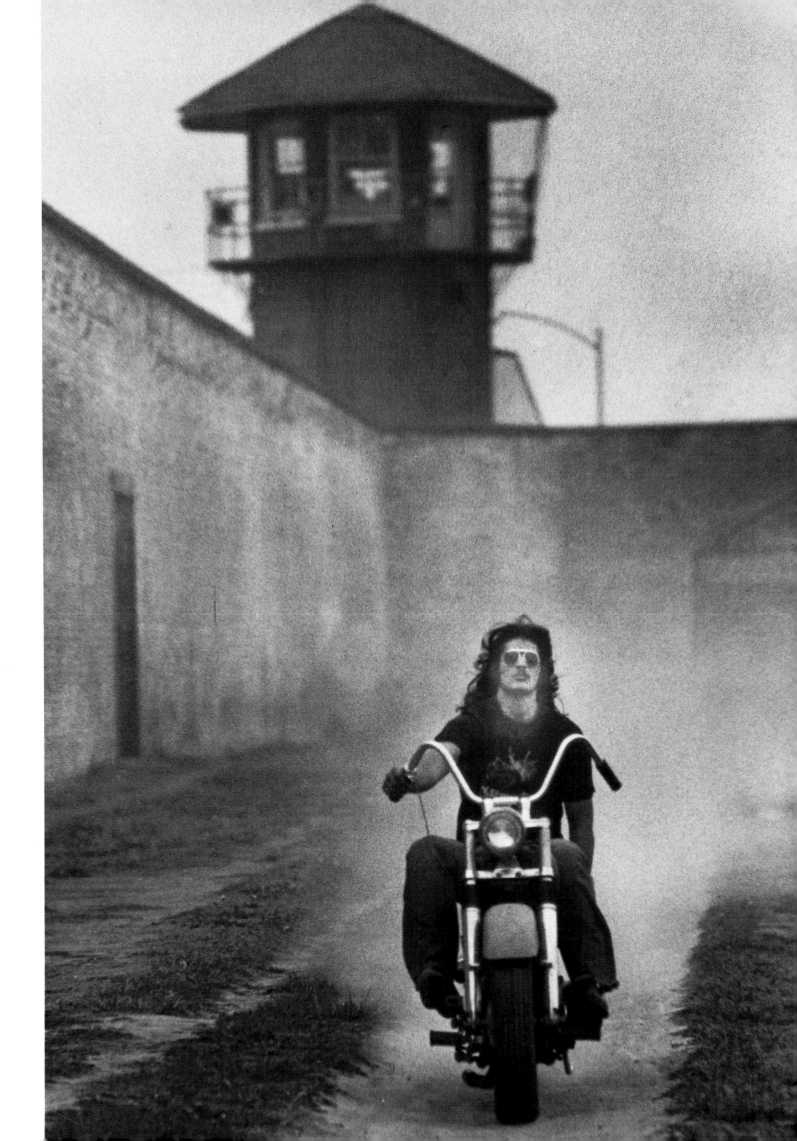

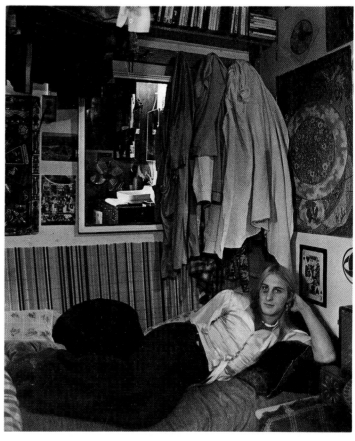

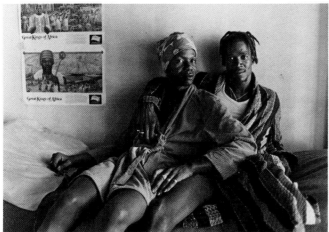

Men against Sexism. As gay advocates demand their rights in the outside world, homosexual inmates have become more vocal. Federal statistics show that over 80 percent of inmates engage in some form of homosexual activity.

Prison officials allow these inmates to choose their own cellmates, and it is not uncommon for lovers to live together. For some inmates, wearing dresses and decorating their hair is their only reality, while others escape by strolling arm in arm in the recreation yard.

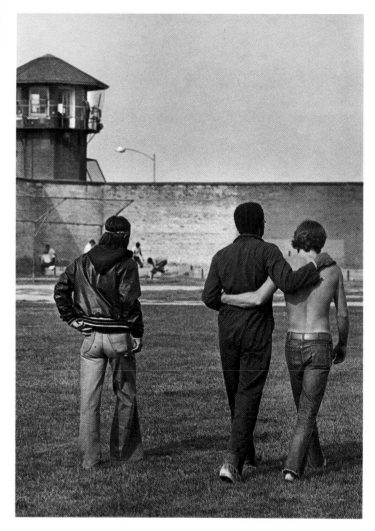

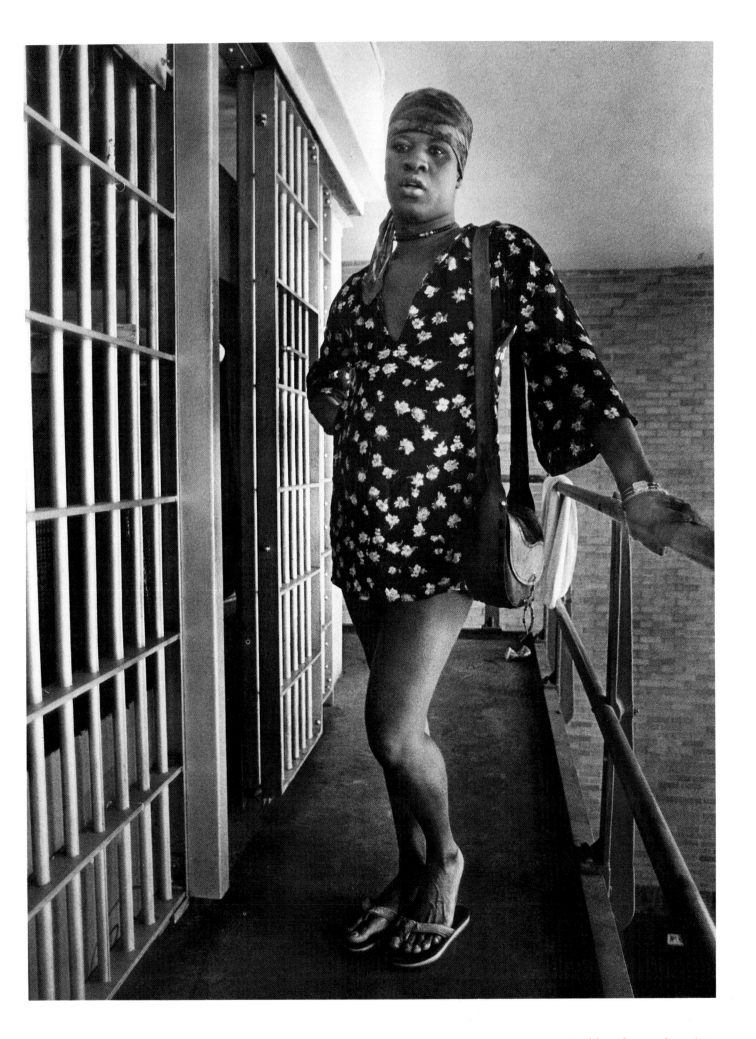

The scar on Bud's neck and the tattoo on his back tell it all. When the Bikers learned Bud had a good drug connection on the outside, they demanded that his wife smuggle some drugs into the prison and then pass them to him while kissing in the visiting room. When Bud refused, he was nearly killed.

A gambling dispute left this man half an ear. The prison doctors refused to treat him unless he revealed his attacker. He chose to go without medical help, knowing he'd surely die if he developed a reputation of being a snitch.

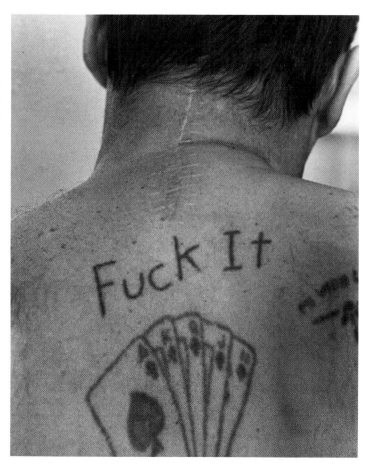

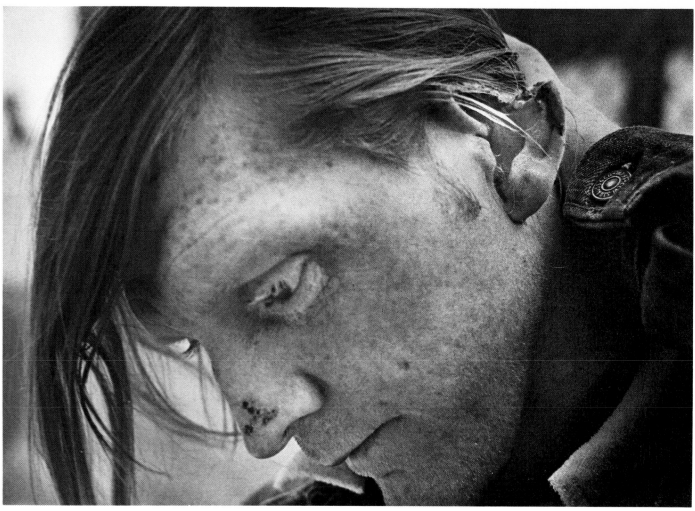

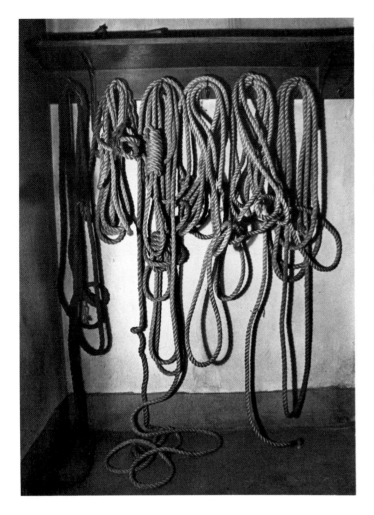

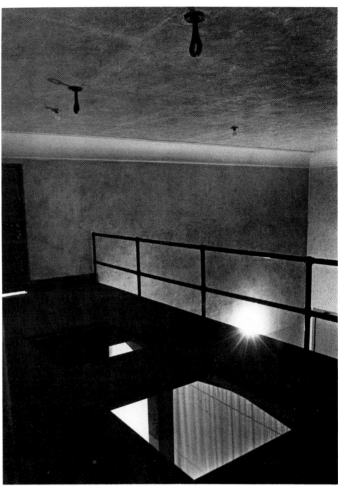

Washington State Prison is the only prison left that has hanging as its capital punishment. Six men today live on Death Row at Walla Walla, waiting for the day when they would walk down the flight of stairs to the gallows.

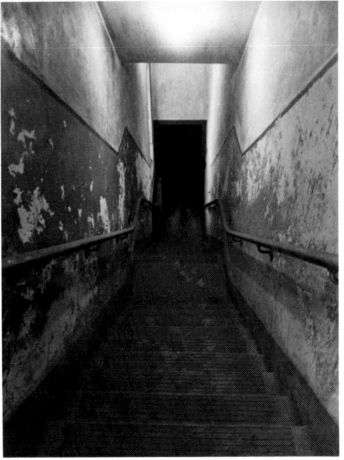

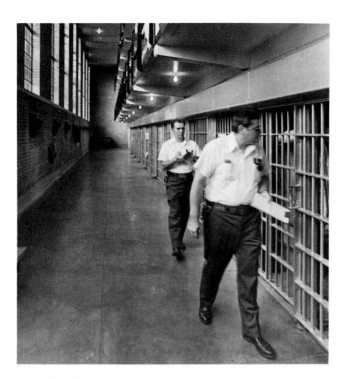
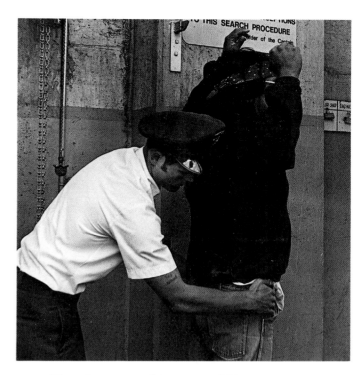

The life of a prison guard is a lonely, frustrating, and dangerous one. There is an annual turnover of 50 percent for this position, and fewer than 15 percent stay on for more than eighteen months. Pictured here are two guards making their rounds, searching an inmate, finding quiet solitude in the locker room, and attending a funeral service.

Since every inmate has a knife or access to one, two guards and four inmates were killed at Walla Walla last summer.

A guard proudly shows off his belt buckle that was made for him by an inmate.

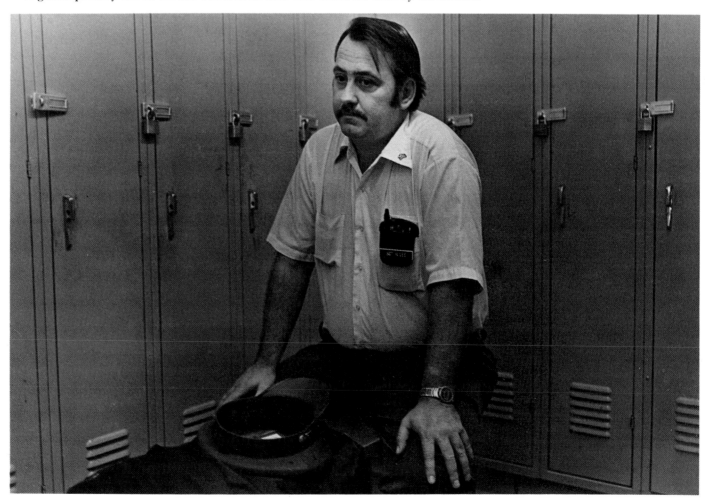

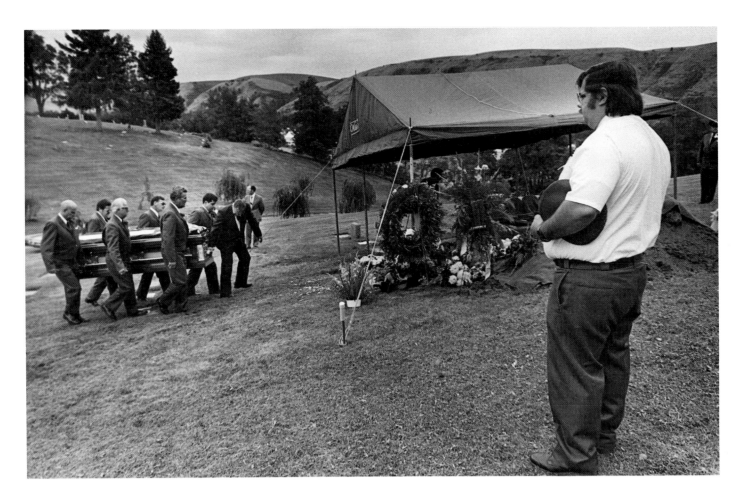

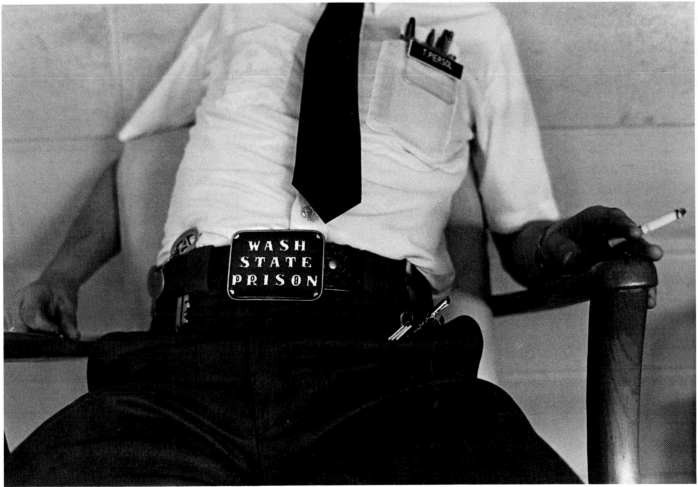

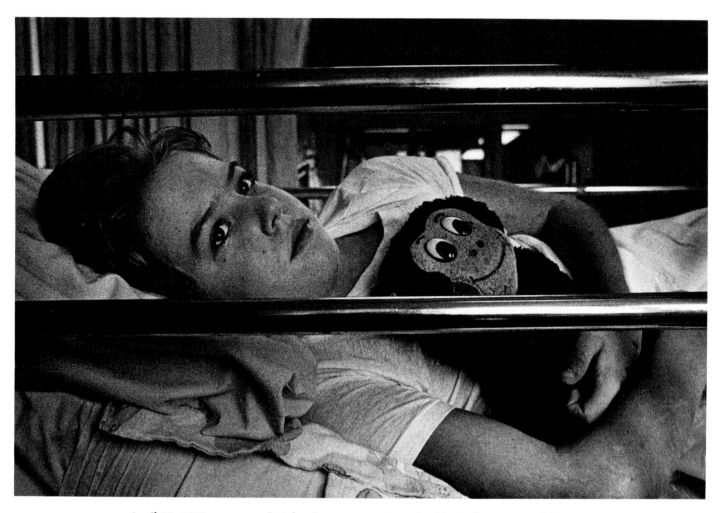

April 18, 1979, was a perfect day for an energetic and athletic eleven-year-old boy to go play some basketball in a neighborhood park. But as it turned out, it was the day when life changed drastically for Wade Scott, the day when he lost the use of both his legs.

While on their way to Kiest Park in Oak Cliff (Texas), Wade Scott and a friend decided to stop at a fast-food restaurant for a bite to eat. Since it was sunny and warm, both boys ate hurriedly with hopes of having more time on the court, and in the sun. Just as they were about to leave, a car—out of control—came crashing through the walls of the restaurant to rest itself on top of Wade's legs.

For many months, Wade was in and out of surgery. The months he had to face were days of phantom pain resulting from having both legs amputated, of grueling therapy sessions, fear, and finally the ultimate acceptance that, for the rest of his life, he would be different.

What follows here is a story of bravery and remarkable courage. It's a story of having to adjust to a far more different and complicated life than one can imagine. It's a story about Wade Scott, the "Comeback Kid," as captured by photographer Michael Wirtz, who has watched Wade's painful and slow ordeal turn into a story of success.

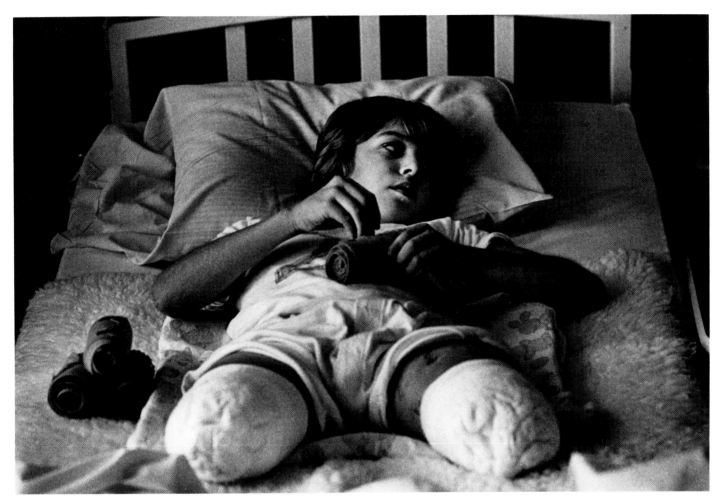

Pictured left is Wade cuddling his pal "Coops," a present given to him by Kenny Cooper (Wade's idol), the former Dallas Tornado goalkeeper.

A pensive Wade nervously plays with an elastic bandage before wrapping the stumps of his legs to prevent the muscles from becoming flabby.

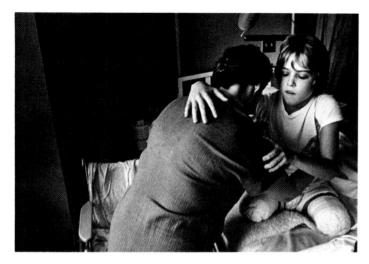

Wade is helped into his wheelchair by his mother, Sue Scott.

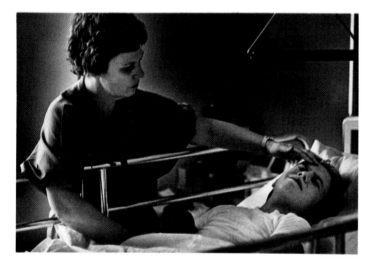

Experiencing phantom pain, Wade is caught in a rare moment of emotional outburst as Mrs. Scott tries to comfort him.

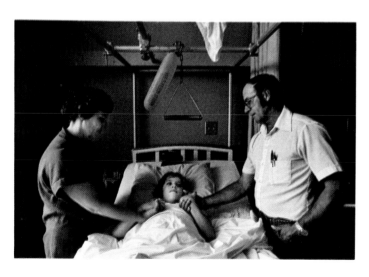

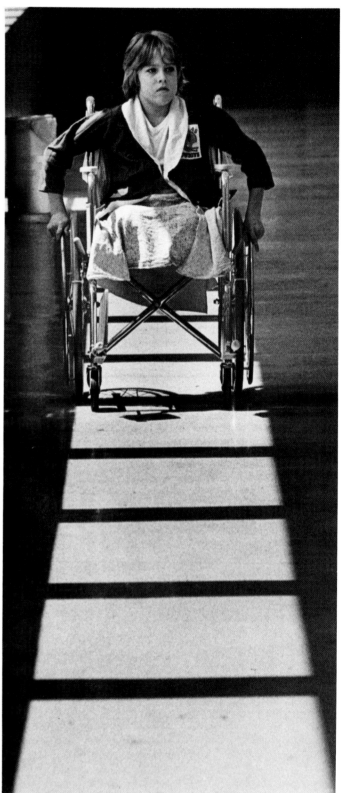

Mr. and Mrs. Scott visit their son, giving him the strength and courage to help him through this ordeal. Both Scotts believe that God has allowed this freakish accident to happen for a reason. "I sin as much as the next guy," Bill Scott (Wade's father) says. "But I believe there's a God who keeps order in this universe. I accept that this happened for a reason. I may not know the reason now, but when I get up there—if I do—I hope I'll find out."

To build up his arm muscles, Wade wheels himself down the hospital hall.

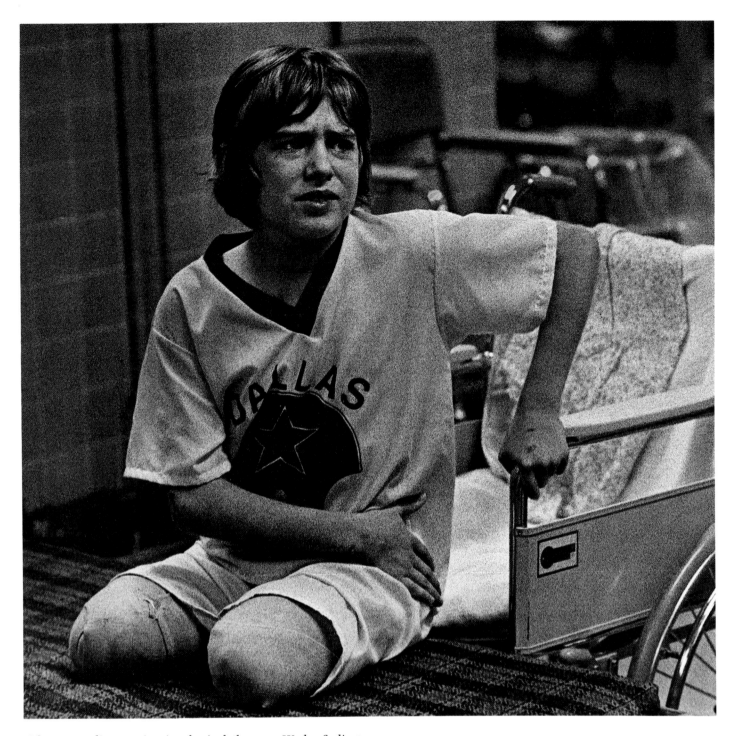

After a grueling session in physical therapy, Wade, feeling
pain in his thighs, fights to hold in his tears.

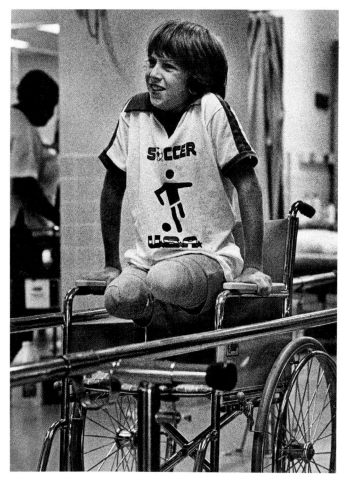

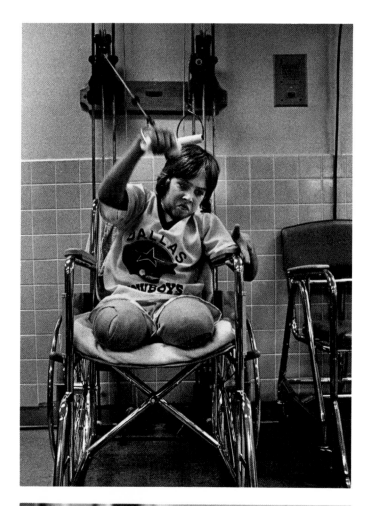

With or without the help of an exercise machine, Wade continues, hour after hour, to strengthen his arms.

Between workouts, he enjoys playing baseball with the other hospital patients.

In a more cheerful moment, Wade horses around with a volunteer friend and an oversize stuffed bear.

Wade, for the first time, pensively looks over the artificial limbs that will serve as his new legs.

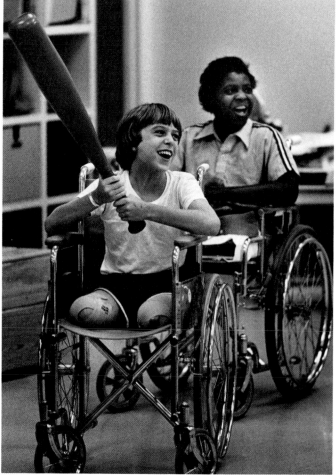

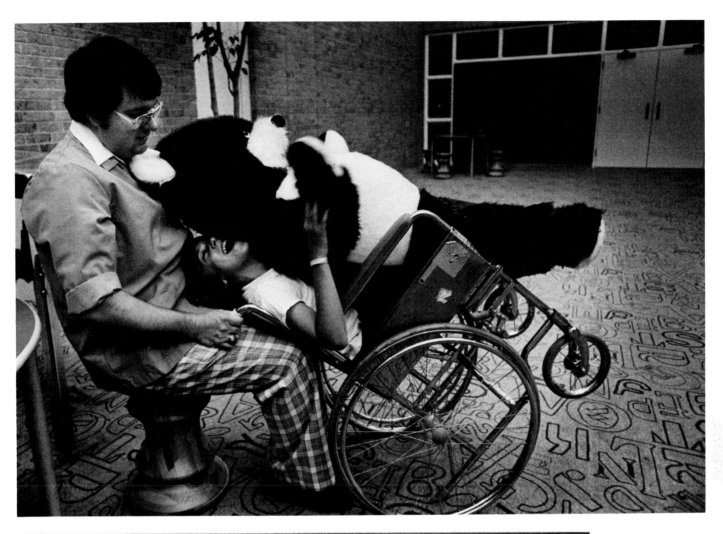

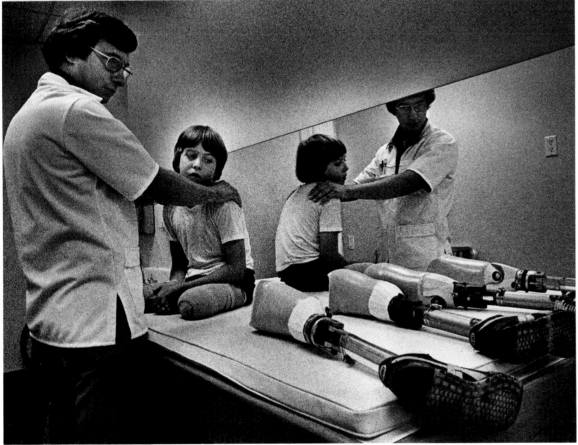

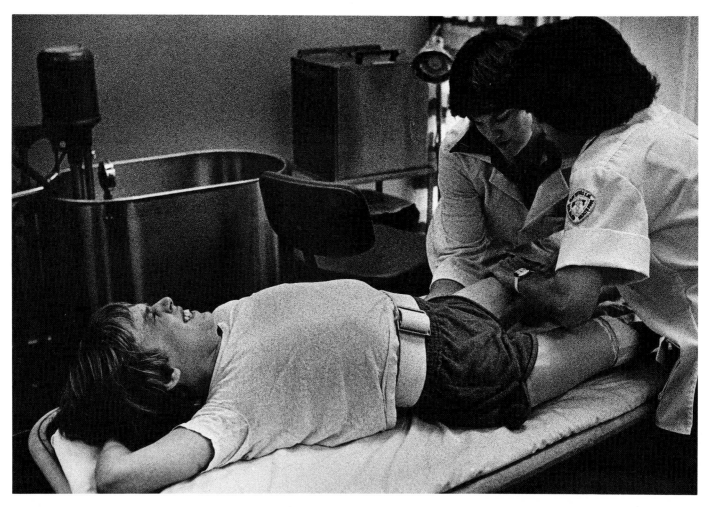

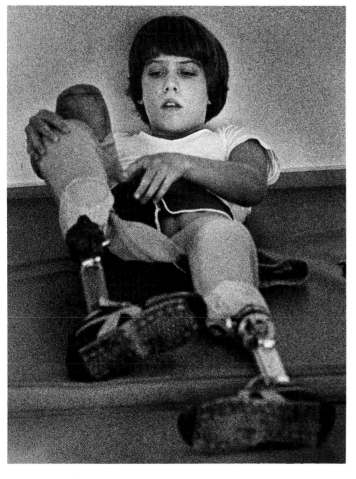

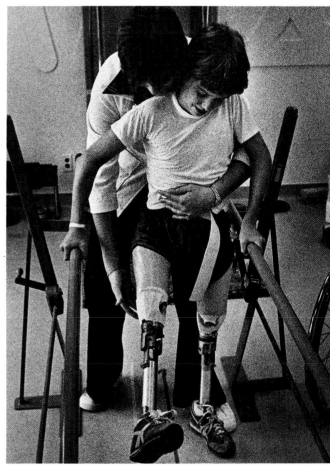

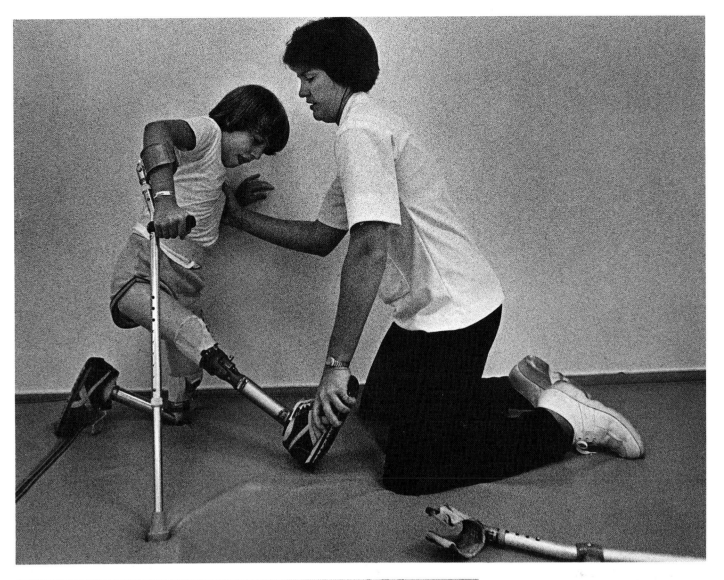

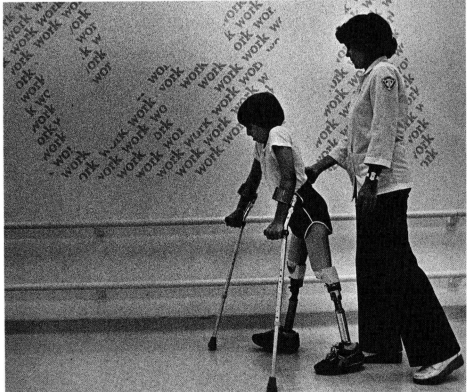

As two therapists fit his new set of legs, Wade grimaces from discomfort.

When alone, he practices putting on his legs.

With the help of therapist Debby Short, Wade takes his first steps while holding onto the parallel bars. This is the first stage of Wade's long and tedious rehabilitation program.

Day after day, he practices walking with the help of crutches, under the watchful eye of a therapist.

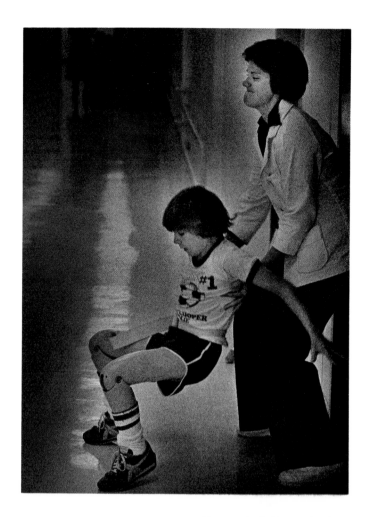 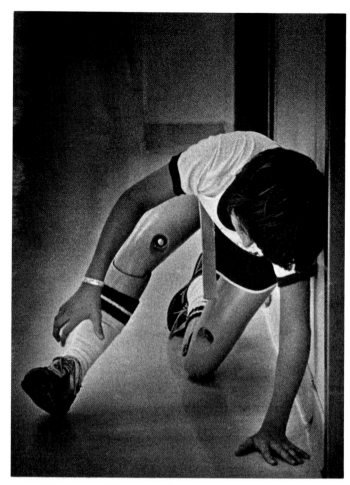

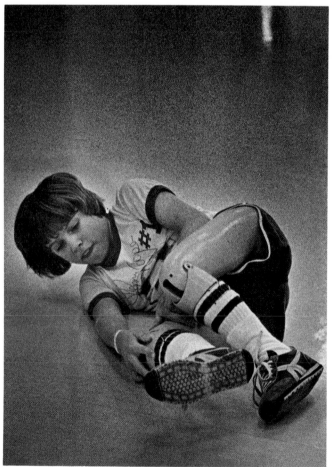 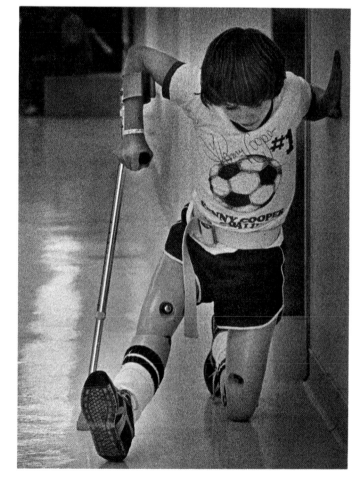

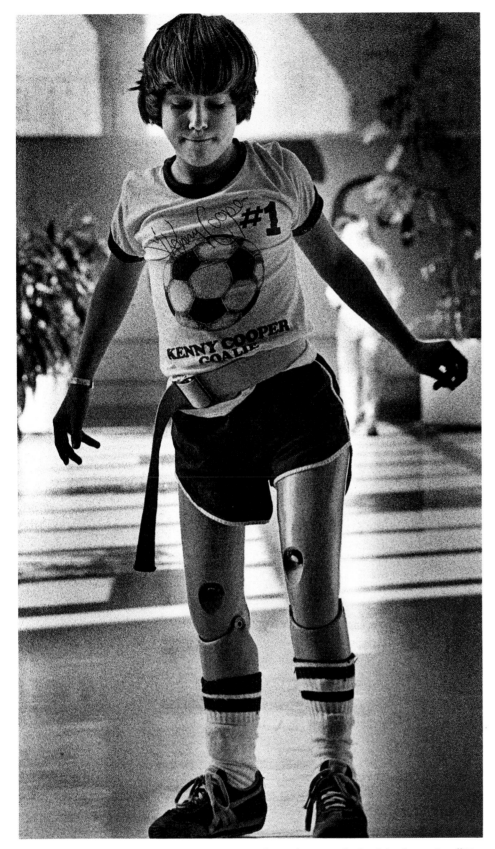

Venturing out on his own, Wade almost falls and is caught by his therapist. "He went through all the stages—denial, anger, then acceptance. There were times when he would get frustrated and there were lots of times when he got mad at me for pushing him so hard," she says.

After taking a few steps, Wade loses his balance, adjusts his legs before getting up again, and with the support of one crutch and a wall he pulls himself up.

Hours and days of practicing finally pay off for Wade as he walks down the hall without the help of his therapists, crutches, and walls.

Home at last, Wade engages in his favorite sport, soccer (next page).

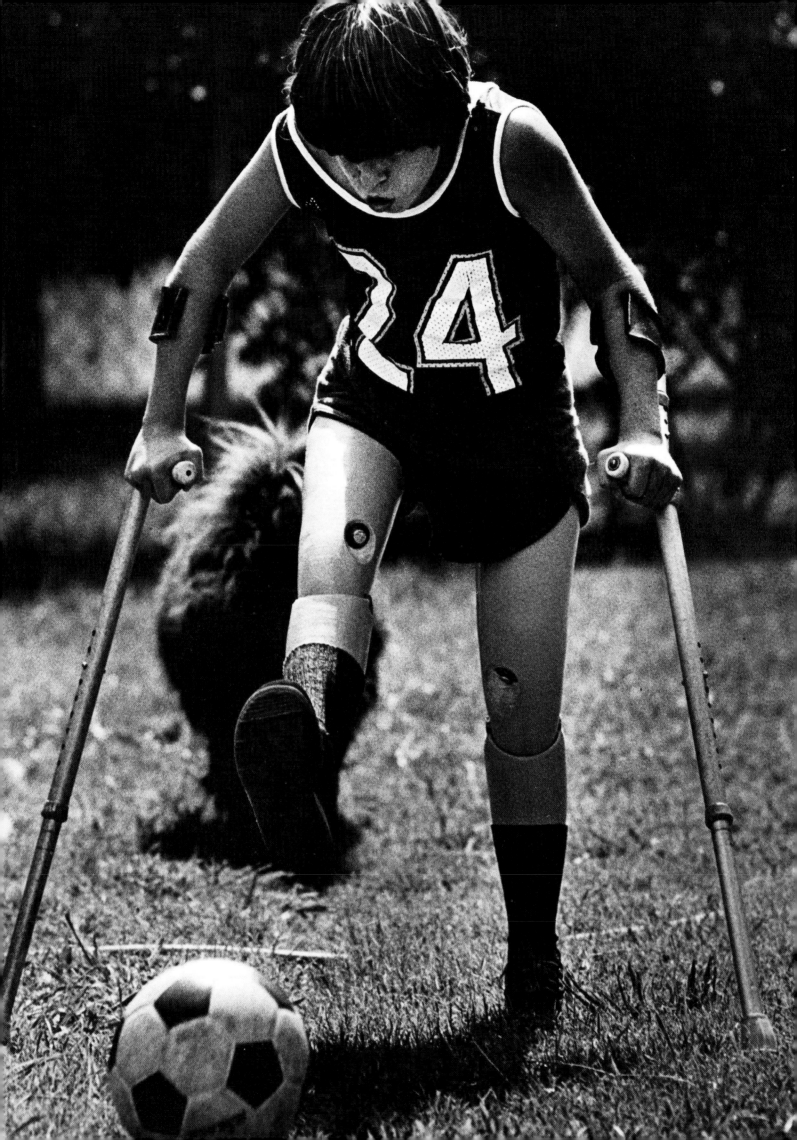

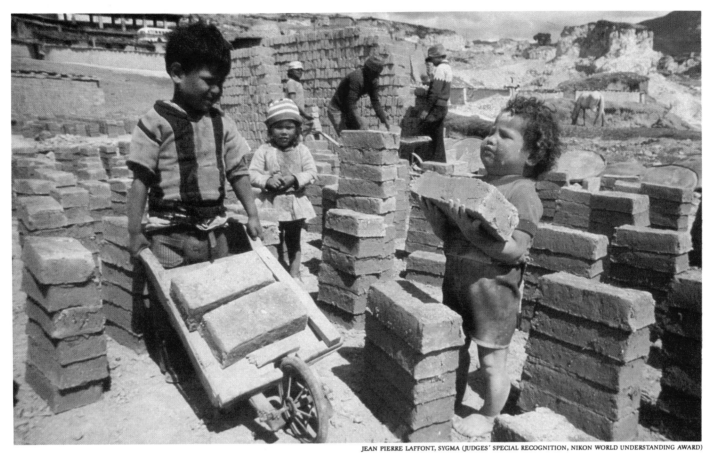

JEAN PIERRE LAFFONT, SYGMA (JUDGES' SPECIAL RECOGNITION, NIKON WORLD UNDERSTANDING AWARD)

Ten miles outside of Bogotá, children, regardless of age or size, learn responsibility very quickly. As the oldest brother takes charge of the wheelbarrow, his other two siblings help to load the bricks.

Six- and seven-year-old boys in Cairo display their work of art. The boys work in a clay pot factory and are responsible for loading and unloading the oven.

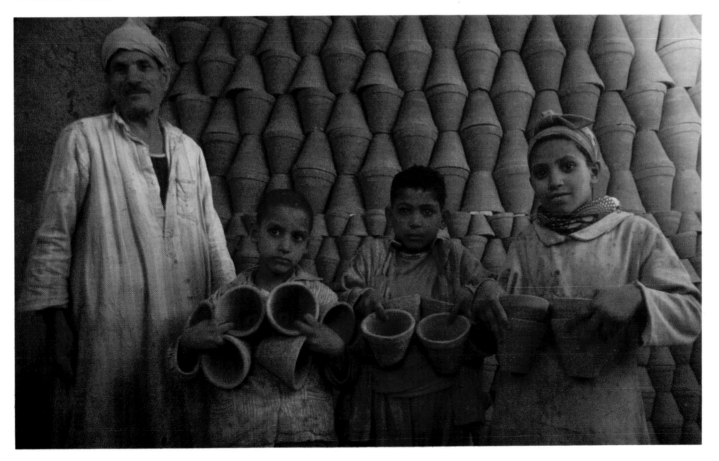

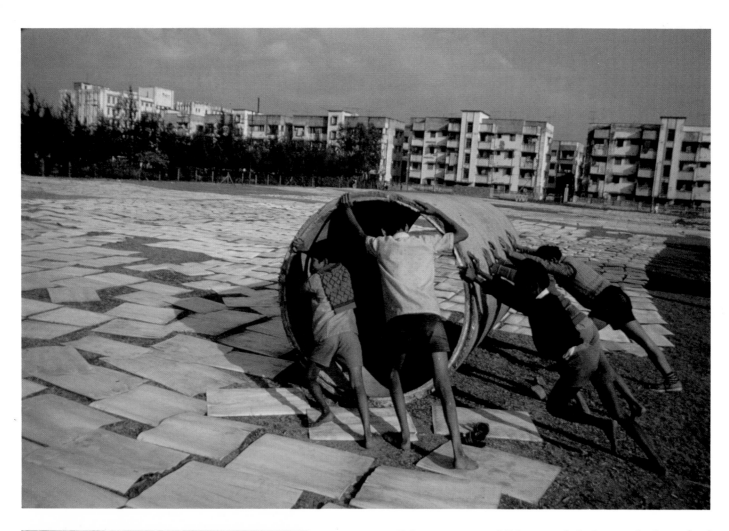

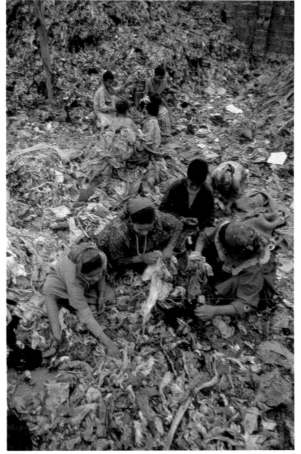

In Calcutta, young children work before and after school pushing a large, heavy cement pipe. The pipe is rolled over curled pieces of wood in order to flatten them so they can be bonded into plywood.

Girls in Cairo, Egypt, spend their days "treasure hunting" for salvage. Seated on a mountain of rags in a garbage dump, the girls are looking for rags that can be reconditioned and made into rugs to be sold to tourists.

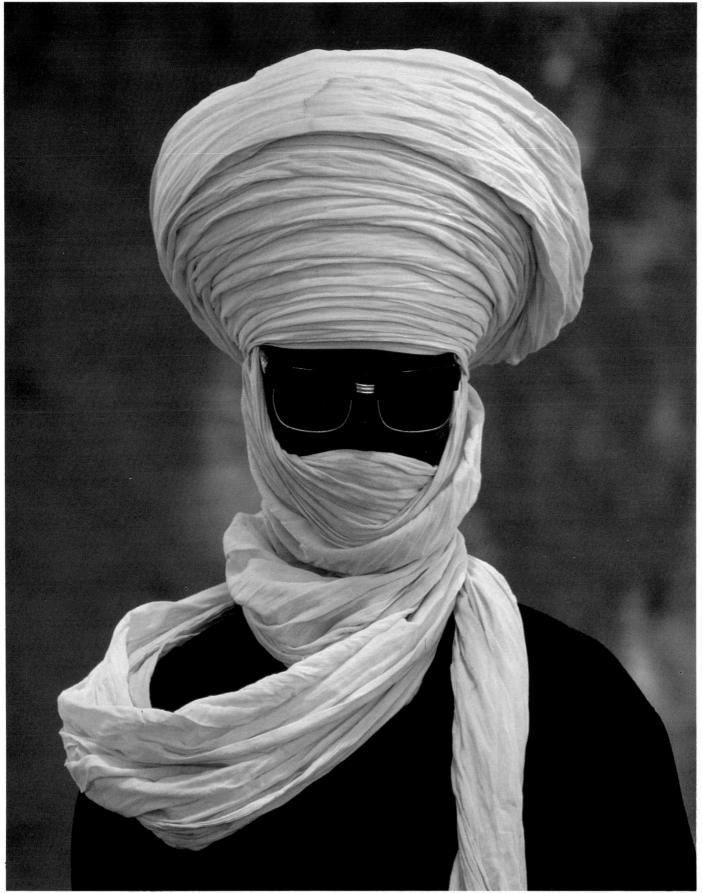

GEORG GERSTER, NATIONAL GEOGRAPHIC (PORTRAIT/PERSONALITY, SECOND PLACE, MAGAZINE)

On the fringe of the desert in Upper Volta, in the Fahel zone, a dandy from the
Bella tribe shows off his garb to his peers. The young men in Upper Volta were
trying to impress each other at, quite literally, the local watering hole.

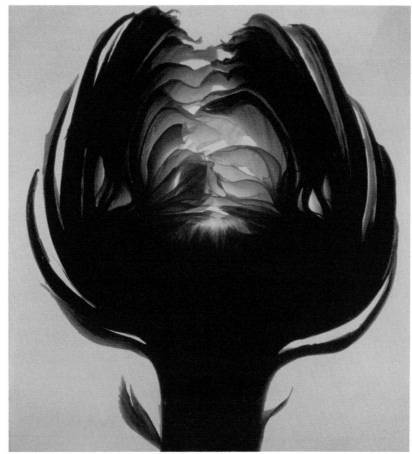

The cross section of an artichoke shows it to be what it in fact is—the bud of a flower ready to burst into bloom.

A Triple Loop Mind Bender, in Atlanta, Ga., gives a spectacular, upside-down thrill to its passengers at the end of the ride.

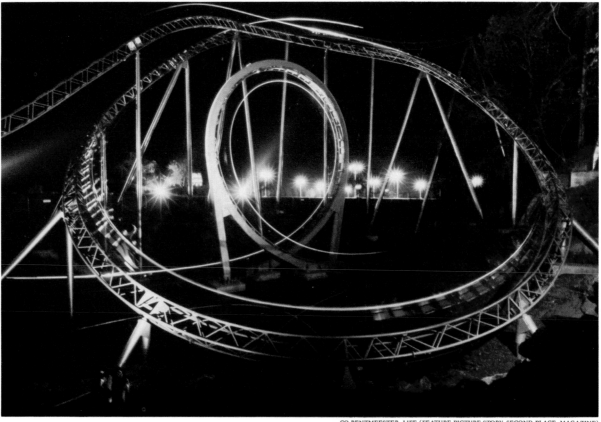

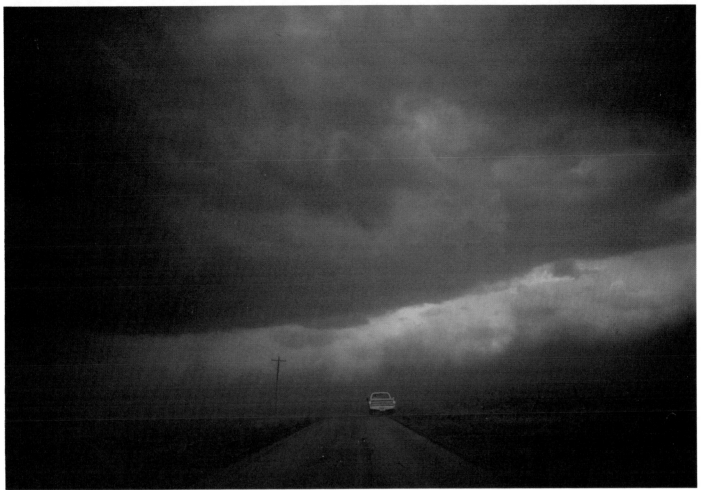

This west Texas brand of dust storm met Peter and Barbara Jenkins during their five-year walk across the United States. The couple was staying at the wheat farm of Homer and Ruby Martin near Galliland. The late spring storm turned the wind red with dust, lit up the entire sky with lightning, and forced everyone in its presence to bow to its fury during its most intense flare-up, which lasted about forty-five minutes.

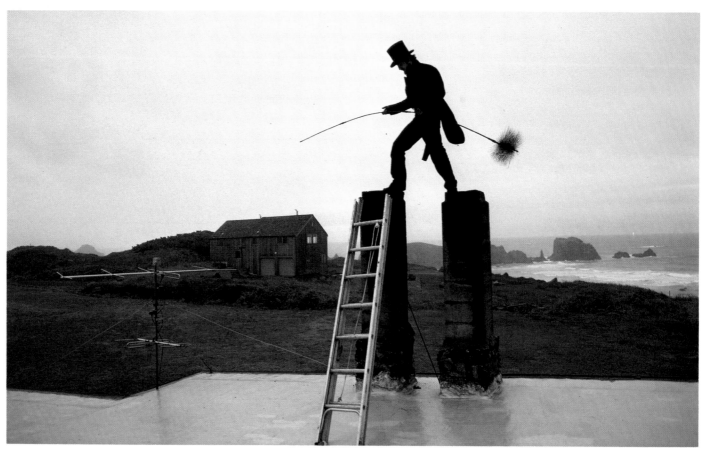

COTTON COULSON, NATIONAL GEOGRAPHIC (FEATURE PICTURE, FIRST PLACE, MAGAZINE)

Top hat and tails are Tom McKegg's working clothes. Looking as though he stepped out of a Dickens novel, McKegg sweeps chimneys in Bandon, Ore. His garb prompts children to ask if he is "a magician or a bad guy."

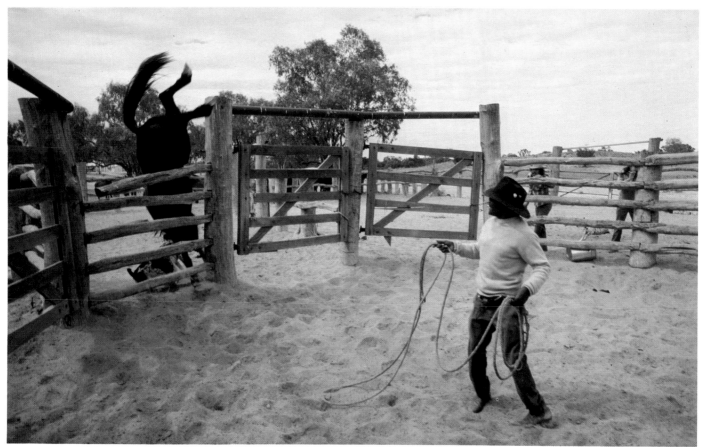

JOSEPH J. SCHERSCHEL, NATIONAL GEOGRAPHIC (FEATURE PICTURE, HONORABLE MENTION, MAGAZINE)

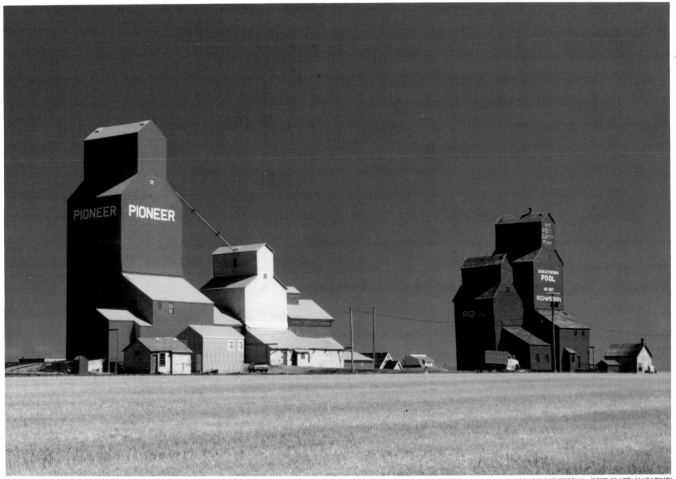

With wheat fields sheared to an even texture just after the autumn harvest, the grain elevators are a monument to Saskatchewan's prosperous lands. As in the American west, railroad towns formed the nuclei for wheat-farming communities in Canada, especially Saskatchewan, which today supplies more than 60 percent of the country's harvest.

In the vast outback of Australia, ringers, the Australian cowboys, can still be found lassoing wild horses. The horse was making a flight for freedom at Innimicka Station, a 5,500-square-mile ranch near Cooper's Creek.

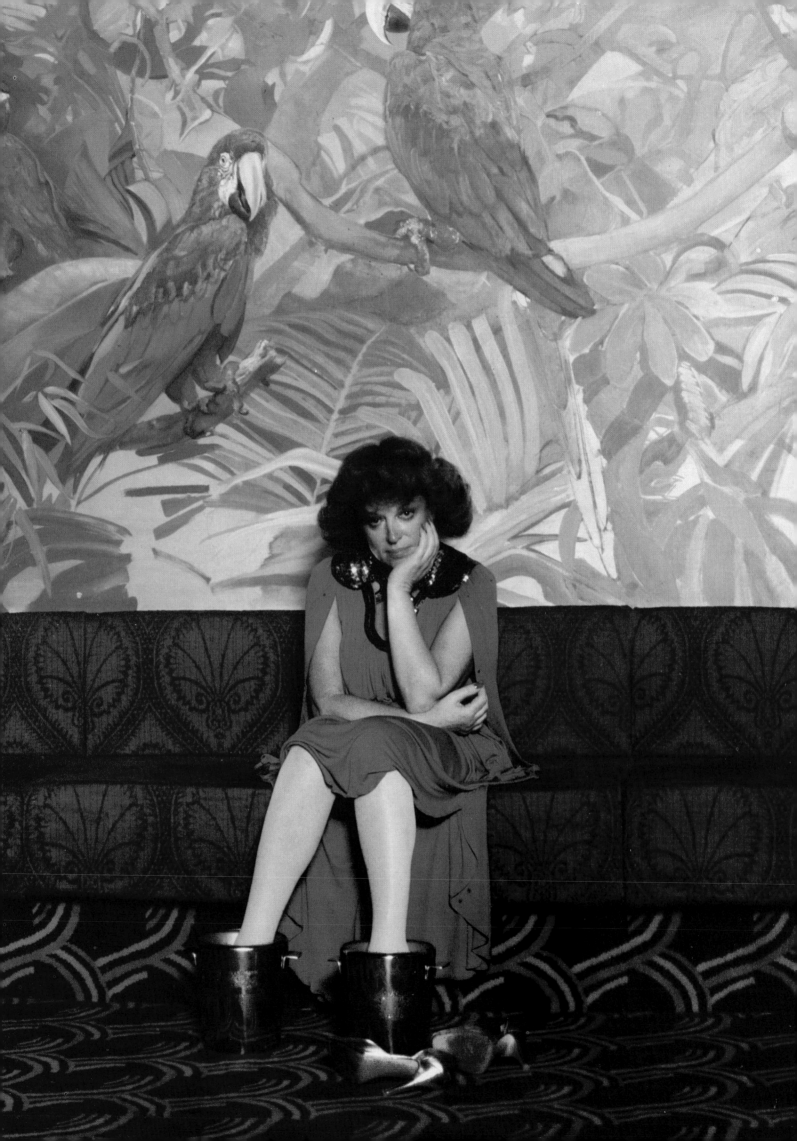

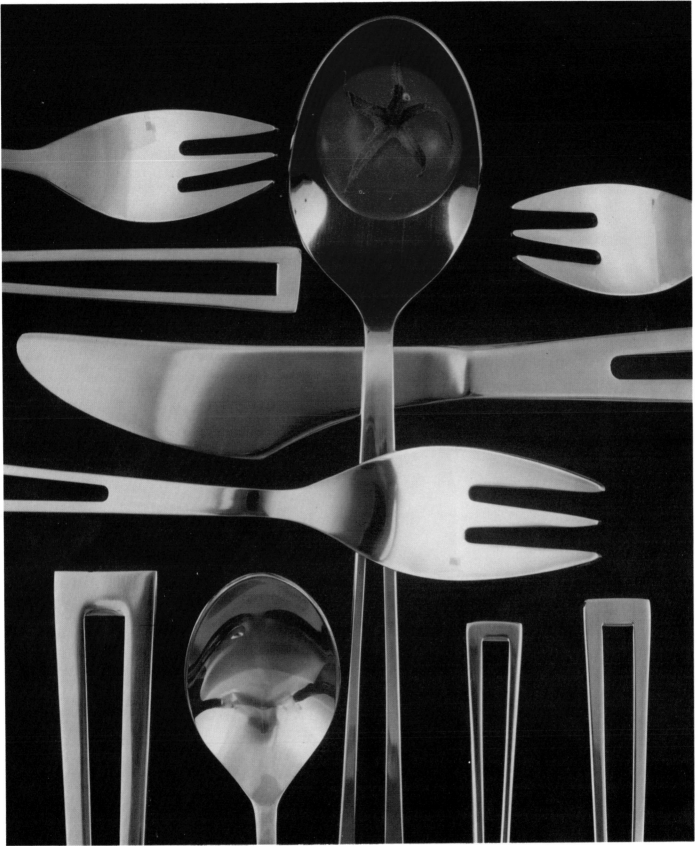

It can take a lot of flatware to eat a tomato. And in this illustration for a feature on flatware, all of the options were offered.

Régine, the diva of the disco, has developed a worldwide network of exclusive disco franchises. A Polish refugee from World War II, she has taken to nightlife well. After dancing until dawn, she rejuvenates her feet in champagne buckets full of ice.

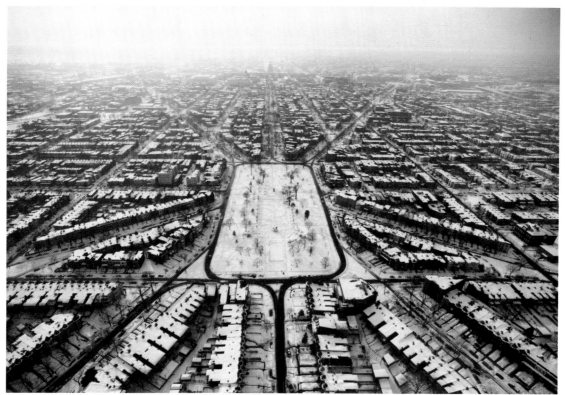

JAMES A. SUGAR, NATIONAL GEOGRAPHIC (PICTORIAL, SECOND PLACE, MAGAZINE)

The outline of Pierre Charles L'Enfant's design of the nation's capital was emphasized by a three-foot blanket of snow that covered all but the rudimentary aspects of the landscape. This clear aerial view looking across Lincoln Park toward the Capitol was taken the morning after the February 22 blizzard.

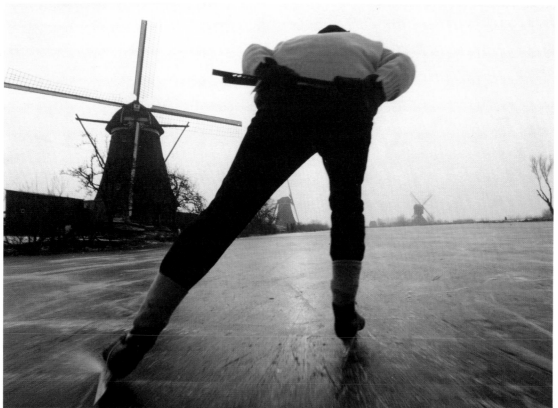

CO RENTMEESTER, LIFE (FEATURE PICTURE STORY, THIRD PLACE, MAGAZINE)

The frozen canals of Holland are quite familiar to Dutch photographer Co Rentmeester. This picture was taken in January near Broek up Wakerland, a province in northern Holland.

"Officer, somebody stole my watch!"—While California is reputed to be tolerant of its many eccentrics, this pedestrian was handcuffed and driven away from this corner in Santa Monica.

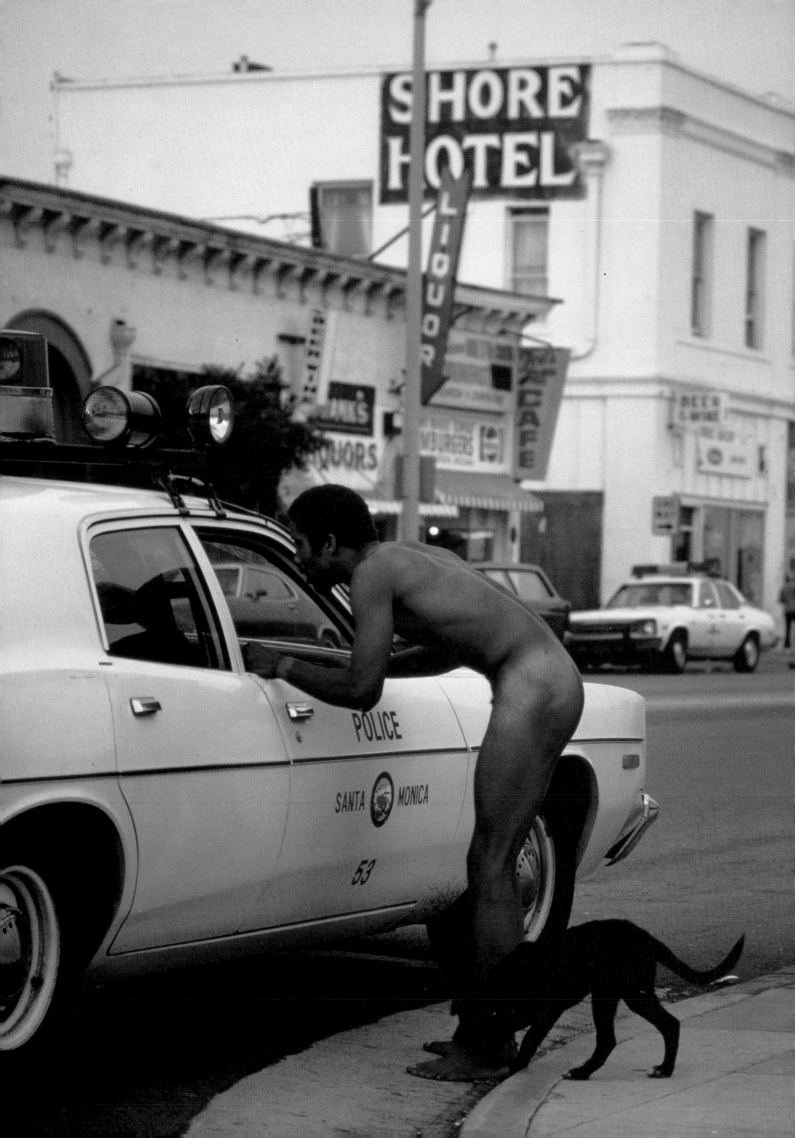

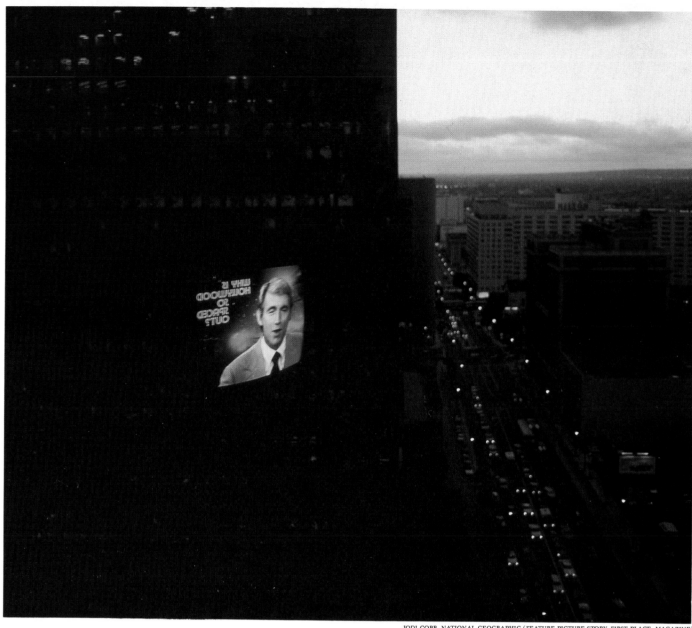

JODI COBB, NATIONAL GEOGRAPHIC (FEATURE PICTURE STORY, FIRST PLACE, MAGAZINE)

The TV screen reflected on the hotel window poses the question, "Why is Hollywood so spaced out?" The characters and the landscape provide the evidence that it is.

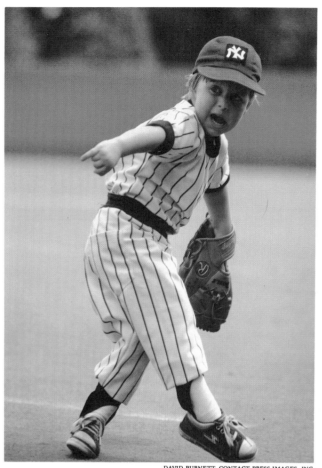

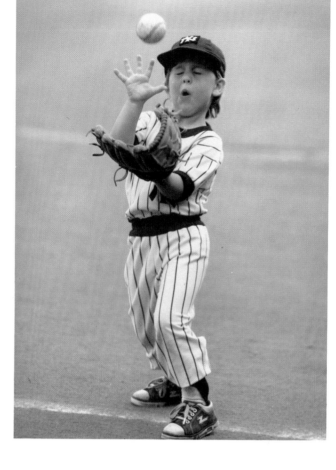

A true rookie; the son of Brian Doyle, a former Yankee, warms up with a coach along the sidelines before a game.

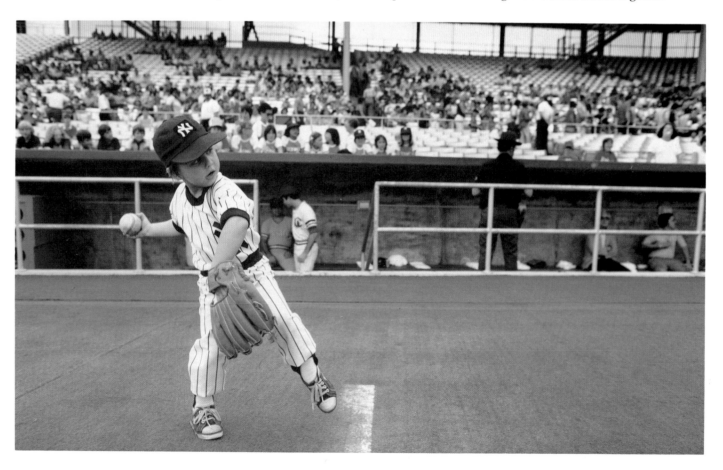

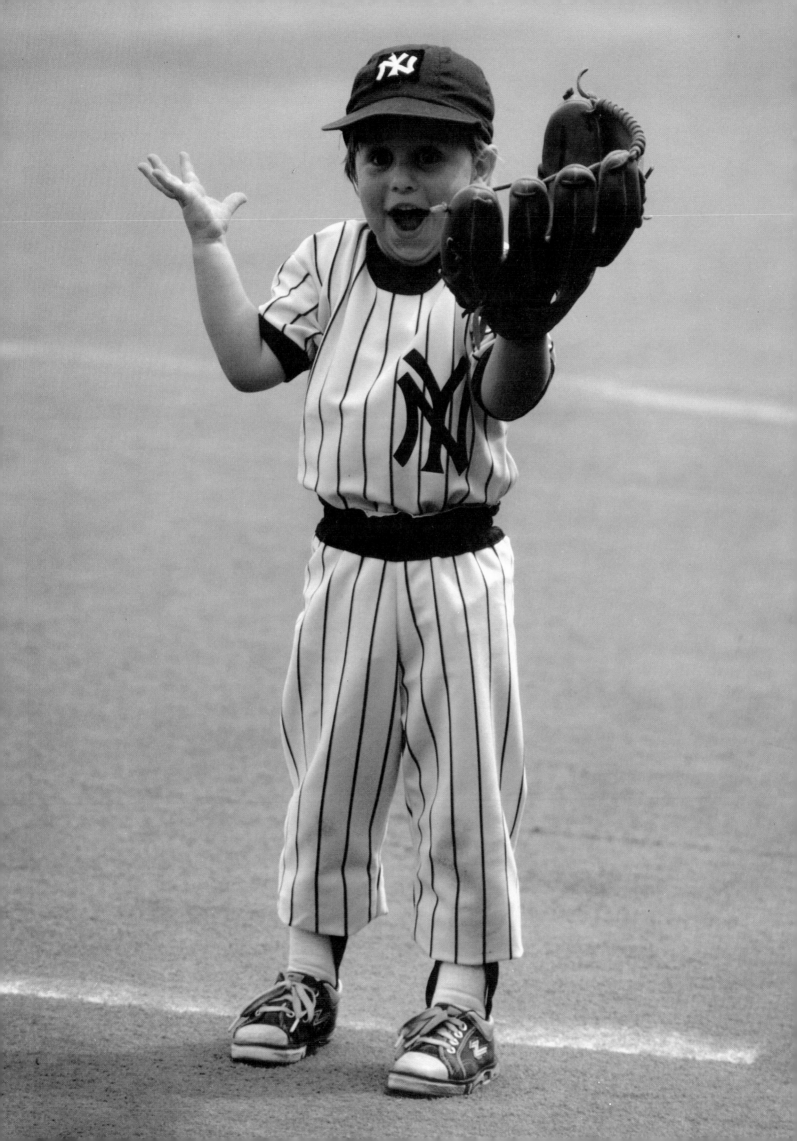

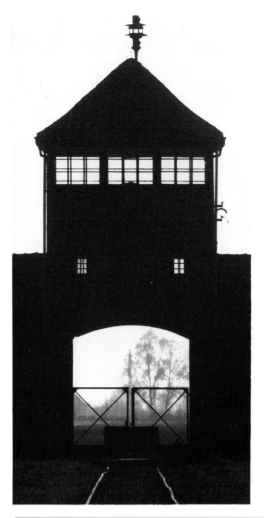

JOHN W. MCDONOUGH, LOS ANGELES TIMES (FEATURE PICTURE STORY, FIRST PLACE, NEWSPAPER)

More than 4 million people were murdered at the Birkenau-Auschwitz death camps in southern Poland. The entrance gates, barracks buildings, guard towers, and fencing provide ominous ghosts of the Nazi horrors of the thirties and forties.

# Features

Writing feature stories is an art that many reporters have worked very hard to learn. In contrast to the news story, the purpose of a feature is to inform or to entertain. It is easy to see how photographs have a particularly important function in a successful feature story. In fact, a group of photographs can be so effective that some stories barely need words to fill in the details. David M. La Belle's story on Tuffy, the Brittany spaniel (pp. 142–43), or Carla Hotvedt-Horne's feature on the "Crisco Kid" (pp. 168–69) portrays a heart-breaking situation with a compassion that words can seldom match.

In evaluating the individual feature photographs, the judges looked for a "found" situation, a fresh view of the commonplace, and these photographs are both "found" and "fresh" in a variety of ways. Jodi Cobb just happened to have her camera with her when she spotted a naked man on the streets of Santa Monica, and she waited for the perfect moment to snap an out-of-the-ordinary photograph (p. 123). On the other hand, we can all see an artichoke in the supermarket any time, but who has taken the time to look at one as closely as Scott Braucher (p. 116)?

Above all, these feature photographs illustrate a fundamental premise of the Pictures of the Year competition, that the value of a photograph lies in the creativity of its visual communication, not in the newsworthiness of the event that it portrays.

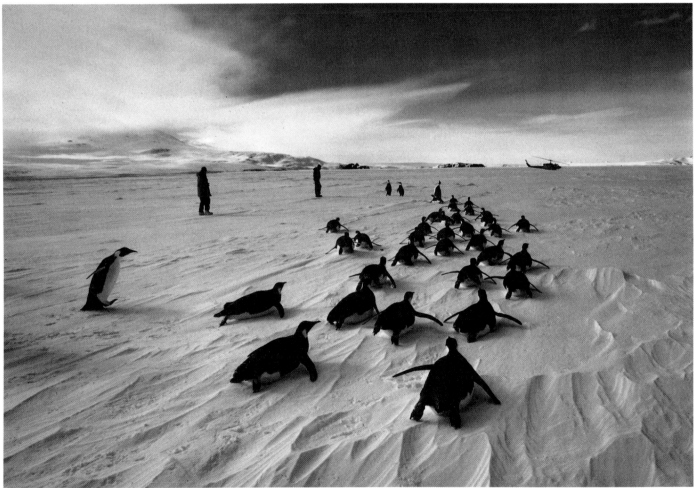

MARTIN ROGERS, NATIONAL GEOGRAPHIC (FEATURE PICTURE, SECOND PLACE, MAGAZINE; ALSO INCLUDED IN FEATURE PICTURE STORY, HONORABLE MENTION) ORIGINALLY IN COLOR

Scientists traveled to Antarctica to capture penguins for scientific research. These penguins were taken back to the United States and given to scientists to complete research on the birds.

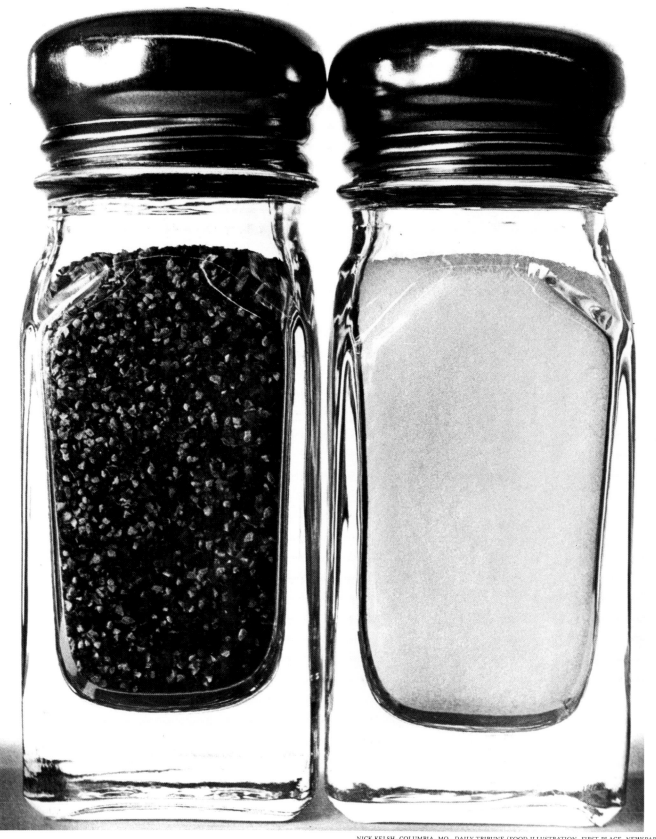

NICK KELSH, COLUMBIA, MO., DAILY TRIBUNE (FOOD ILLUSTRATION, FIRST PLACE, NEWSPAPER)

A lucid, well-arranged illustration of a pair of real shakers, this photograph will be of interest not only to Susie Salt and Paul Pepper, but also to anyone interested in dining, munching, or even starvation dieting.

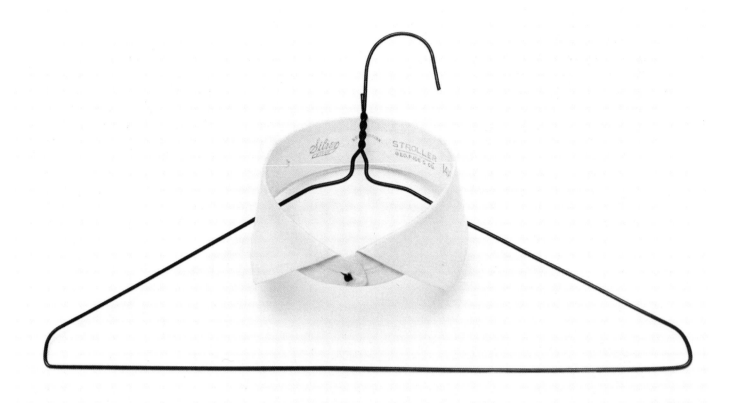

Dressing with less—less money to buy a smaller clothing wardrobe—is graphically
illustrated by this collar on a coathanger.

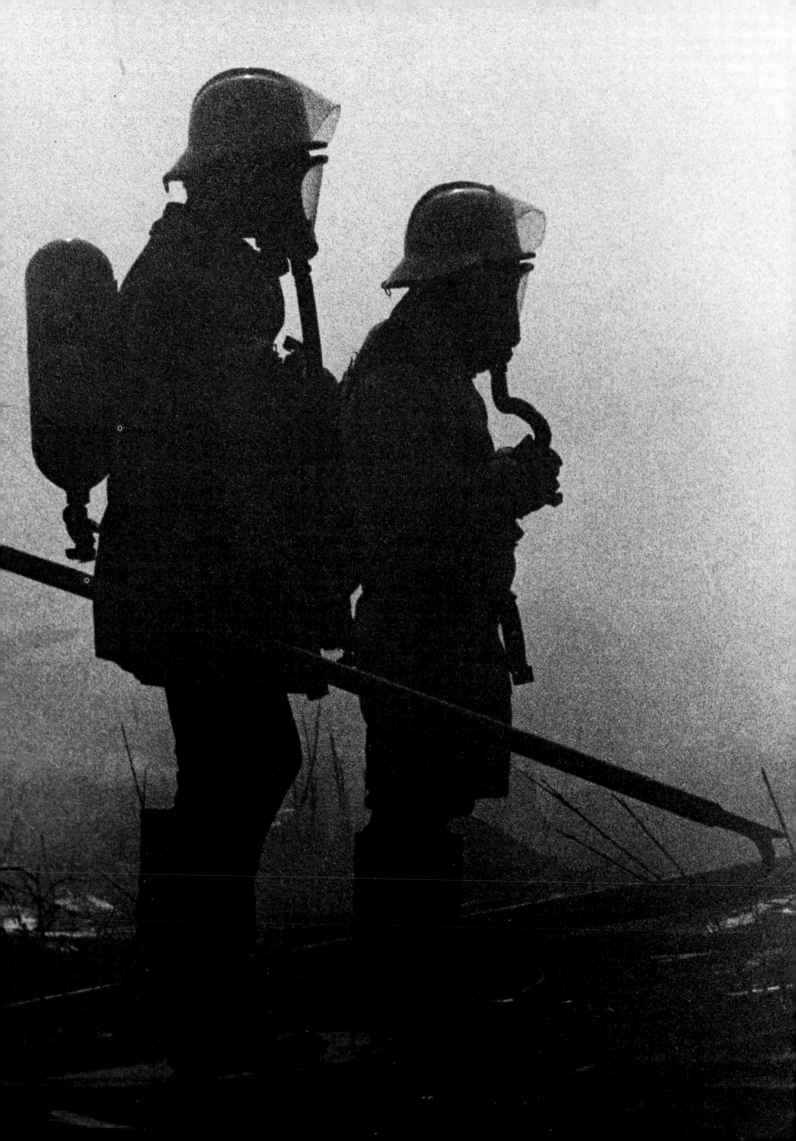

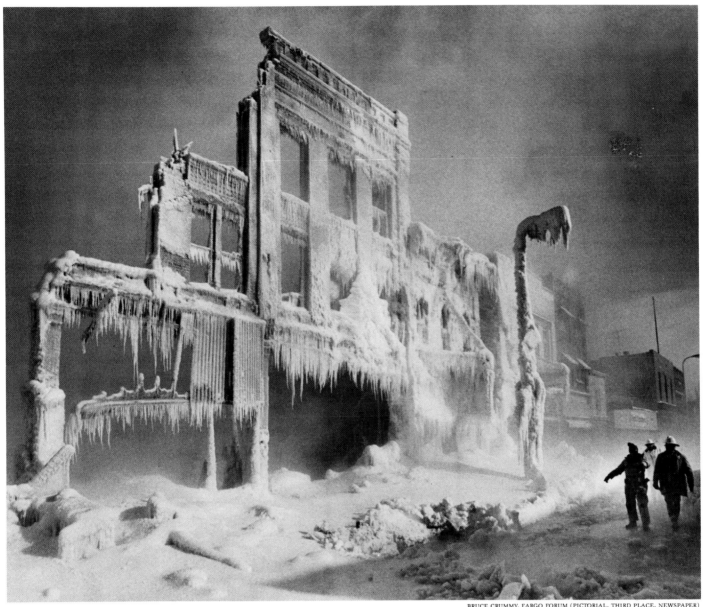

Fire is a dramatic disaster wherever it happens, in the arid Southwest or in North Dakota in midwinter. These firemen of Del Rio, Tex., were surveying the damage to nearly ten acres of grass and brush. They contained the fire before it reached a nearby mobile-home park, though.

The occupants of the hotel in Grand Forks, N.D., were not as fortunate. Fire fighters worked in shifts to put out the blaze in minus twenty degree temperatures. Twenty-nine people were forced to flee the building during the early morning hours and were left homeless.

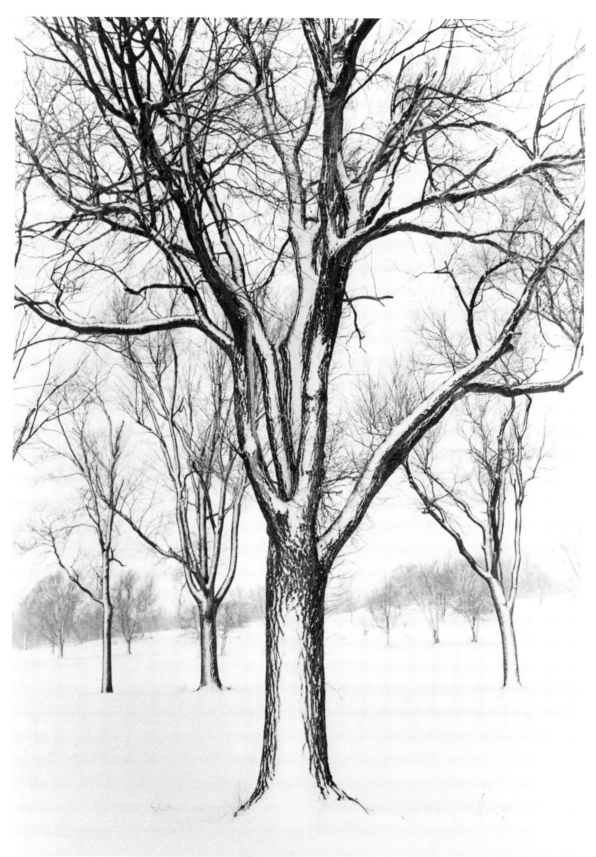

A newly fallen snow turns a gray winter day at a golf course in Chanute, Kans., into a work of art in black and white, created by the elements of nature.

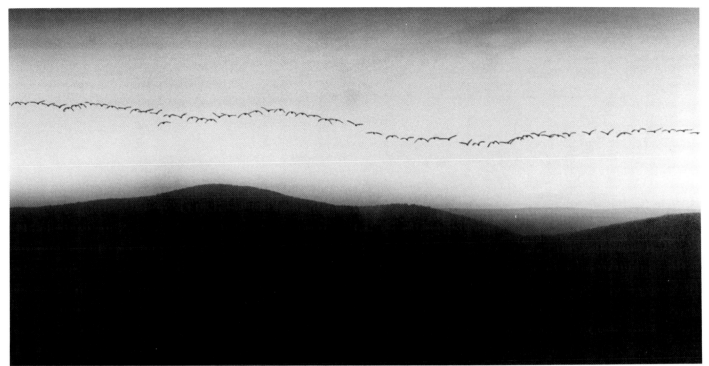

JOEL LIBRIZZI, BERKSHIRE, MASS., EAGLE

A long line of Canada geese graced the morning sky of Berkshire, Mass., last October. The Taconic Range forms the misty backdrop for the scene.

While it might appear that the photographer luckily happened upon this herd of Virginia white-tailed deer on a brisk winter morning walk in the wilds, they were photographed at the Charles W. Green Wildlife Research Station, Columbia, Mo. Several generations have been reared in the two-acre pen, affording wildlife experts an opportunity for controlled observation.

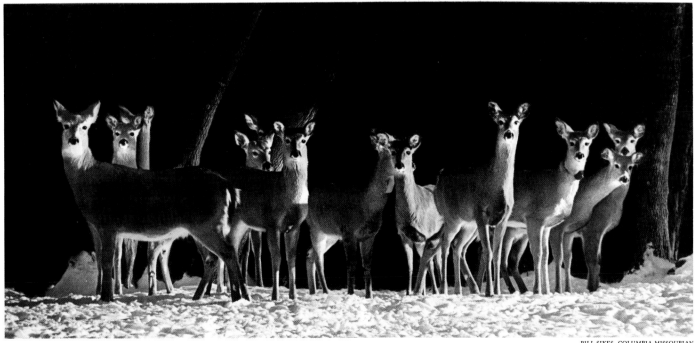

BILL SIKES, COLUMBIA MISSOURIAN

Arabian horses get their afternoon rations at a ranch near
Micanopy, in northeastern Florida.

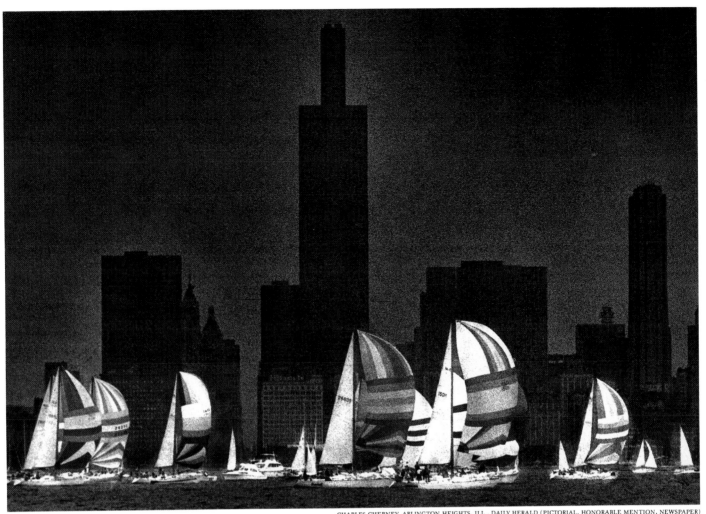

Sailboats of all sizes passed Chicago in the 72d Annual Mackinac Boat Race in July. The 330-mile race is run from Monroe Street Harbor up Lake Michigan to Mackinac Island near the northern point of Michigan's Lower Peninsula. The 288 boats, ranging in length from 27 feet to 70 feet, spent about forty-eight hours completing the course.

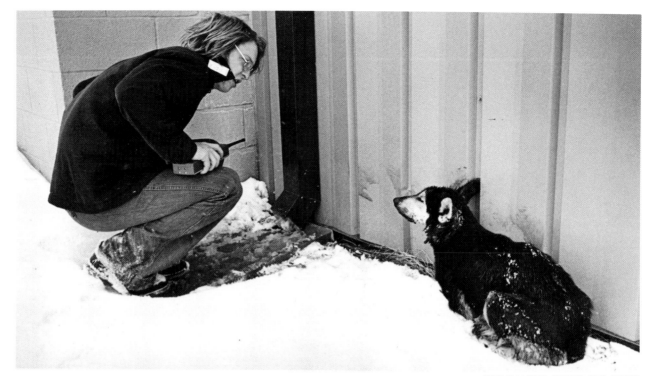

DAVID M. LA BELLE, CHANUTE, KANS., TRIBUNE

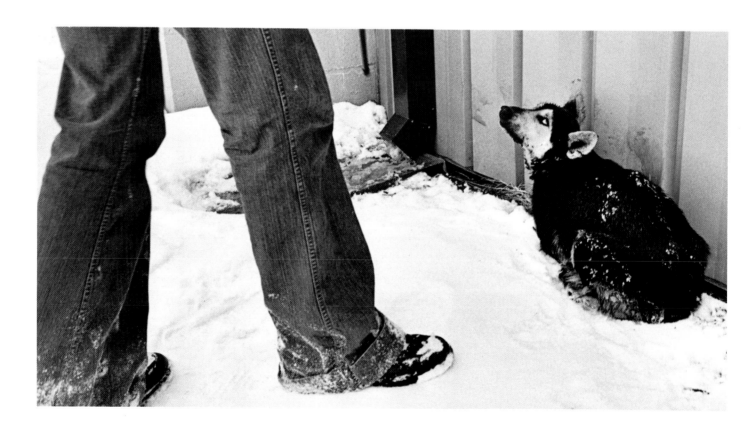

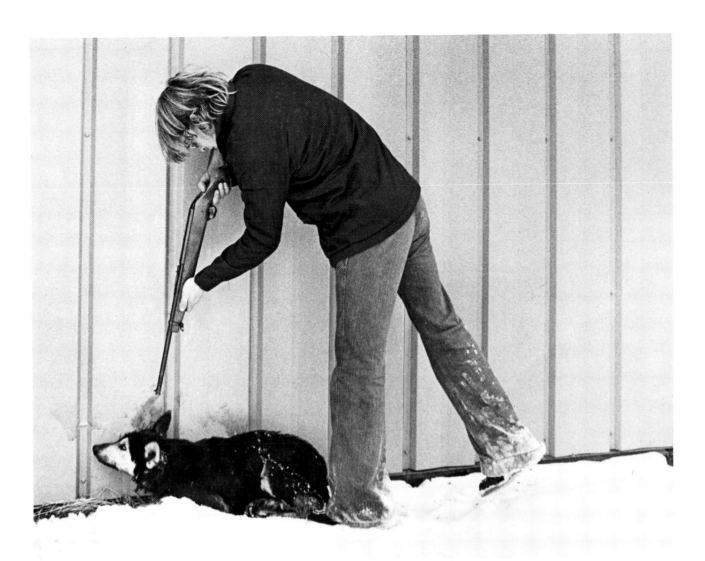

Dave La Belle's story about an animal control officer living up to a sad duty caused a great deal of controversy in Chanute, Kans. The dog had been severely mistreated; it had already been shot in the head twice. The officer obtained a permit to fire a gun within the city limits to humanely end the dog's suffering, but this story resulted in so much harassment that he was forced to quit his job and leave town.

As an epilog, however, the problem of strays in Chanute was so dramatically illustrated that the public took action. For the first time, a full-time animal control officer has been hired, and a new animal shelter is under construction.

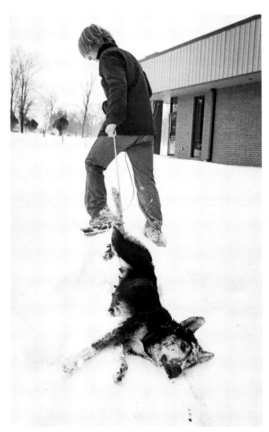

There are several Amish communities in the rural areas of Iowa, and their citizens continue to live the lives they have lived for the past two hundred years. Here, a buggy's pace is illustrated in the eyes of a still camera on the Buchanan County landscape. Seconds later, the pace changes.

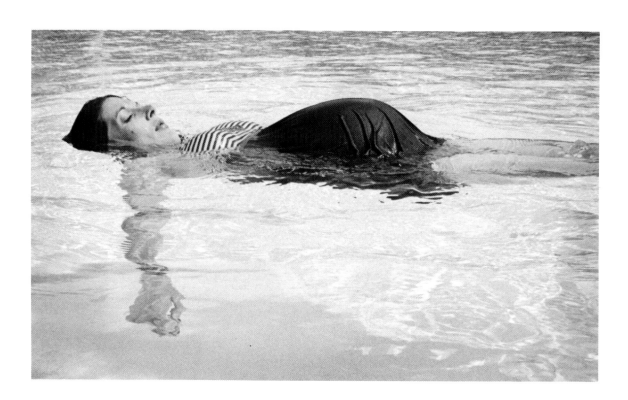

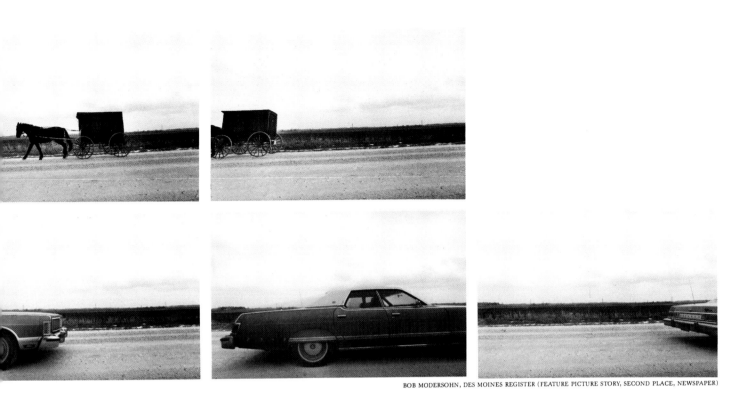

BOB MODERSOHN, DES MOINES REGISTER (FEATURE PICTURE STORY, SECOND PLACE, NEWSPAPER)

You've seen the crawl, the breast stroke, and the side stroke.
But how about the belly stroke?

ALISON E. WACHSTEIN, FREELANCE (SPORTS PICTURE STORY, HONORABLE MENTION, NEWSPAPER)

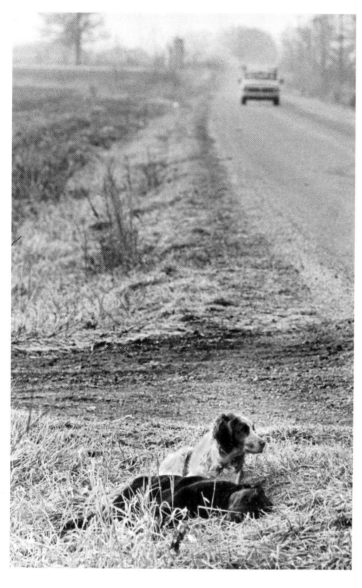

Tuffy, a five-year-old Brittany spaniel, held a vigil for more than thirty-six hours beside his playmate, Midnight, who had been killed by a car. The spaniel refused to leave the side of his friend until the owners found the pair and loaded the dead dog in their truck. Tuffy followed.

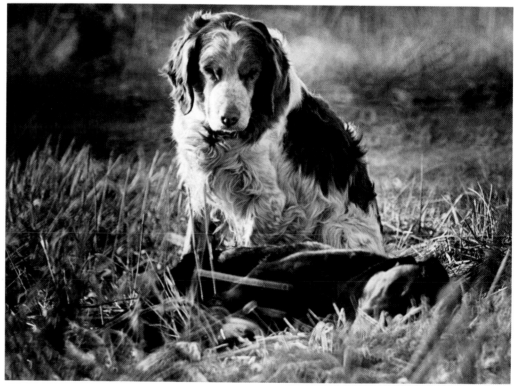

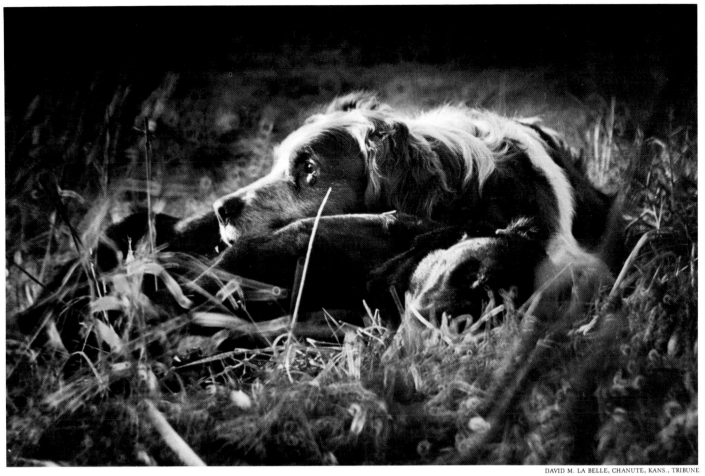

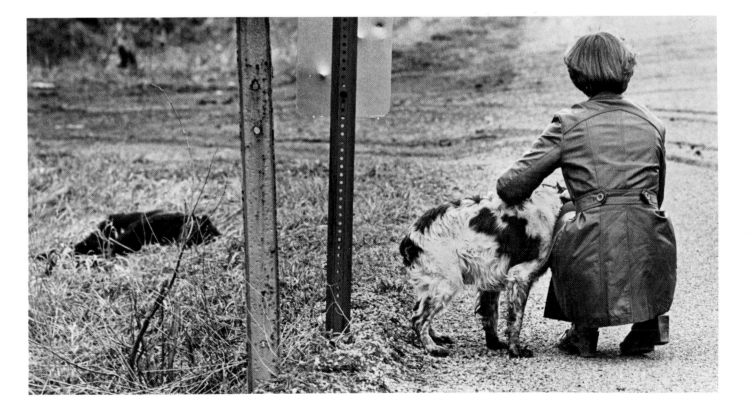

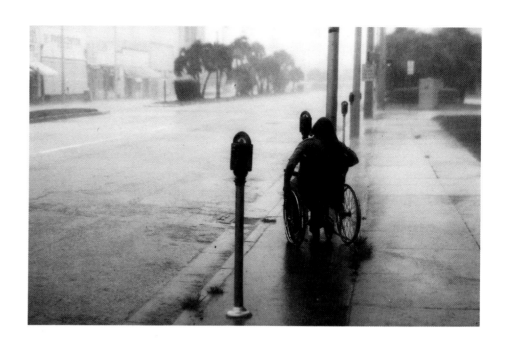

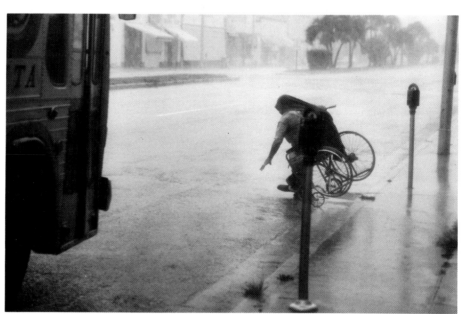

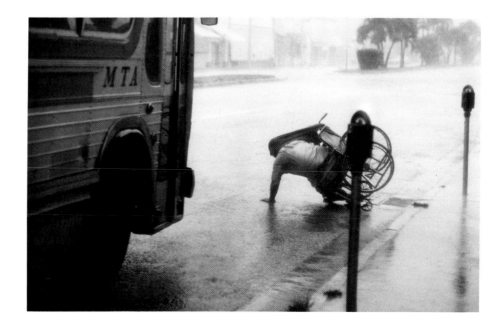

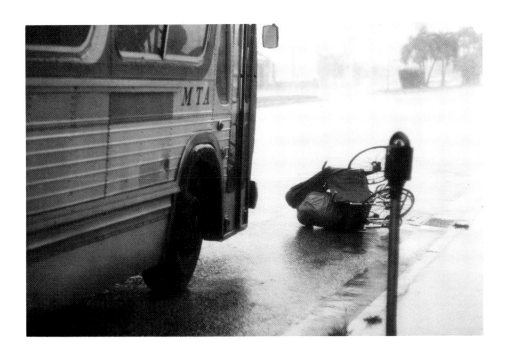

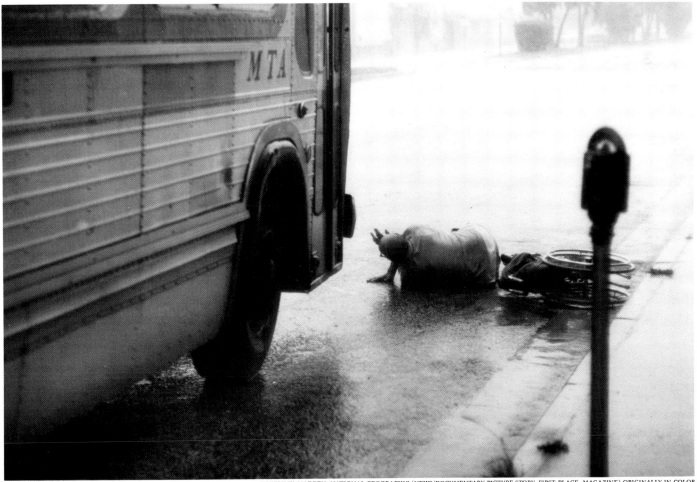

Hurricane David was, by many accounts, the worst storm of the century in the Caribbean. It appeared that south Miami would be a landfall for the storm, so thousands of elderly citizens were being evacuated. A small group had gathered at this pickup point when the rain, the first warning that David was approaching, began. This old gentleman, with a towel draped over his head, apparently became confused and began to wheel away from the group. His chair fell off the curb just as a city bus approached, the driver struggling for control on the wet pavement. The bus finally stopped, sixteen inches short of the man's head.

This lingerie had a chance to see the light of day from a garage in Atlanta, Tex.

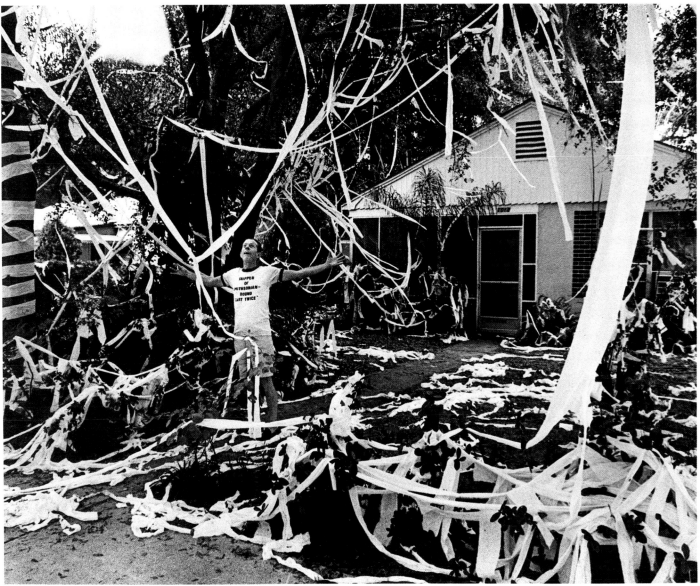

Two hundred and twenty rolls of toilet paper, displayed over trees and lawn, greeted Robert Price the morning after his high-school band received a superior rating from the district band competition. Price has been directing the band for twenty-four years, and the "rolling" is a traditional celebration for a superior rating.

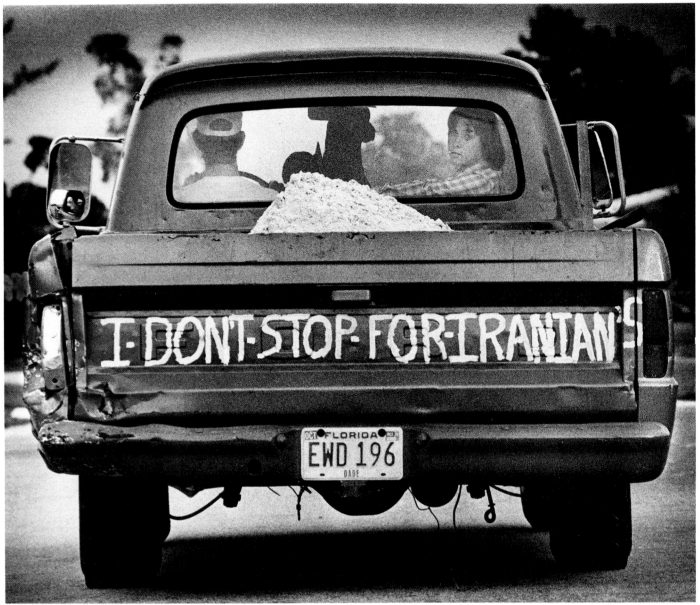

Phillip Goode editorializes on his diplomatic sentiments on the tailgate of his pickup. He feels he has a lot of company among his peers. "A lot of people tell me the situation stinks," he said last December.

A photographic political cartoon; the photographer happened upon this car (parked in front of a fireplug) in Des Moines, Iowa. The obvious caption: stylish but obsolete.

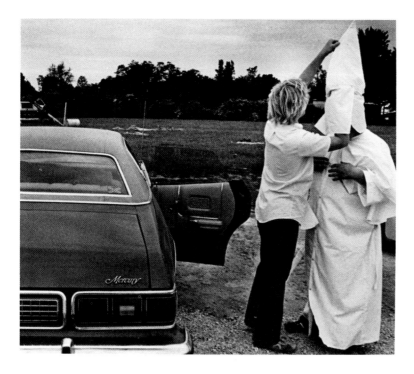

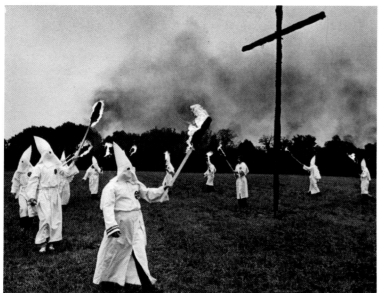

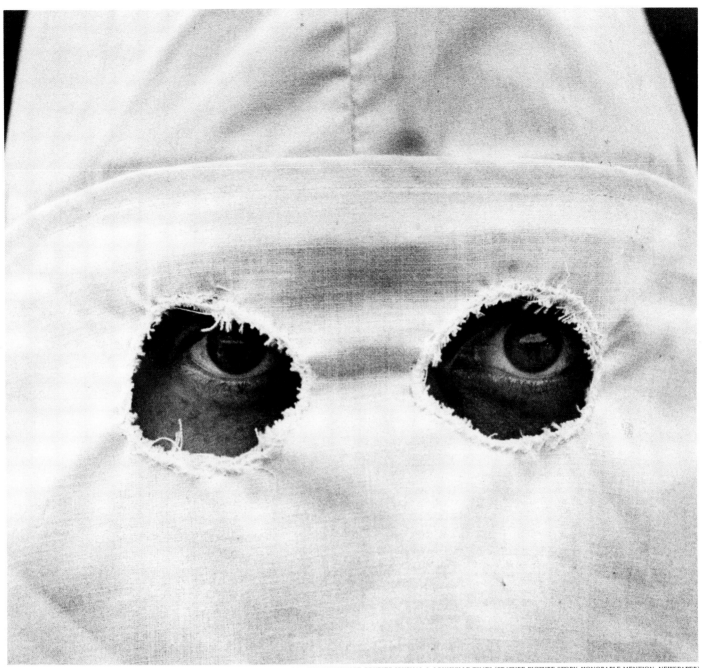

A "Saturday night sheet party" held in honor of David Duke, Grand Wizard of the Ku Klux Klan, about thirty miles from Louisville, Ky. Klan members from throughout the region attended and, for the most part, were unconcerned about being photographed—with hoods on.

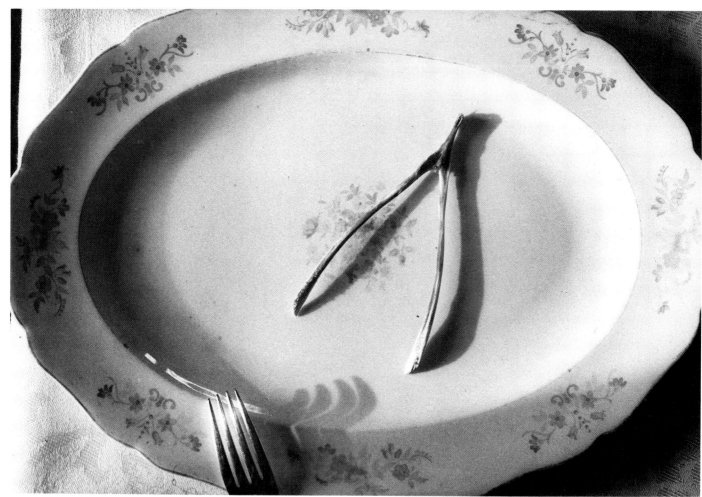

While everyone wants to make the most of the Thanksgiving leftovers, even the dog might pass up this suggestion, used to illustrate a holiday food feature.

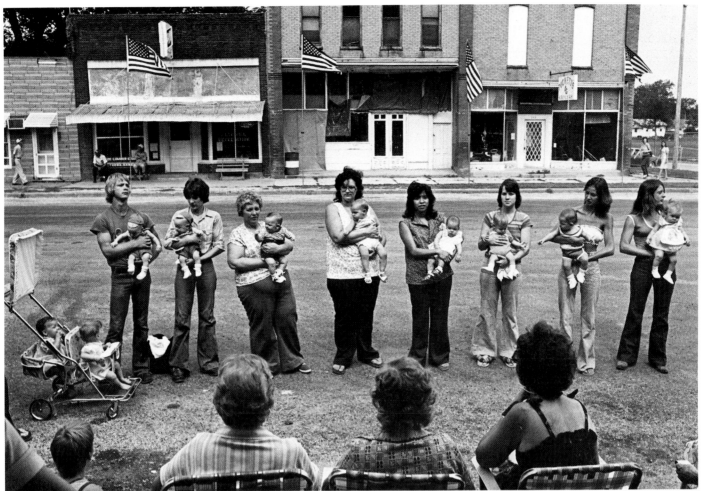

DAVID M. LA BELLE, CHANUTE, KANS., TRIBUNE (GENERAL NEWS/DOCUMENTARY, HONORABLE MENTION, NEWSPAPER)

The baby contest is still a feature event of the Fourth of July celebration in Altoona, Kans., which has a population of less than one hundred. As many as twenty mothers—and even a father or two—were willing to stand in the hot sun while the judges made their pronouncements.

A sunset at a crossroads north of Gainesville, Fla., forms an
optical triangle where a county road overpasses Interstate 75.

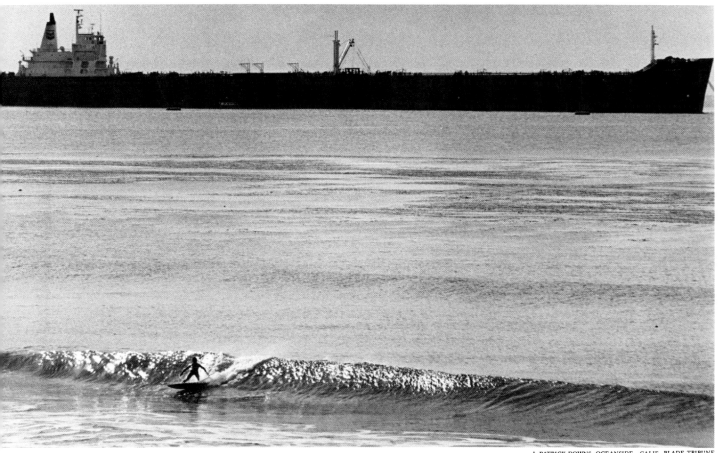

A surfer surfs while a tanker unloads fuel to a Carlsbad, Calif., power plant.

Mikhail Baryshnikov rehearsing at the Hollywood Bowl.

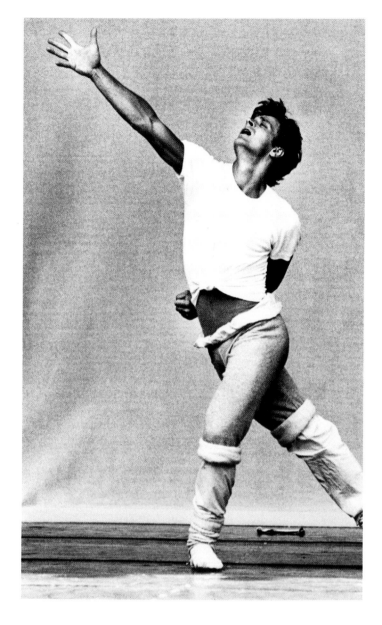

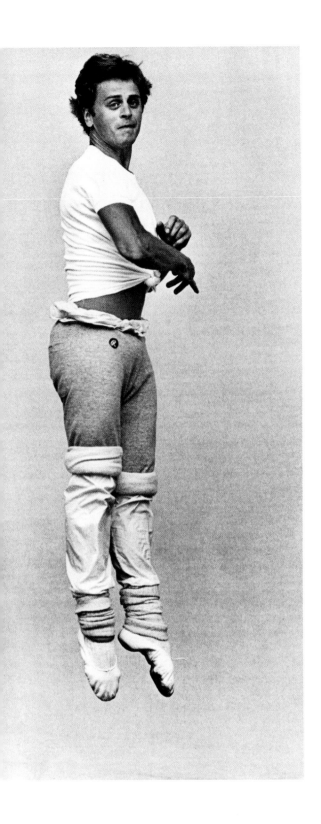

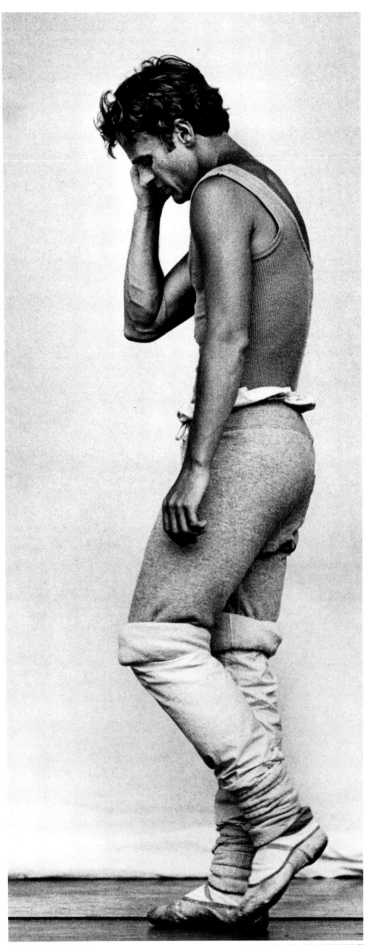

JOSÉ AZEL, MIAMI HERALD

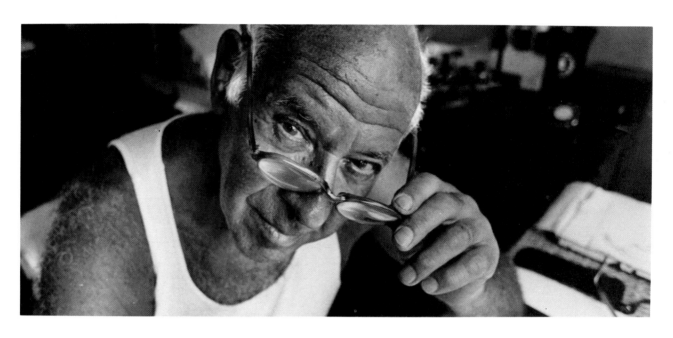

With all of the technological advancements in the printing industry, Max Ettlinger's turn-of-the-century Kluge press is a working antique. Ettlinger still hand sets letterhead stationery and business cards from California job cases of lead type, a scene that may soon retire into history.

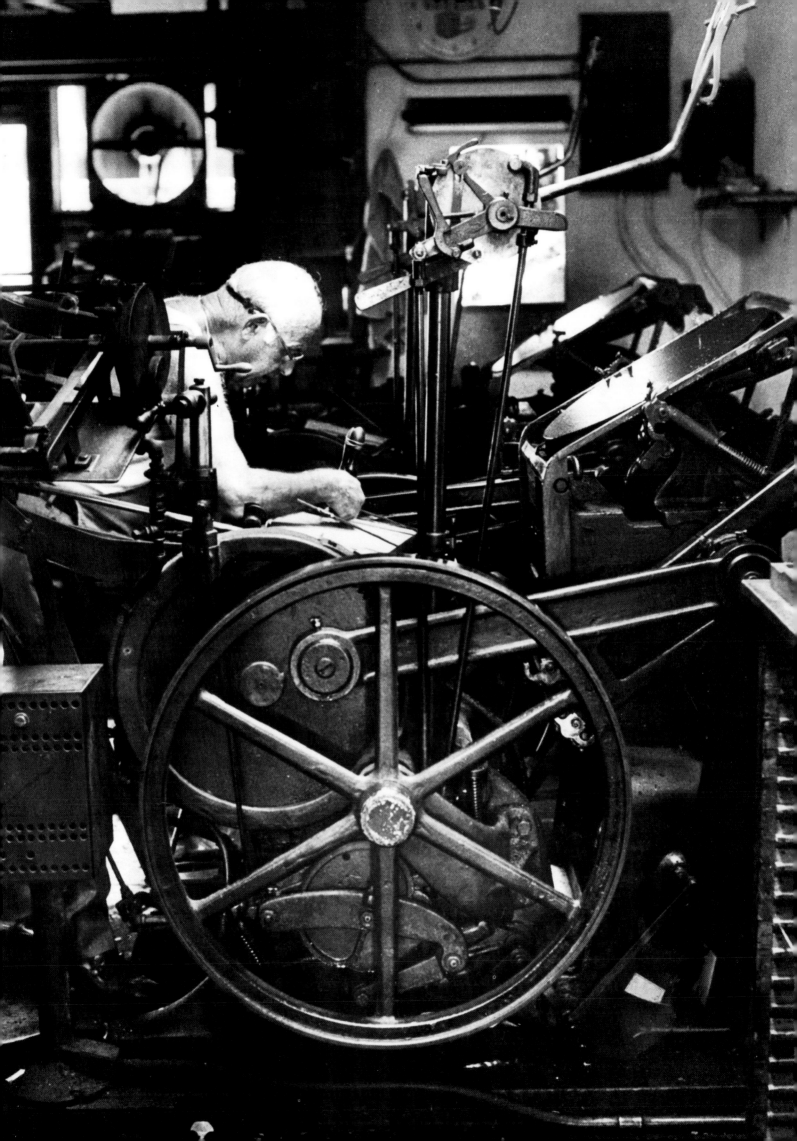

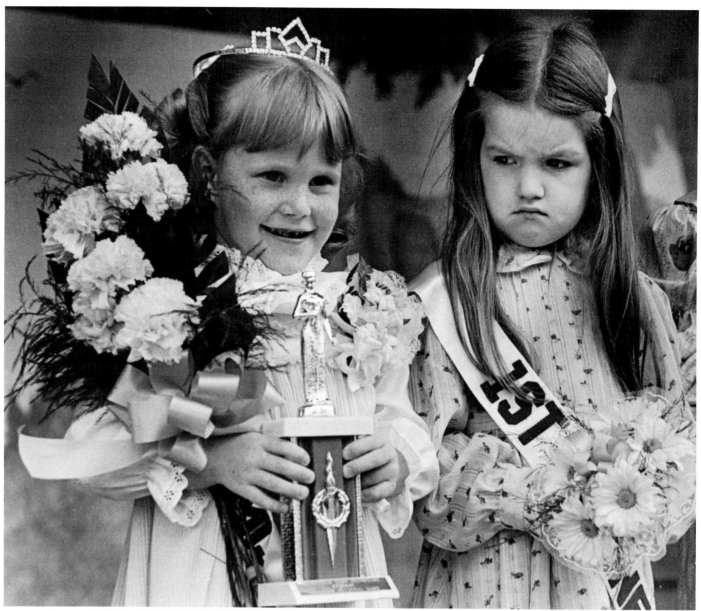

Disappointed because she didn't get to wear the "Little Miss Moonshine" crown, Debbie (right) is not playing the gracious runner-up. The competition was held during an annual festival in New Straitsville, Ohio.

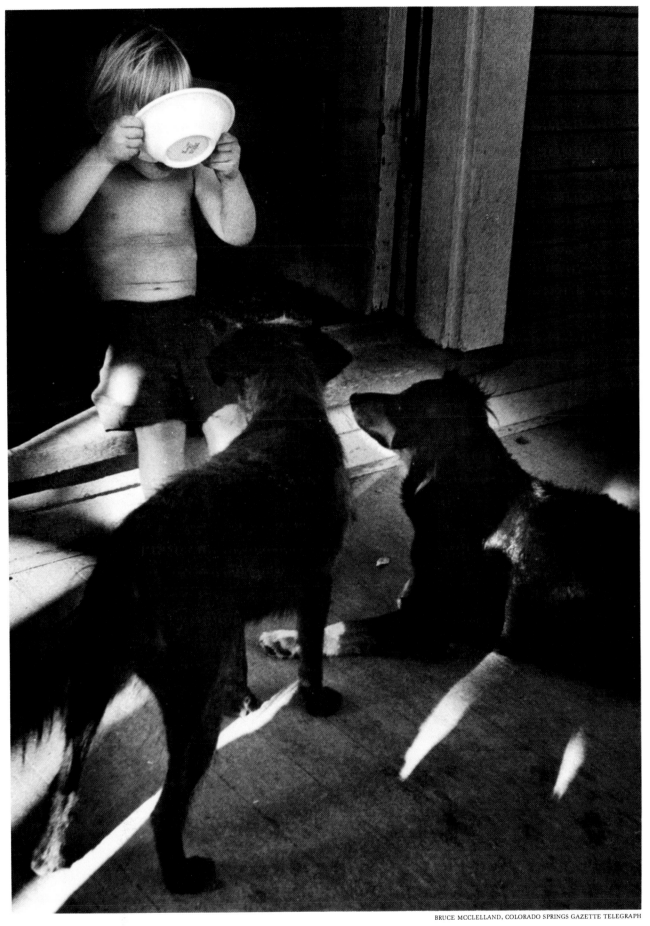

Once this young lad had had his fill, he returned the dish to its rightful owners.

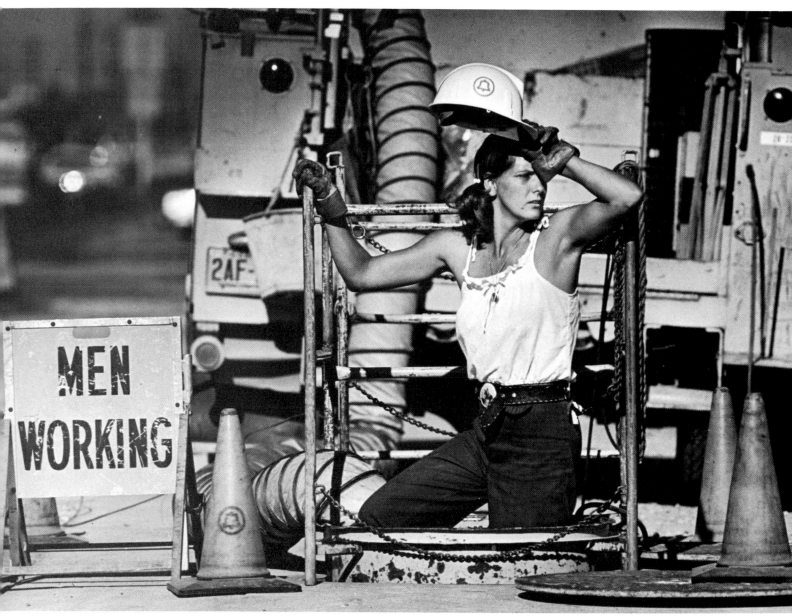

Perhaps Ma Bell in Mesa, Ariz., should consider ordering new signs, in line with more modern hiring practices. The photographer happened on this scene on, of all times, Labor Day.

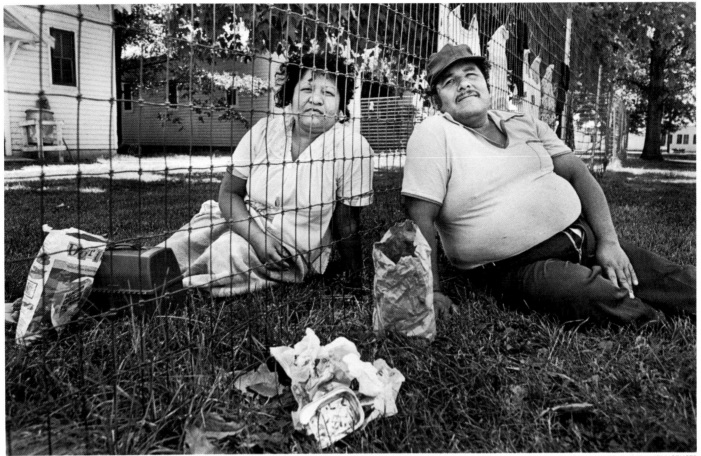

Mr. and Mrs. Rojas, married for many years, share their lunch through a fence dividing the men's and women's migrant farmworkers' quarters in a camp in Dayton, Wash. A shortage of family housing caused this living arrangement. Guillermo and Lydia Rojas pick asparagus, a difficult crop to harvest because of the unusually great amount of stoop labor it requires.

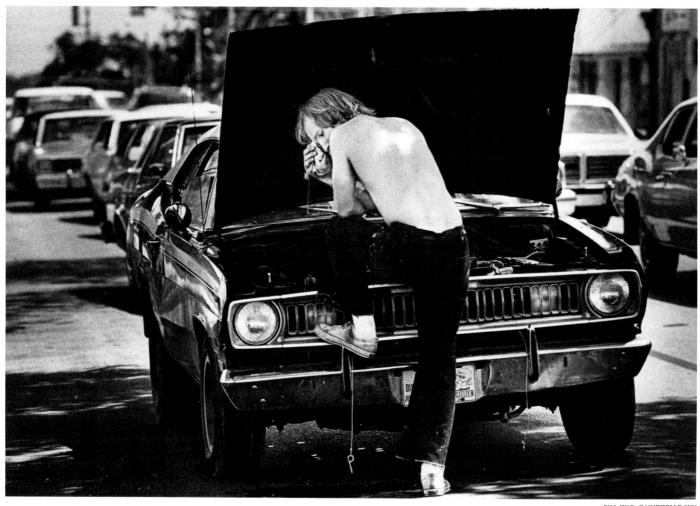

John Sinclair had the misfortune to run out of gas on Gainesville's Main Street during rush-hour traffic. Two policewomen happened along shortly after and eased his dilemma.

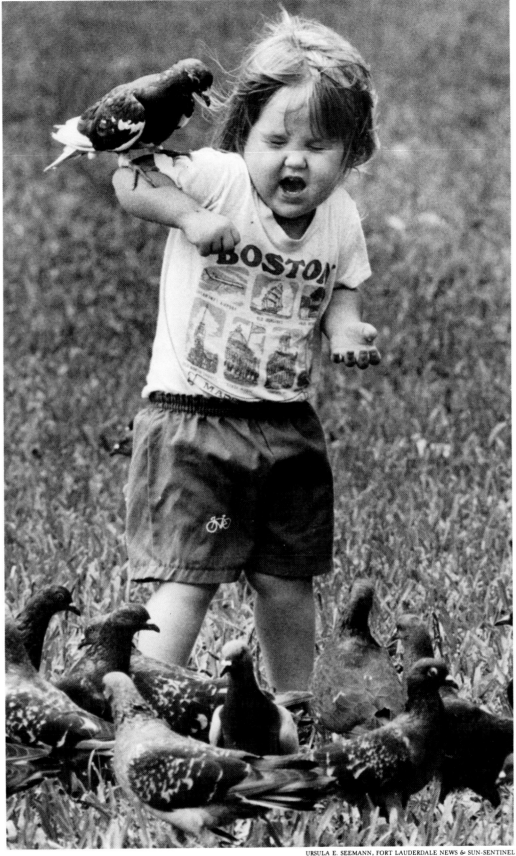

Sara Peck, two years old, has been visiting this Fort Lauderdale park since she was a tiny baby. On this occasion, however, some of her old acquaintances became a little overly familiar.

Taking on the responsibilities of being a big brother is a tough job, especially at age three. Seth David Modersohn first got to know his new sibling be feeling him kick in his mother's belly. Sometimes Seth takes on the role of a parent, by feeding Mark Jacob or by bathing his own doll while Mark gets a bath. Other times he'd rather return to being a baby himself, sitting in Mark's seat and shaking a rattle. When Seth touches Mark, he makes sucking noises with his tongue, the way he does when he holds his old security blanket.

The Crisco Kid—nine-year-old Michael Ray Hammond is the victim of a rare and painful skin disease, epidermolysis bullosa. The disease is characterized by blistering sores, provoked by the slightest touch, and webbed hands and feet. His nickname was coined by the people who love and care for him at Sunland Training Center, Florida's state home for retarded persons, because the best treatment for his infant-sized body is dressings of Crisco, which help keep the sores from becoming infected. Although Michael is not retarded, he has been termed environmentally deprived because of his lifetime confinement to incubators and hospital wards. His only hope for survival is to make it through puberty.

Lee Fryman gives Michael his morning medicine and ends his day with a kiss, the only touch that is not painful to the boy. He seldom complains of his constant pain, but the look in his eyes betrays it.

Since the story was published, Michael's condition has improved enough for him to spend short periods of time in a wheelchair. Readers of the story contributed enough to buy him a waterbed, which has made him much more comfortable.

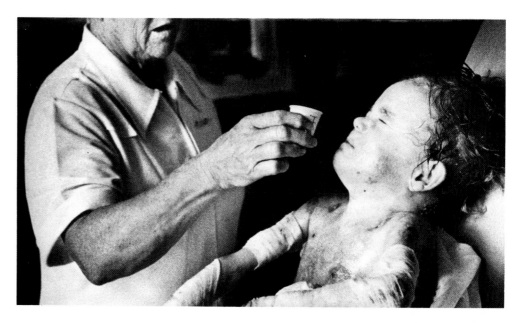

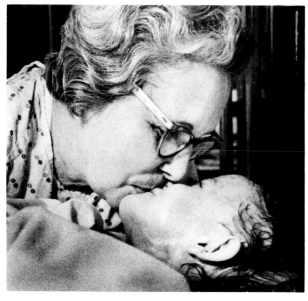

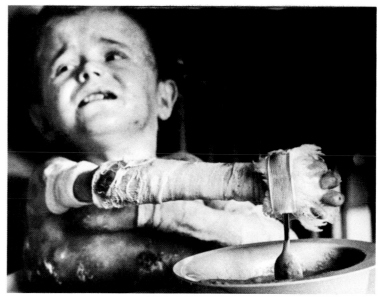

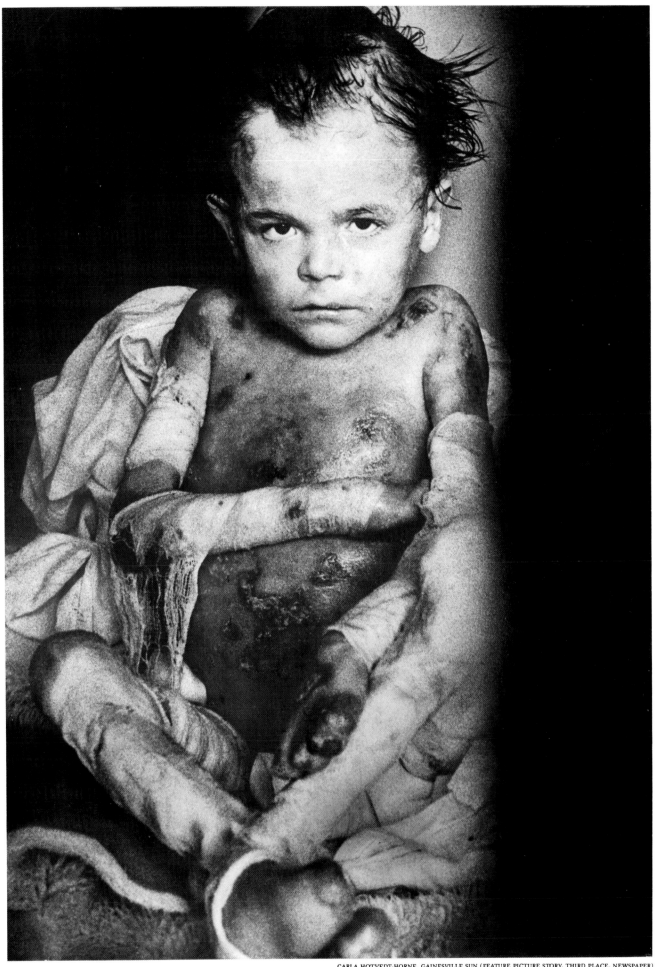

CARLA HOTVEDT-HORNE, GAINESVILLE SUN (FEATURE PICTURE STORY, THIRD PLACE, NEWSPAPER)

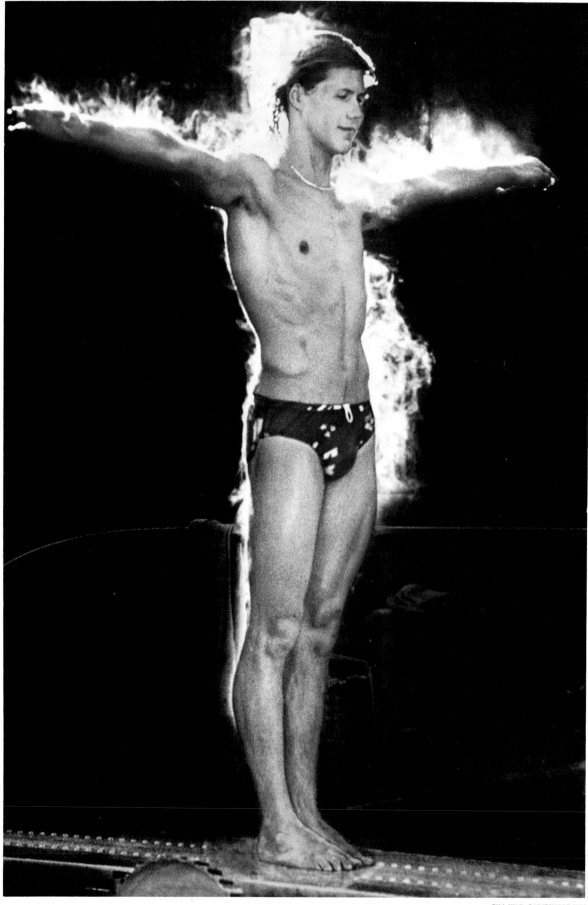

BILL WAX, GAINESVILLE SUN

Haze rising from the heated waters of Florida Pool provides a backdrop for Chris Snode's practice dive on a cold midwinter morning. Snode is a University of Florida all-American diver and the 1978 NCAA diving champion.

# Sports

Unlike many participants in news events, those who participate in sports are there by choice. Thus, the sports photographer takes pictures of people testing themselves, their physical abilities and their physical limitations, rather than being tested by external events beyond their control. At times sports photographers find people conquering these tests; at other times they see them failing. But the camera can capture the moment in an athlete's performance that the naked eye might never discern at all. And those moments captured still, like a swimmer cutting through the water or a high jumper reaching her apogee or a basketball shattering a backboard, recall the movement as well as moving pictures would. They give the photographer with a quick eye endless opportunities to give his work a special form.

Pictures of major team sports are such a regular part of daily reading that it is easy to take them for granted, and there are very few examples of that stock-in-trade in this collection. We have all seen the winning basket or the missed shot that decided the game. But the show in the stands at Arrowhead Stadium in Kansas City, which is a combination of the staged and the spontaneous, is a special treat (pp. 186–87). The interlude with the 'possum at Dodger Stadium is a scene that most baseball fans may have missed (p. 184). These are the sorts of records that give a personality to the individual sports.

The field of sports can always claim its fair share of lively personalities. And some celebrities outside of sports bask in seeing their faces depicted on the playing field. Muhammad Ali has been a pompous celebrity for fifteen years, and although he announced his retirement in 1979 (p. 185), his corner certainly won't be silent. Next to the athlete-turned-entertainer, there is the actor-turned-athlete Paul Newman, taking his place as a race-car driver (p. 190). And Gerald Ford, replacing the Oval Office with the fairway (p. 183).

Whenever people are testing their limits, there is potential for mishap. A small malfunction in equipment or a human error, especially at high speed, can result in tragedy. Spectators are teased by the idea of possible accident in any race; maybe the thrill is in the close calls in which everyone walks away unharmed.

The young amateur athletes, however, give a special dimension to sports. Anyone can empathize with the six-year-old swimmer, whose greatest accomplishment was to finish the race (p. 175). Kelly Finn's antics on the skateboard (p. 172) and Sally Samaya's diving (p. 173) are youthful poetry. It is these pictures, especially, that depict sports in its least complicated and, perhaps, purest forms.

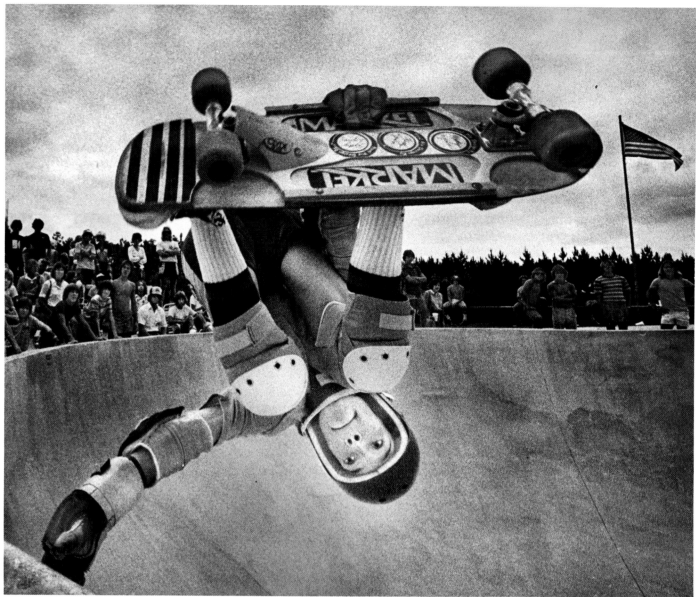

No, this picture is not upside down; but the young athlete on the skateboard is—and in midair! Kelly Finn is demonstrating the form that won him top national ranking among thirteen-year-old skateboarders.

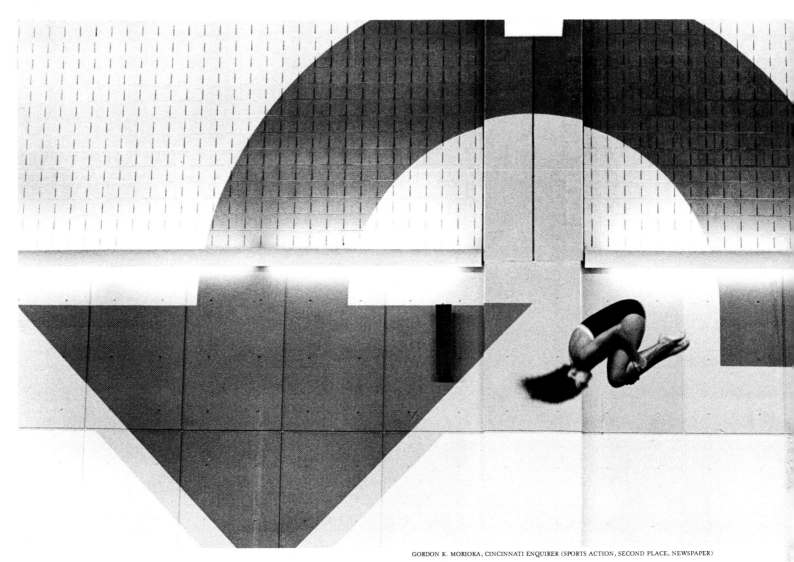

An arched arrow points the way to the water—up and in—especially for Sally Samaya. The graphic illustration is a constant reminder of the correct way to enter the pool for divers at Sycamore High School in Cincinnati, Ohio.

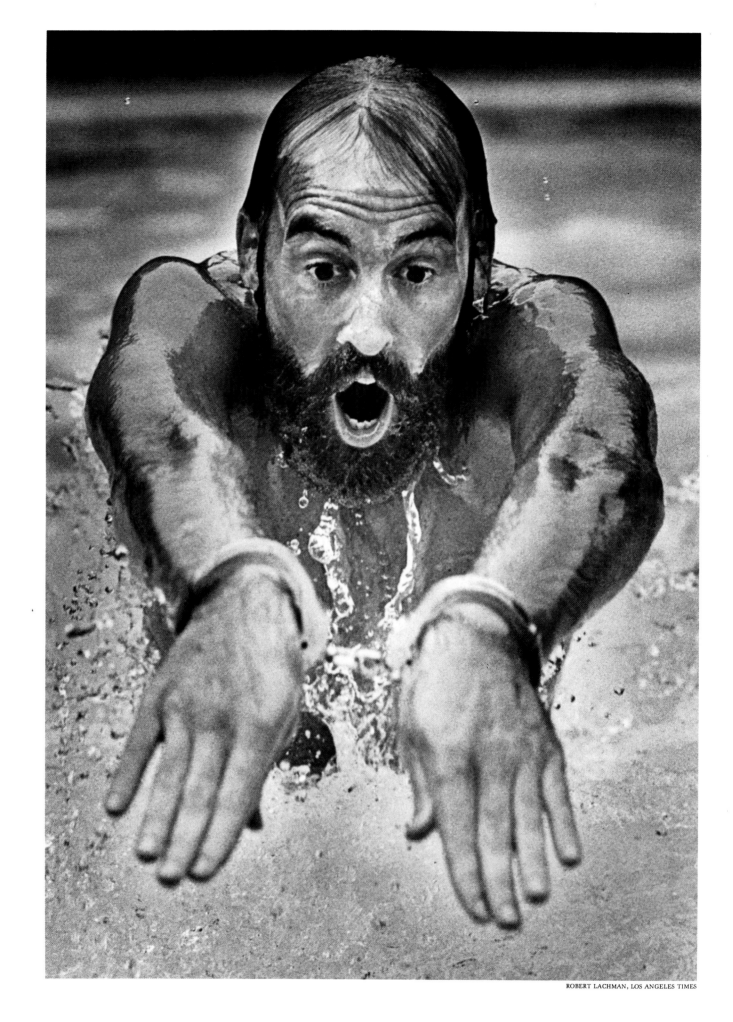

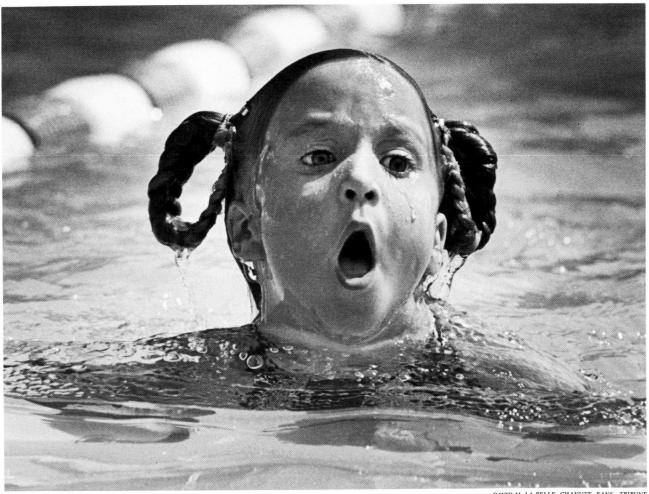

Two swimmers—one a prospective Channel swimmer and one merely strug-
gling to finish a twenty-five-yard heat in a local meet. The handcuffed swimmer
is training for the long swim, while six-year-old Nicole Haley veered off course
and finished in last place. But she did finish.

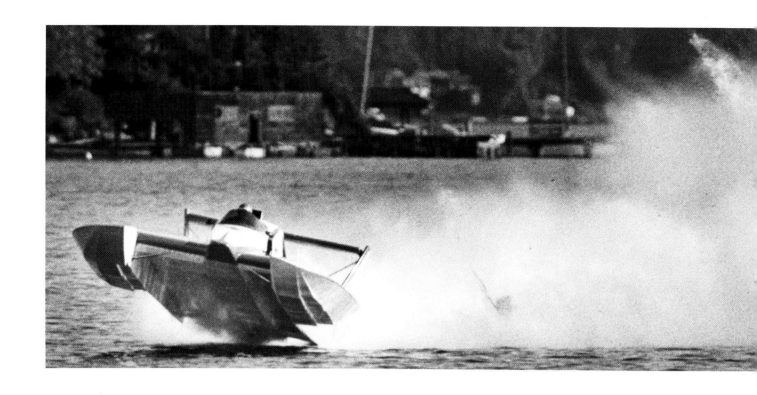

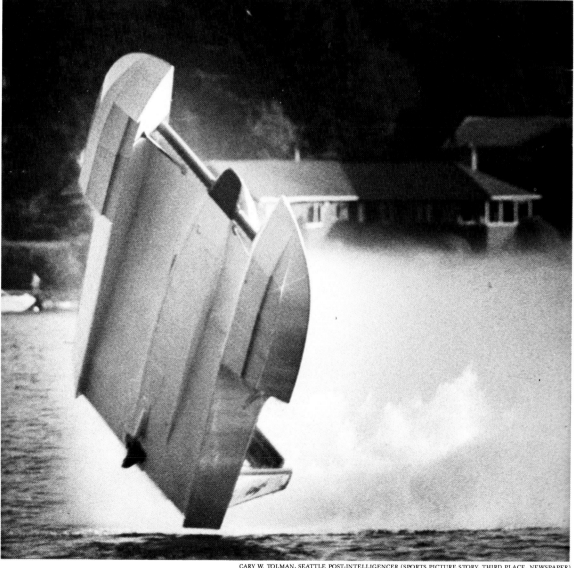

CARY W. TOLMAN, SEATTLE POST-INTELLIGENCER (SPORTS PICTURE STORY, THIRD PLACE, NEWSPAPER)

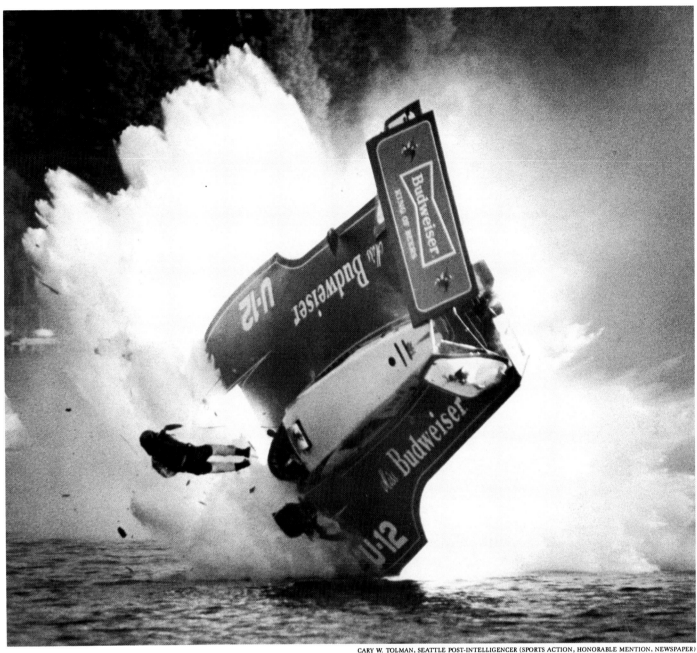

CARY W. TOLMAN, SEATTLE POST-INTELLIGENCER (SPORTS ACTION, HONORABLE MENTION, NEWSPAPER)

Miss Budweiser, driven by Dean Chenoweth, crashes while attempting a record speed run on Seattle's Lake Washington. The boat was traveling at more than 200 miles per hour. Chenoweth was rescued by coast guard personnel shortly after the spill.

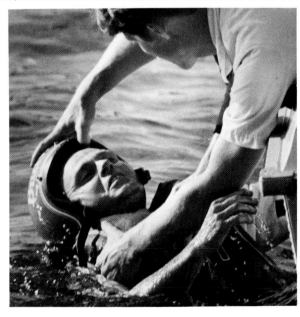

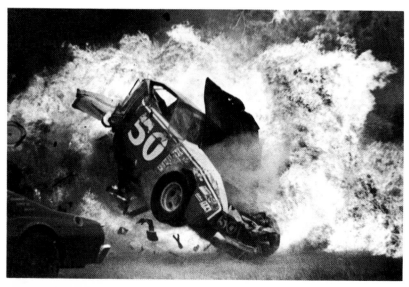

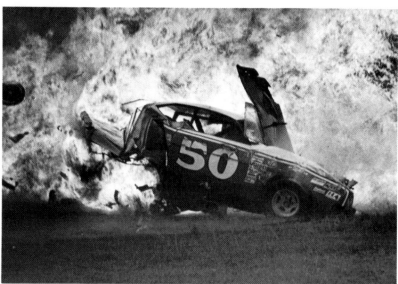

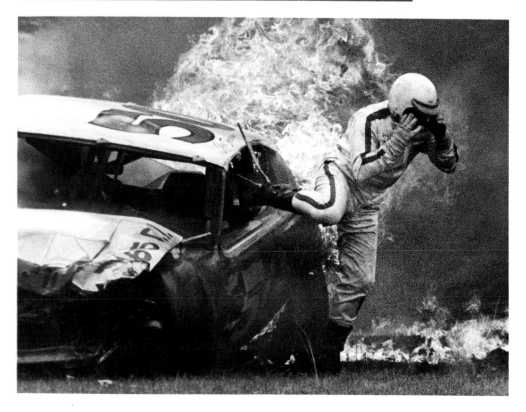

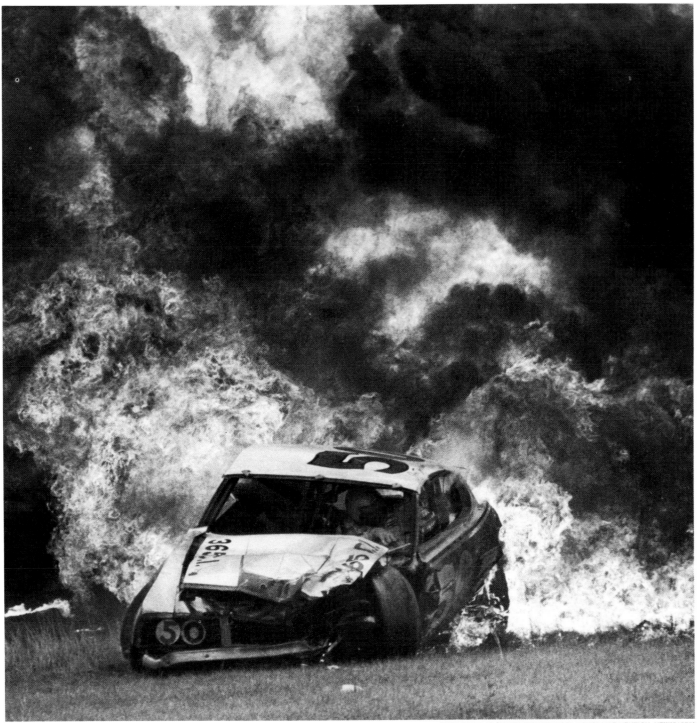

A car exploded after an eight-car wreck during the Sportsman 300 at Daytona International Speedway. The driver, Joe Frasson of Pauline, S.C., escaped his car unharmed, but at least one of the other drivers was seriously injured.

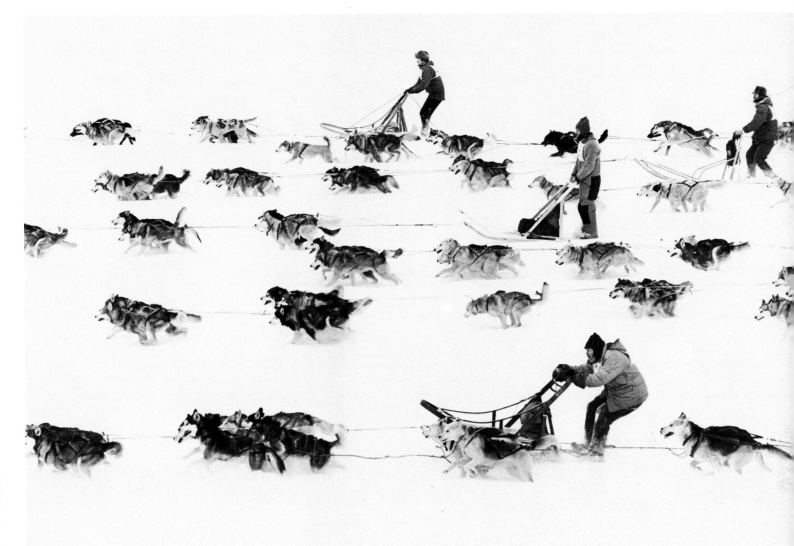

BRUCE BISPING, MINNEAPOLIS TRIBUNE (SPORTS ACTION, THIRD PLACE, NEWSPAPER)

Minnesotans are said to celebrate winter in a way that anyone south of the state cannot understand. Certainly the dogsledders were invigorated at the start of the second day of the Gunflint Trail Mailrun Dogsled Race, held each year in the northern part of the state.

Motocrossing in the mud created this strange bit of statuary from one of the racers. The race was a weekend event in the Athens, Ohio, area in May, and the morning of the race, rain made a mire of this turn on the course.

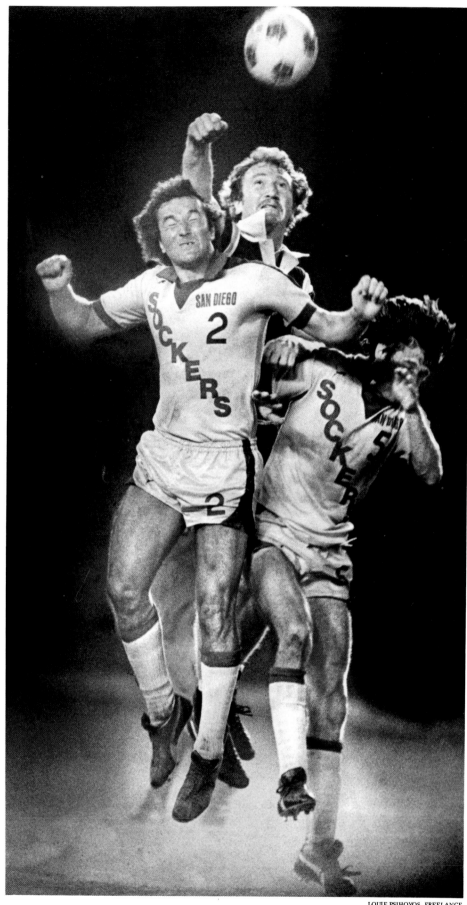

A momentary pyramid was formed as a Philadelphia Fury punched the ball through two San Diego Sockers during a game in the North American Soccer League.

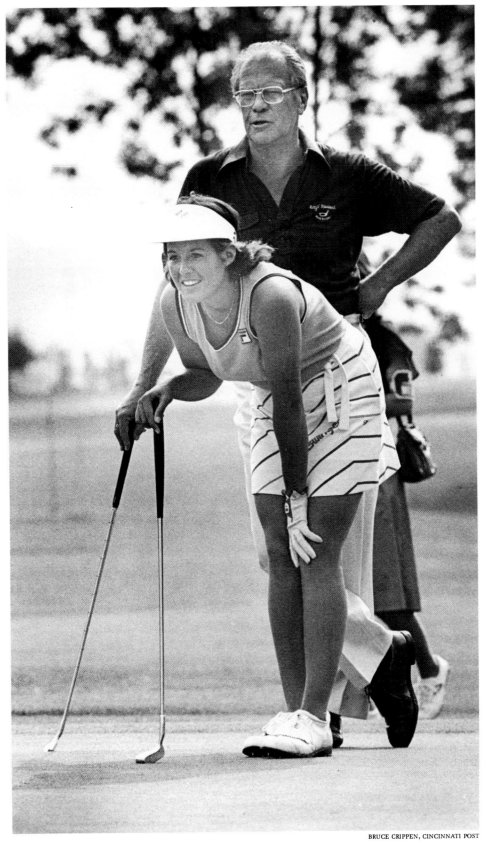

Nancy Lopez lines up the putt of a visiting amateur at the Jack Nicklaus Golf Center in Mason, Ohio. Lopez and Gerald Ford were playing a preview round before the LPGA tournament.

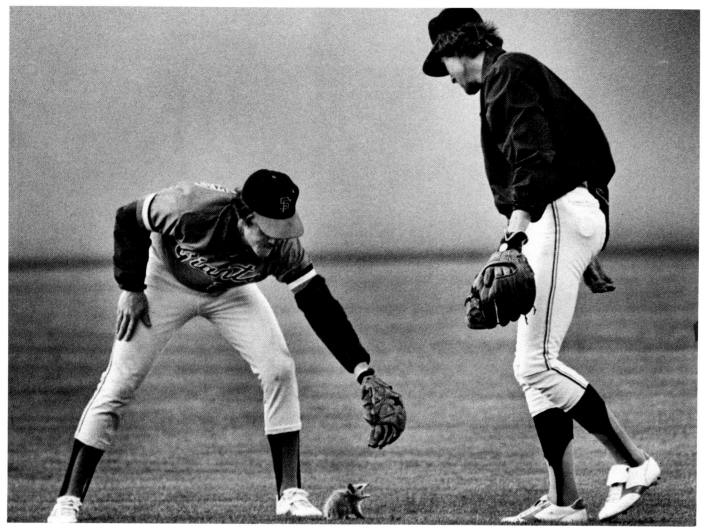

Perhaps the futility of arguing with the umpire led these two Giants to take on a smaller, if no less fierce, adversary. (The two players chased the opossum from the field at Dodger Stadium immediately after the photograph was taken.)

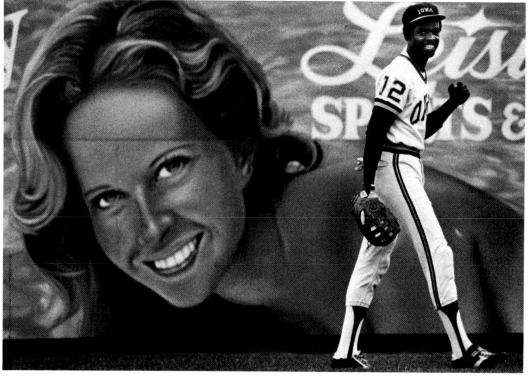

A more attractive visitor to the outfield, the young lady smiles upon the nifty cutoff play made by Iowa Oaks left fielder Thad Bosley.

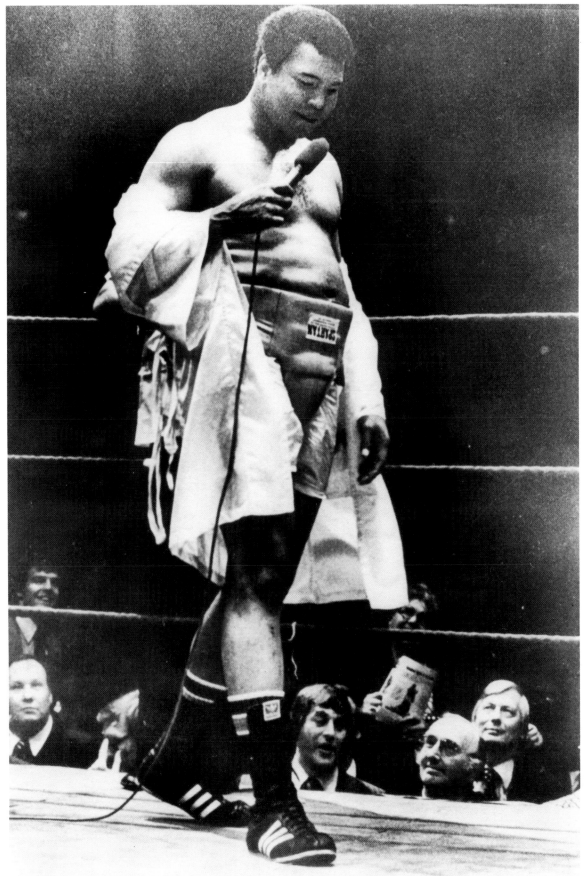

A pear-shaped Muhammad Ali announced his retirement from boxing in Royal Albert Hall, London, in May. His physique a far cry from the youthful Cassius Clay of the Olympics, he also stated that he was relinquishing his World Boxing Association heavyweight title.

A sell-out crowd watched the contest between the Chiefs and the Denver Broncos at Arrowhead Stadium in Kansas City. Part of the show went on in the stands—a conglomerate of sincere rowdies, wierdos, and not-quite sober fans. Crazy George, a paid promoter and rabble-rouser, wears the Number 1 jersey.

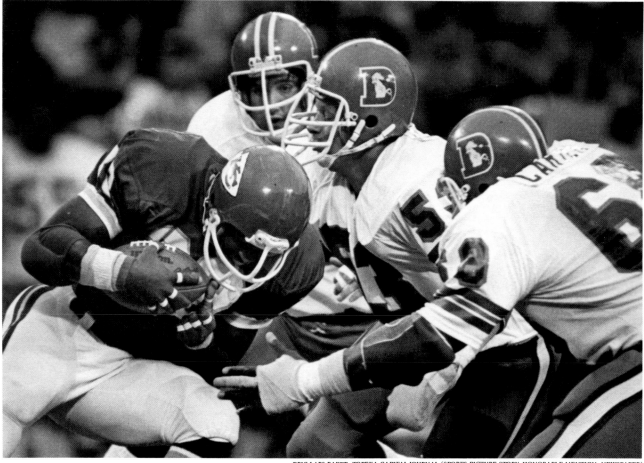

Just like the big guys, Billy Coe III is working out with the University of Cincinnati Bear Cats. Billy Coe, Jr., is one of the team's coaches.

Not all of the bruisers in a football stadium are in the game. This corpulent Michigan fan photographed his team leaving the locker room during the Rose Bowl. One can only imagine that the shaky California soil shook when his team lost.

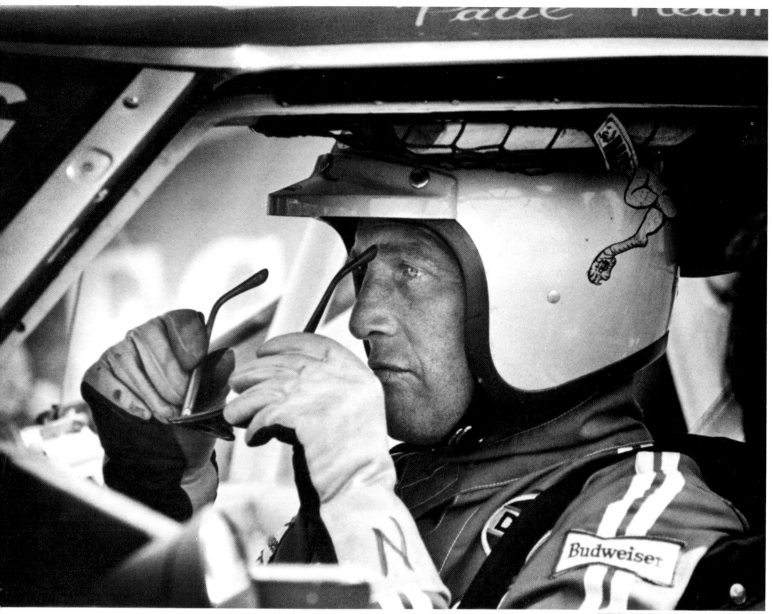

Paul Newman faces a different sort of performance as a race-car driver at the Cumberland National held at Nelson Ledges, Ohio. Newman is a licensed Sports Car Club of America driver and has finished respectably in several prestigious races.

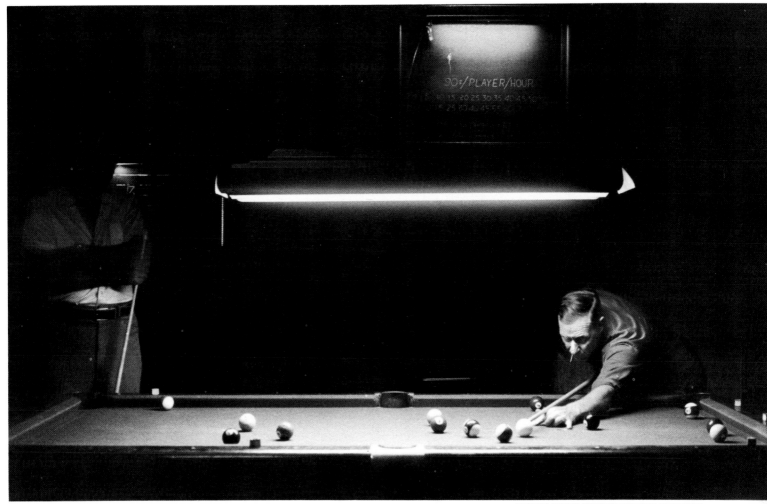

THOMAS J. ONDREY, KETTERING-OAKWOOD, OHIO, TIMES

A pool hall in Dayton, Ohio, during its last days as an all-male hangout. Shortly after the picture was taken, Belmont Billiard Parlor was remodeled, its bar tripled in length, and for the first time in its thirty-seven-year history, women were allowed to enter. Also, the rate is now $1.20 per player per hour.

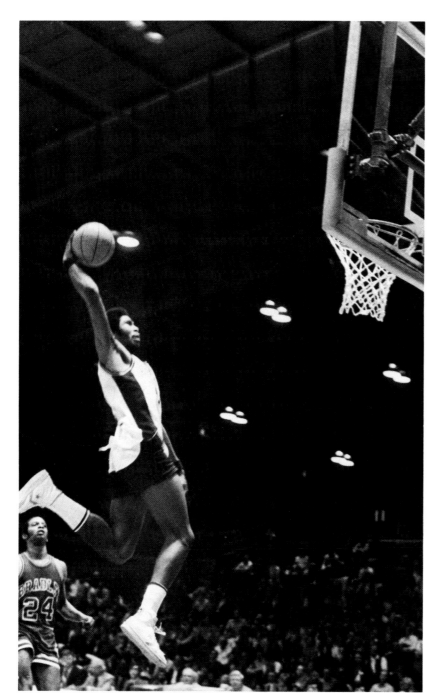
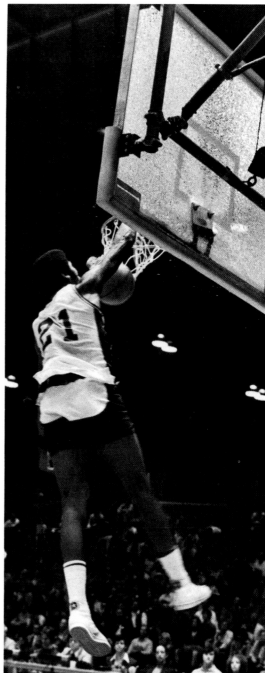

A spectacular shot—but no score! Kevin Spewer of Loyola shattered the backboard at Northwestern during a game between his team and Bradley. Loyola did win the game.

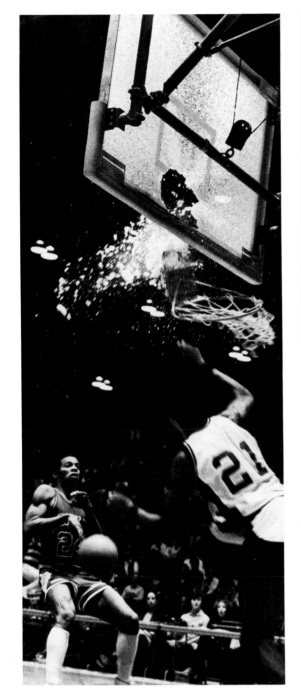
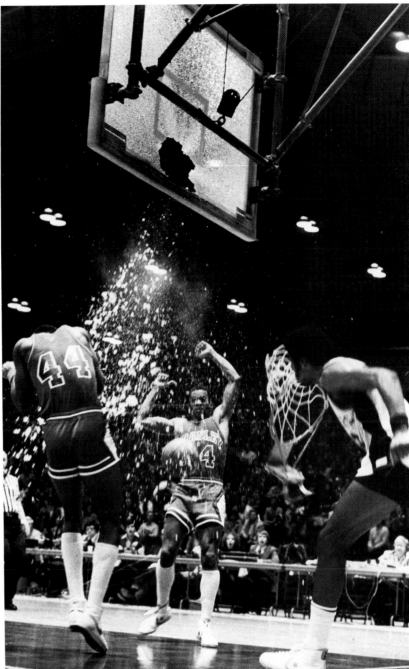

PHIL MASCIONE, CHICAGO TRIBUNE (SPORTS PICTURE STORY, FIRST PLACE, NEWSPAPER)

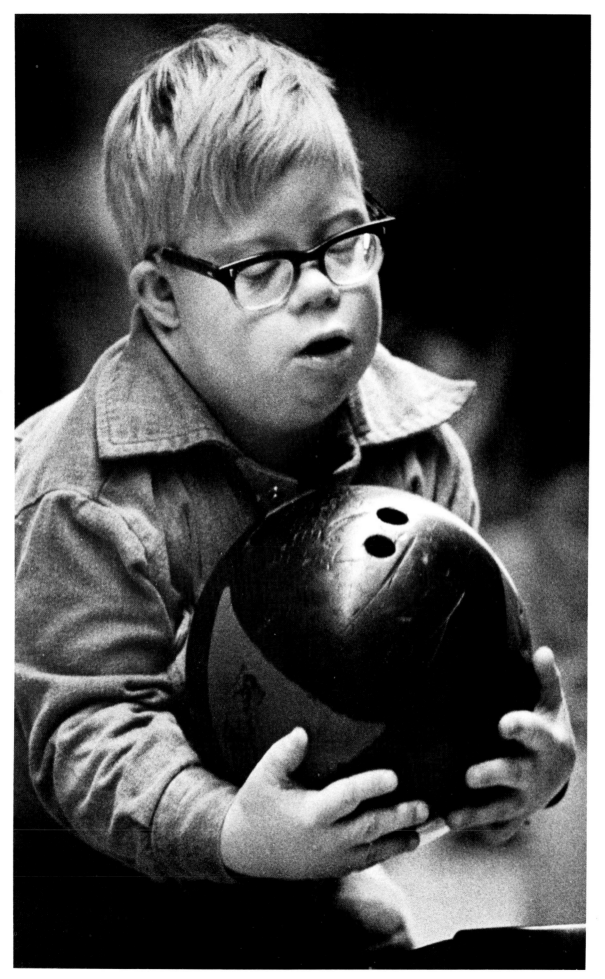

The spirit of determination of this young athlete in the Special Olympics is apparent in every move. Mark, nine, staggered under the weight of his bowling ball, dropped it to the floor with a resounding boom, and gave it his mightiest shove.

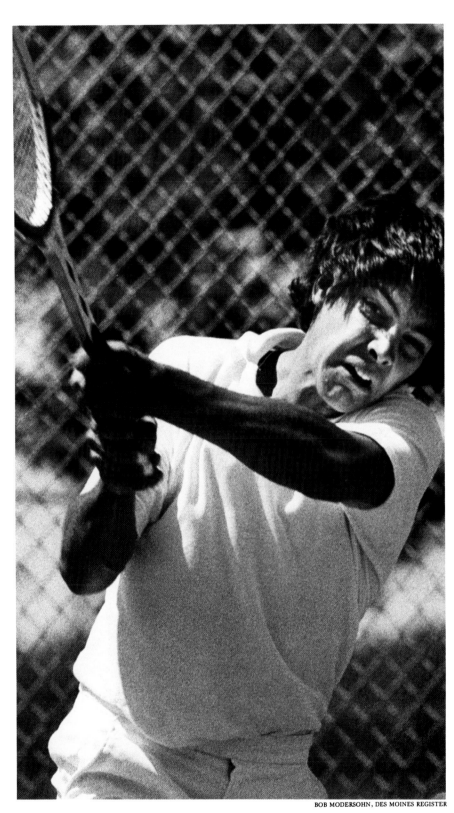

The movement during the volley is caught in the shifting attention of the gallery. Dave Parker volleys with John Stauffer at the Hawkeye Open in Des Moines, Iowa.

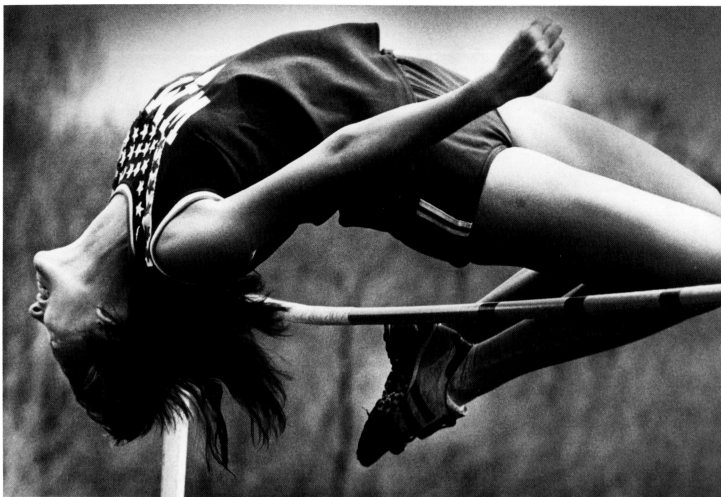

The determination of the young female athlete is demonstrated by Ann Bair, clearing the five-foot, four-inch mark in the high jump during a meet in Morris County, N. J. It's the competitive spirit that distinguishes athletes like her.

Wrestlers come in all sizes — from 400-pound Erland van Lidth de Jeude to 114-pound Dennis Odenbaugh. But even big guys can be beaten by other big guys. Lidth de Jeude was pinned in the first round at the National Amateur Athletic Union Wrestling Tournament at Hilton Coliseum, Ames, Iowa.

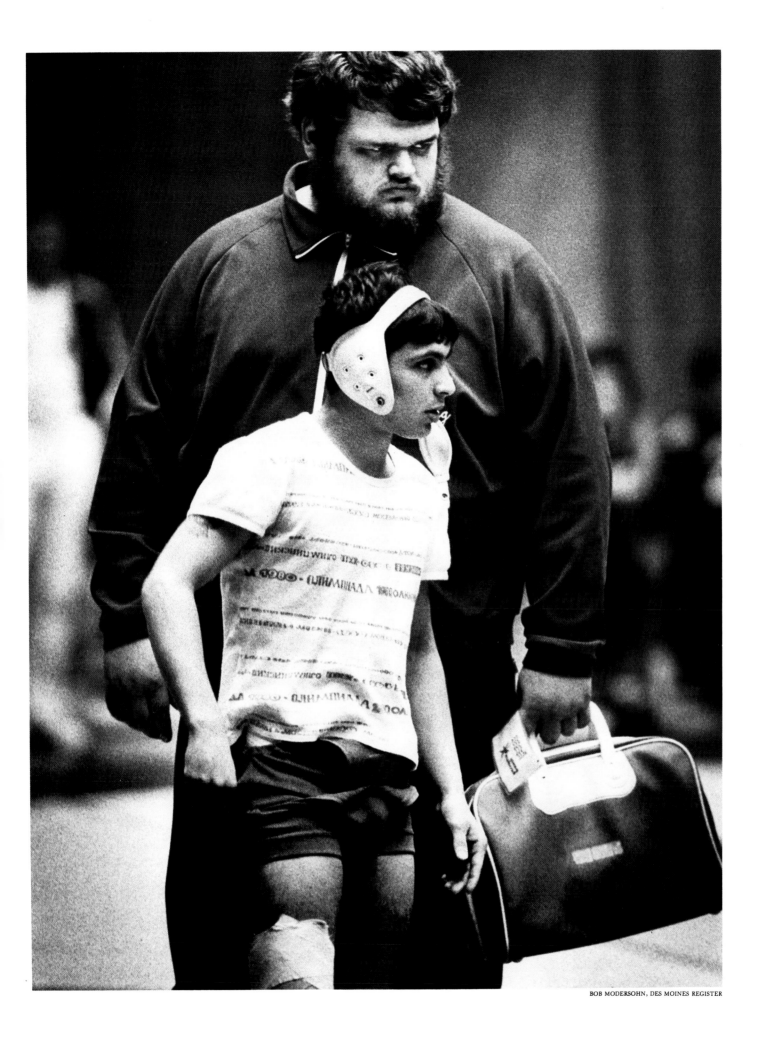

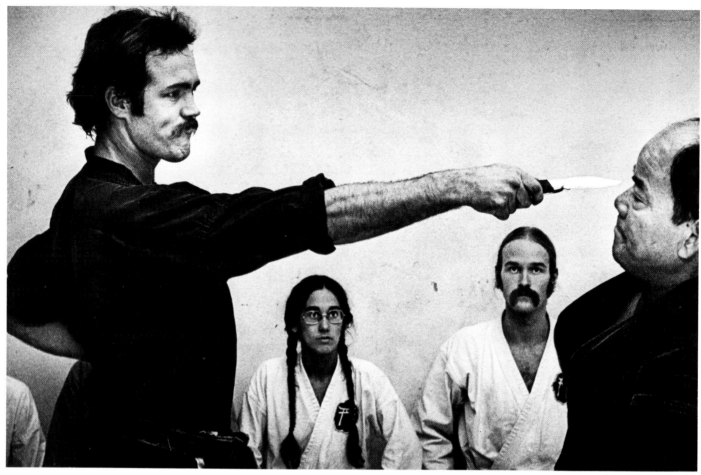

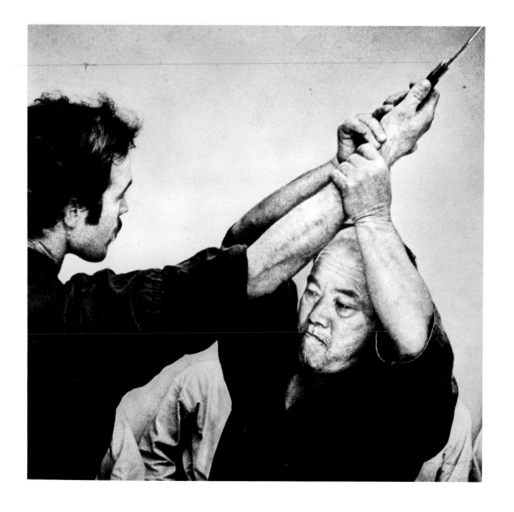

Eizo Shimabukuro, a fifty-three-year-old Okinawan karate master, demon-
strates how his specialty, the style of Shorin-Ryu, might be used to overpower
an armed attacker. Shimabukuro is one of only a handful of the world's
tenth-degree Shorin-Ryu red belts, and, after the demonstration, his student
bows to acknowledge his superiority.

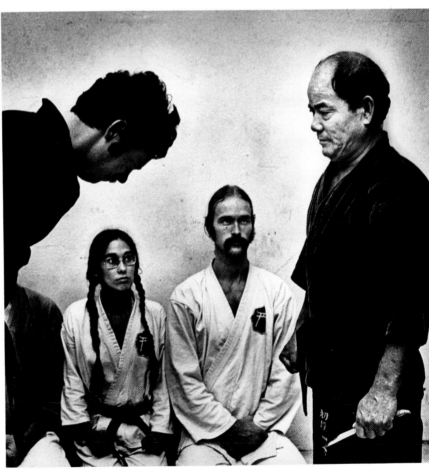

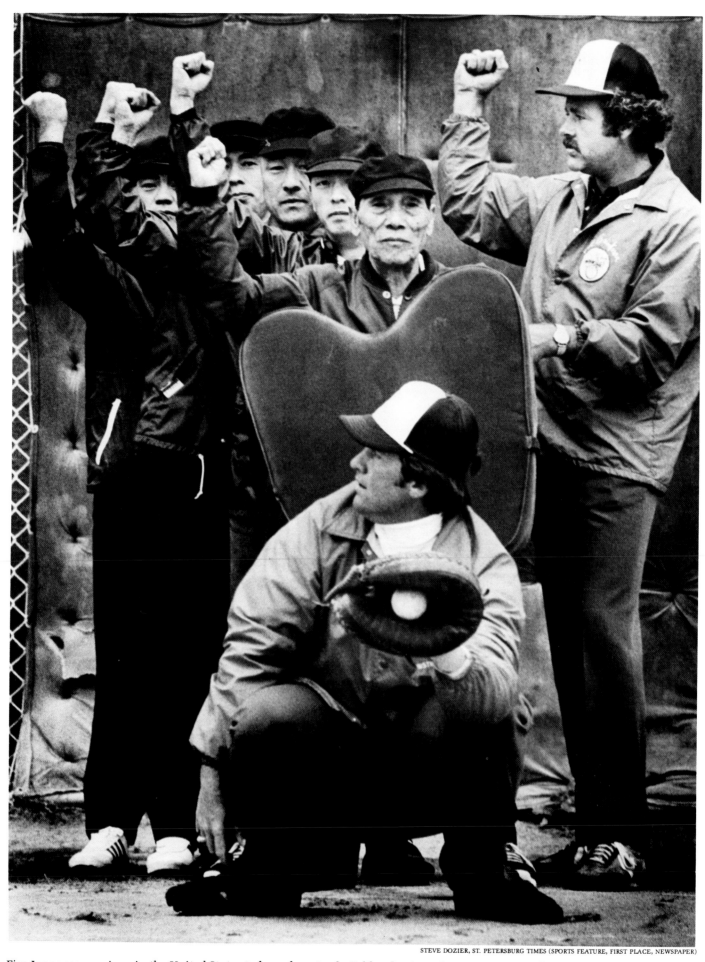

STEVE DOZIER, ST. PETERSBURG TIMES (SPORTS FEATURE, FIRST PLACE, NEWSPAPER)

Five Japanese umpires, in the United States to learn how to do it like the Americans, practice calling strikes.

# People, Portraits, Personalities

It is obvious that all of the photographs in the Pictures of the Year competition—and for that matter all photographs—deal with people and their environs. People are always interested in portraits of themselves. But this particular category demonstrates the photographer's penchant for capturing a new and intriguing aspect of the subject's character.

It would be inappropriate to make any comparison between these photographic portraits and studio portraiture. In many ways these pictures are more objective; in many ways they are more subjective. As any form of artistic expression, these photographs are as much portrayals of the photographers' perspectives as of the subjects.

This year's "People" are most notable for the fact that notables are almost entirely absent from their ranks. (The only exceptions are Kurt Waldheim, Bette Midler, and Ted Kennedy.) Slice-of-life characters and caricatures make this group of photographs especially heartwarming. Benny Kelly the meatpacker (p. 227), Chef Duglass Duglass and his fantastic confection (p. 226), Phil Crothers the blacksmith (p. 221)—these are the pictures of people pursuing their livelihoods, people who are perhaps unsung celebrities in their own rights.

Side by side with ordinary people carrying on their routine existence are ordinary people caught in extraordinary situations, like little Mary Louise Sloseck (p. 211). A lot of these photographs could be drawn from the "Life in These United States" column of *Reader's Digest:* the bride waiting for her wedding party to change a flat tire (p. 212) or "The Pumpkin Lady" from Denton, Tex. (p. 238).

No collection of pictures is complete without a full complement of children and animal pictures. Young children are so unselfconscious before a camera that the range of photographic possibilities is very broad. Whether we view two youngsters showering after a swim (p. 222) or the face of a starving Cambodian child (p. 204), the faces of children are tremendously revealing. And cats, dogs, even ostriches are so innocent with regard to caricature that the temptation to photograph them again and again is irresistible.

The variety of entries in this portrait and personality competition, and the quality of the entries, attests to the photographers' inventiveness and to their dedication to recording expression where they find it. It puts a new turn on a statement made at the turn of the century by Max Beerbohm, an English artist best remembered for his caricature drawings: "It seems to be a law of nature that no man is loth to sit for his portrait." In this case we see that there were no characters whom these photographers were "loth" to record as portraits, that there is a conscious determination to have a visual record of the expressions of people during an enormous range of events.

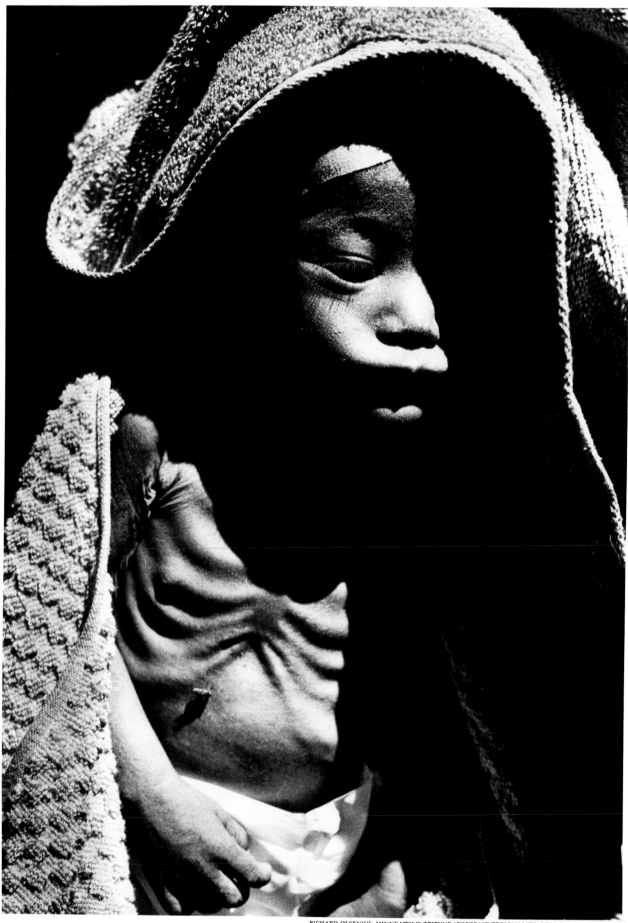

In the intensive-care ward of the refugee camp at Khao-I-Dang, the face of a badly mal-nourished Cambodian child reflects the sorrow felt by the thousands of homeless refugees.

Kurt Waldheim, secretary general of the United Nations since 1972, pauses thought-fully during a question-and-answer session at a Detroit press conference.

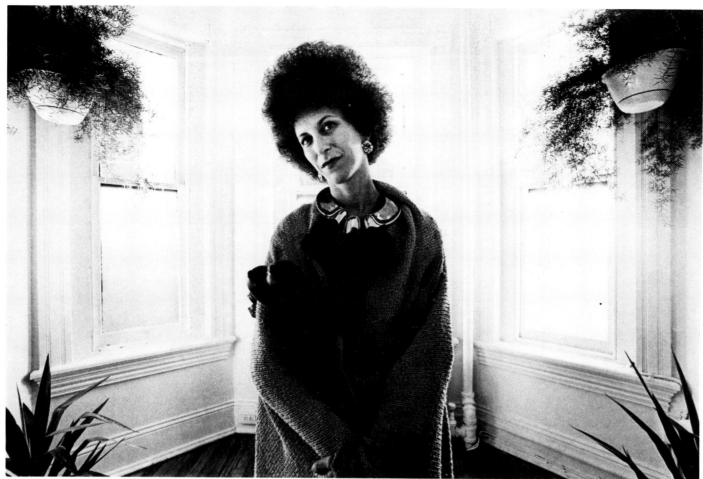

JOHN MCDONNELL, WASHINGTON POST (PORTRAIT/PERSONALITY, THIRD PLACE, NEWSPAPER)

Margie Goldberg, a wood sculptor, poses in the Zenith Gallery, an artists' co-op she manages in Washington, D. C.

When invited to wear an "old costume" to an ice-cream social at a local senior citizens' center, Earl Tyler of Denver was proud to discover that he could still fit into his World War I uniform.

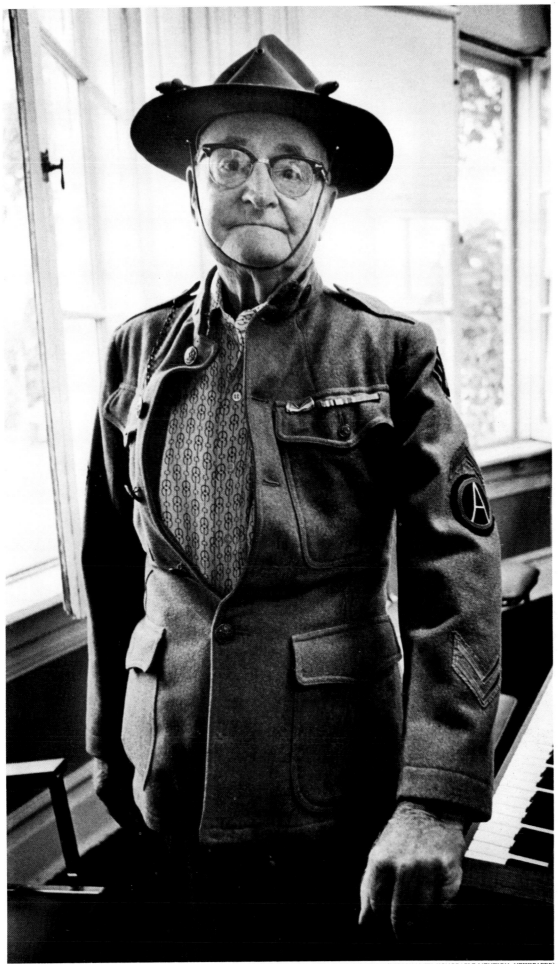

JOSIE LUNDSTROM, FREELANCE (PORTRAIT/PERSONALITY, HONORABLE MENTION, NEWSPAPER)

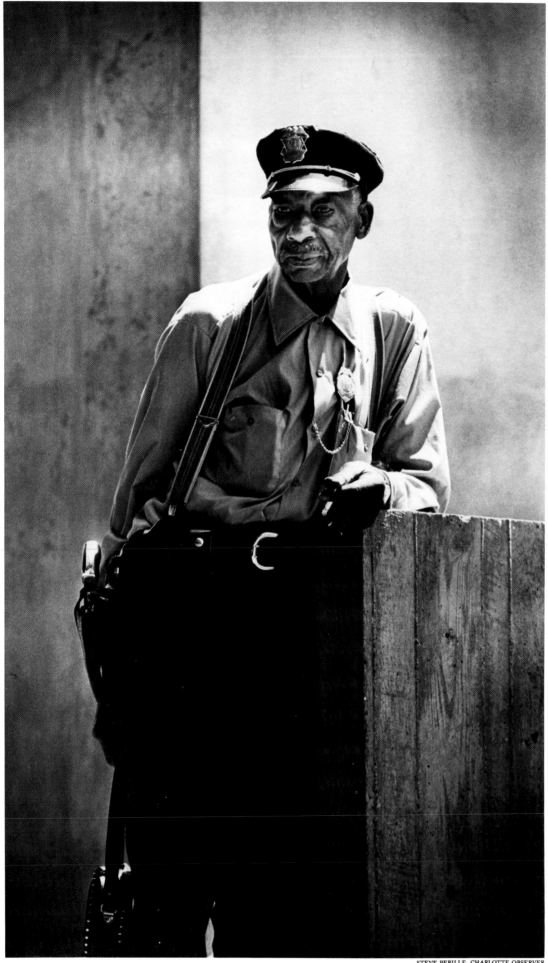

STEVE PERILLE, CHARLOTTE OBSERVER

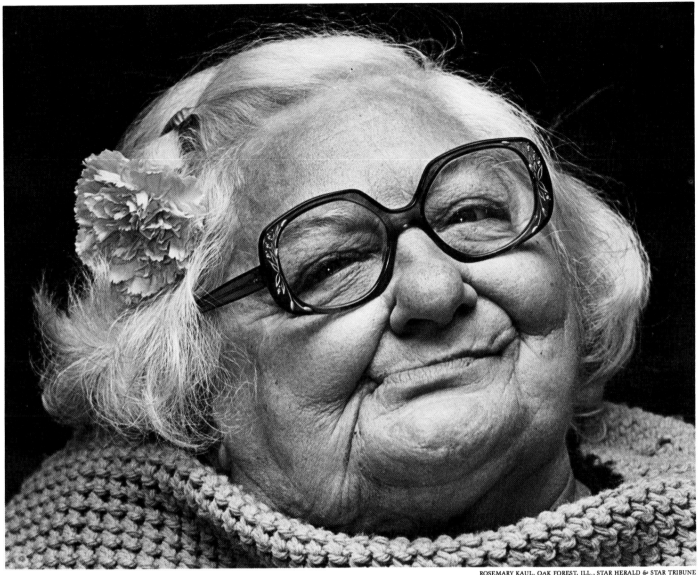

On a rare night out, Kathy Pfeiffer, a resident of Glenwood Terrace Nursing
Home in Glenwood, Ill., is entranced by a scene from William Inge's *Bus Stop*,
performed at Thornwood High School in South Holland, Ill.

During a free moment, a guard pauses for a cigarette in a park in Charlotte, N.C.

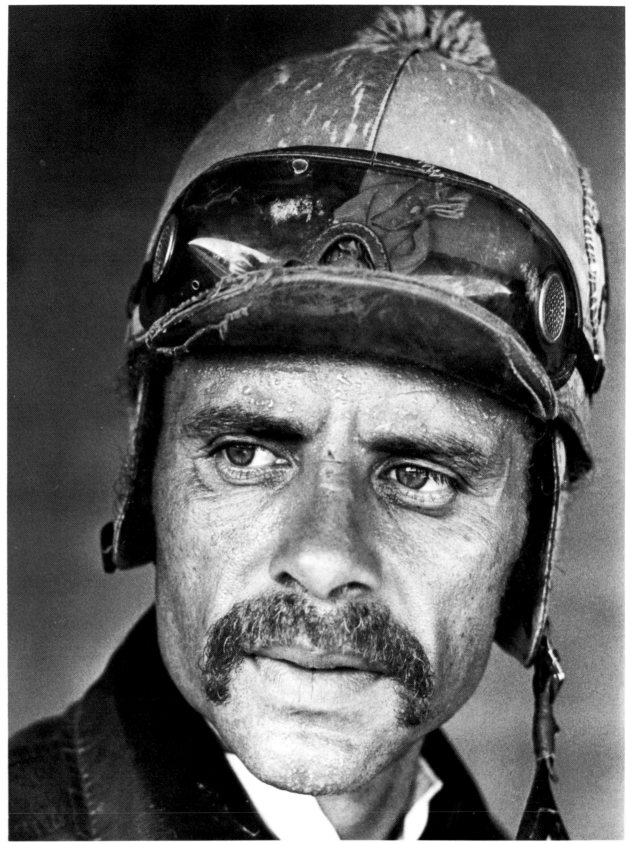

Alexander Monell, one of the top jockeys at the Juarez, Mexico, racetrack, relaxes in the barns after a workout. Monell, who has at various times been an animal trainer and a prize fighter, suddenly decided to realize an old fantasy, and at age forty-one became a jockey. "It's easy for somebody to go on a diet and lose twenty to twenty-five pounds," says Monell, "but see if you have enough strength to bend down and pick up your pants."

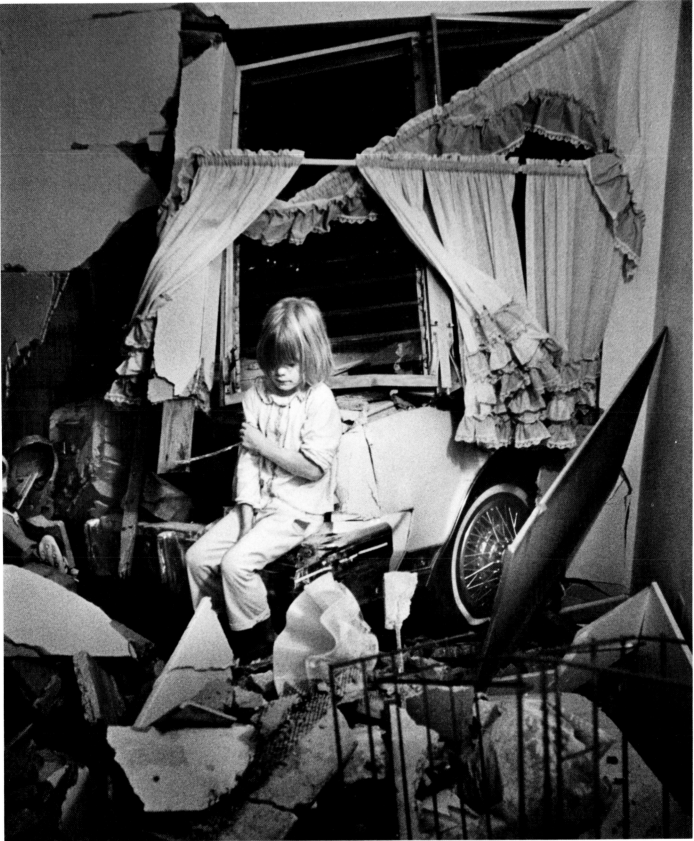

Mary Louise Slosek of Gainesville, Fla., sits in bewilderment on the bumper of a car that only moments before had smashed through her bedroom wall.

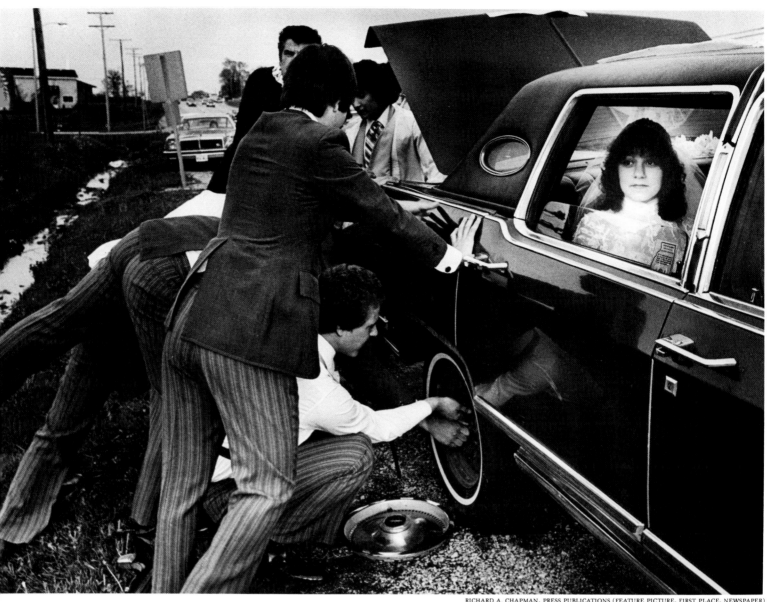

RICHARD A. CHAPMAN, PRESS PUBLICATIONS (FEATURE PICTURE, FIRST PLACE, NEWSPAPER)

This Bloomingdale, Ill., woman had expected marriage to have
its ups and downs, but a flat tire on the way to her own wedding
reception was a little more than she had bargained for.

Muriel Nelsen, of South Lake Tahoe, Calif., had a great time one Saturday
afternoon rummaging through the clothes in a second-hand store.

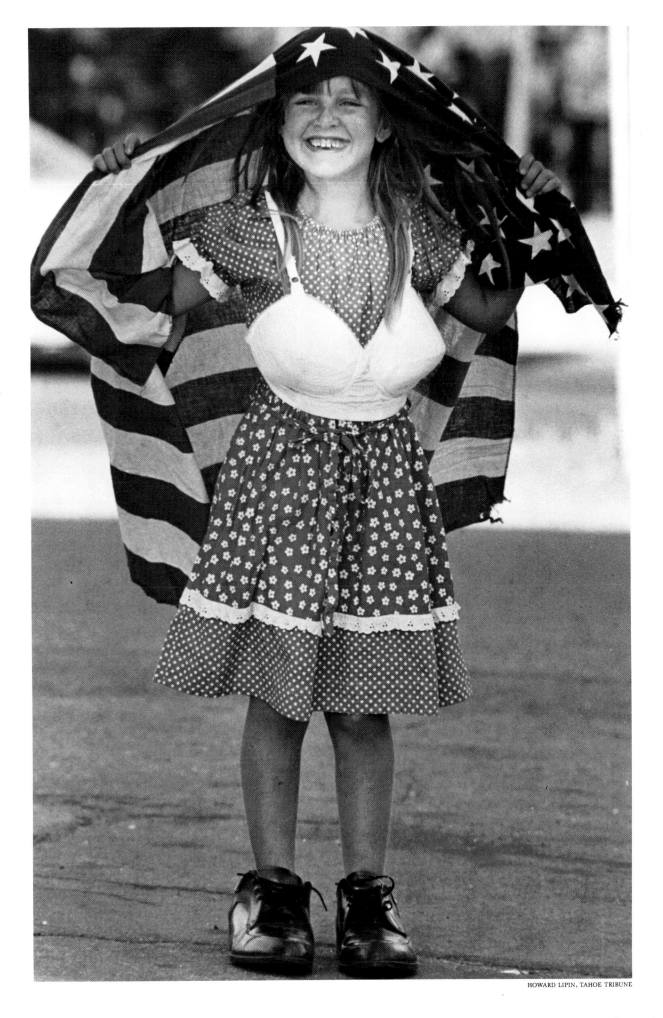

HOWARD LIPIN, TAHOE TRIBUNE

People, Portraits, Personalities / 213

Fine Sunday Dude, a quarter horse belonging to Stan
Hansen of Randall, Iowa, nuzzles his friend the goat.

A homeless sheepdog posed endearingly for the camera at the humane society in Columbia, Mo.
His efforts were not in vain, for he was adopted the day after the picture ran in a local paper.

LOUIE PSIHOYOS, COLUMBIA MISSOURIAN (FEATURE PICTURE, HONORABLE MENTION, NEWSPAPER)

MICHAEL HAYMAN, FLINT, MICH., JOURNAL (PORTRAIT/PERSONALITY, SECOND PLACE, NEWSPAPER)

On their three-hundred-acre farm near Flint, Mich., Joe and Jean Wazney pose with their nine children and an assortment of their animals. Joe Wazney also works full time at an automobile foundry in Flint.

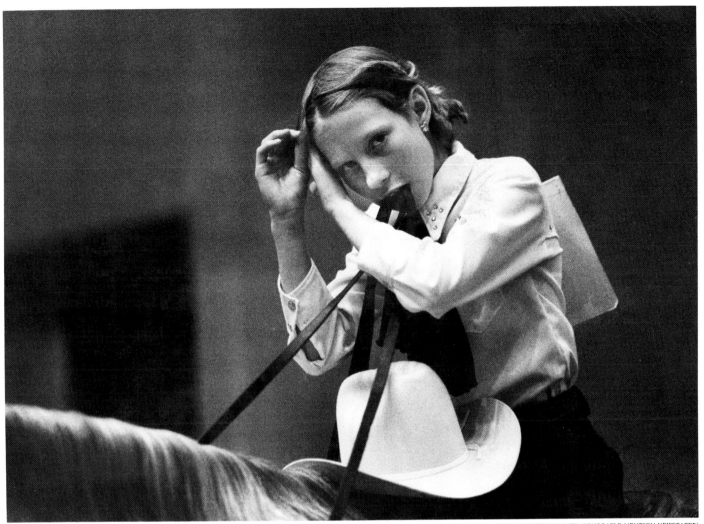

JAY B. MATHER, LOUISVILLE COURIER-JOURNAL (PORTRAIT/PERSONALITY, HONORABLE MENTION NEWSPAPER)

Twelve-year-old Pam McKnight of Meade County, Ky., makes sure her hair is secure before entering the ring to compete in the Western Riding Class of the Kentucky 4-H Horse Show held in Louisville in August.

Just another stupid cat picture.

"Want to neck?" asks a romantically inclined male ostrich of his lady friend at the Philadelphia Zoo.

GERALD S. WILLIAMS, PHILADELPHIA INQUIRER (PICTORIAL, HONORABLE MENTION, NEWSPAPER)

People, Portraits, Personalities / 219

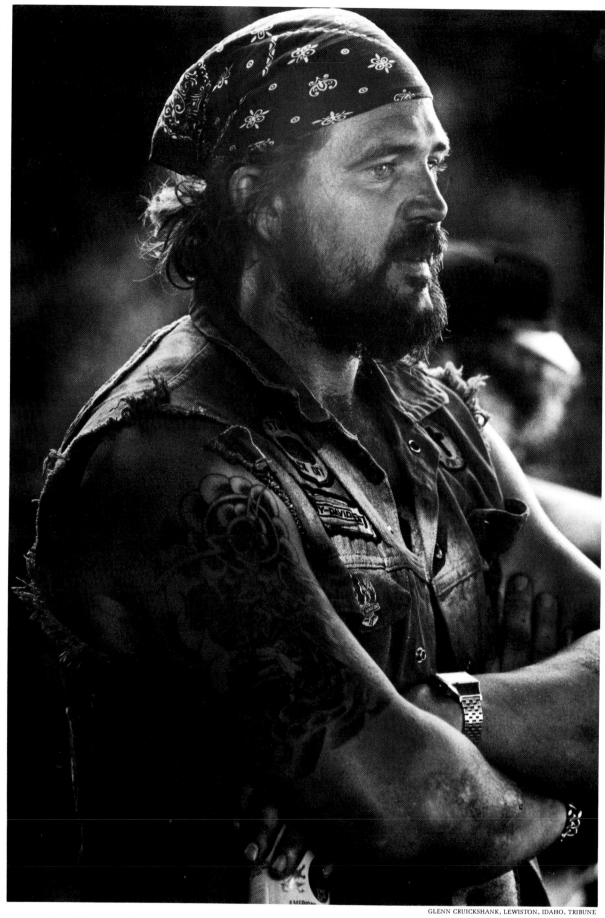

A Canadian biker watches his companions during a bikers' weekend in northern Idaho. Unlike most American bikers, many Canadian bikers hold down white-collar jobs during the week. This man apparently forgot to remove his gold watch when he switched to his weekend identity.

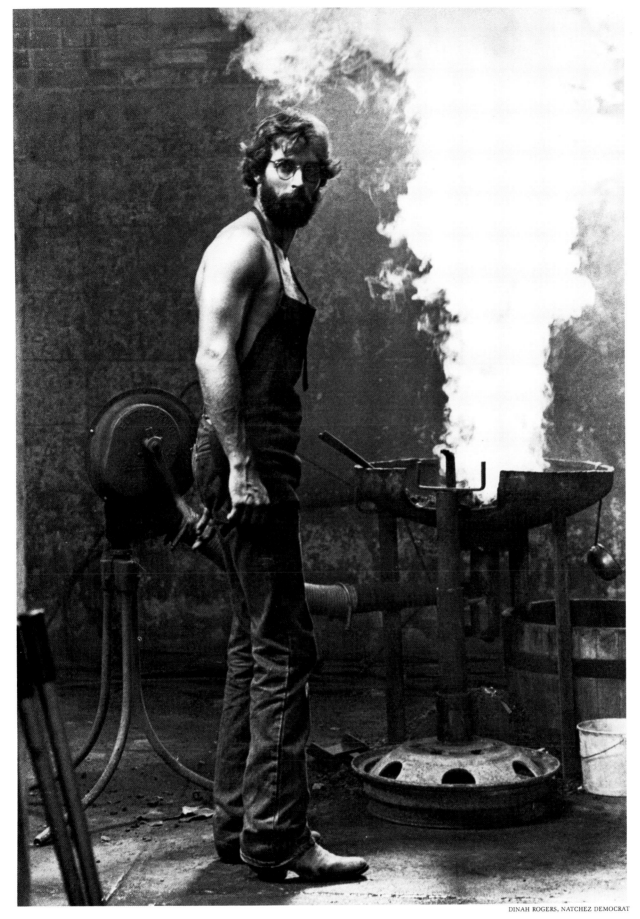

In an old boiler room behind the Mississippi Central Depot in Natchez, Miss., Phil Crothers uses his grandfather's antique tools—some of them handmade—to pursue his career as one of the nation's few remaining blacksmiths.

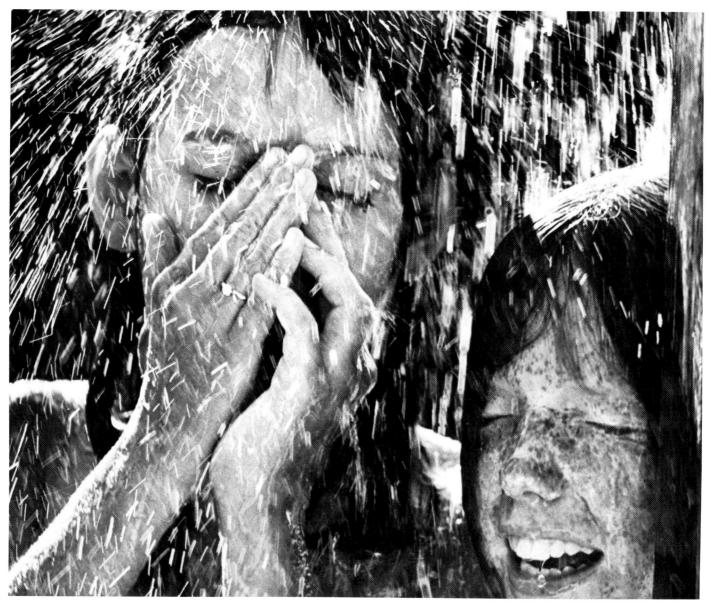

Two youngsters shower off after a dip in a swimming pool in Gainesville, Fla.

Ranked by the World Boxing Association as a top contender for the light heavyweight title of the world, James Scott, an inmate at Rahway State Prison in Rahway, N.J., faces thirty to forty years for armed robbery.

After a breakfast that included three dozen eggs, three pounds of sausage, and a gallon of milk, Larry Gordon Tillery, alias Jolly Jack, greets onlookers on the midway at the Iowa State Fair in Des Moines. For two dollars, Jolly Jack will prove that he can indeed stand up.

Although he looks worried enough, this rabbit is not being sold as anyone's dinner. Actually, he is being weighed by the registrar at a pet show.

In Southfield, Mich., a suburb of Detroit, Chef Duglass Duglass, of the Restaurant Duglass, prepares one of his specialties, a "strawberry staircase."

At five o'clock A.M. in eastern Detroit, Benny Kelly loads sides of beef onto a delivery truck. Kelly is a meatpacker at one of the largest meat processing plants in Detroit, where over 100,000 pounds of beef are cut each week.

RICH FRISHMAN, EVERETT HERALD

The Pope's visit to Chicago in the summer brought out not only
the faithful, but also those in search of another kind of profit.

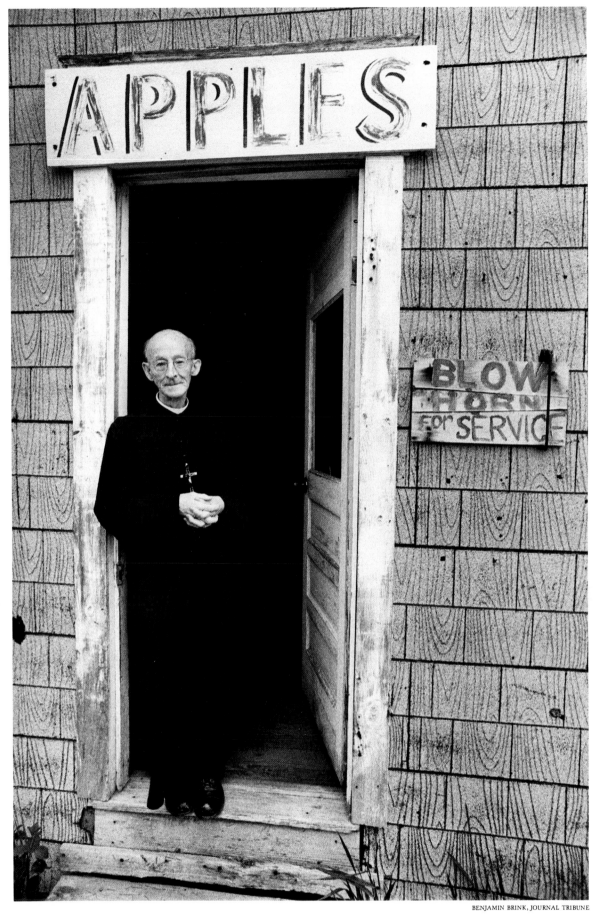

Brother George, of the Brothers of Christian Instruction in Alfred, Maine, is a man at peace with himself and with the world. Since his retirement as an instructor at the brothers' teaching institute, his job has been to care for and sell the apples grown in the brothers' orchard.

ERICA BERGER, GAINESVILLE SUN (FEATURE PICTURE, SECOND PLACE, NEWSPAPER)

Although this woman looks happy enough to be in heaven, she's actually in the Crazy Horse Saloon in North Miami Beach, Fla., where male stripteasers perform nightly for a primarily female audience. The women are not allowed to touch the men, but if they like them they can slip money into their G-strings.

Bette Midler sings up a storm at a concert in Los Angeles.

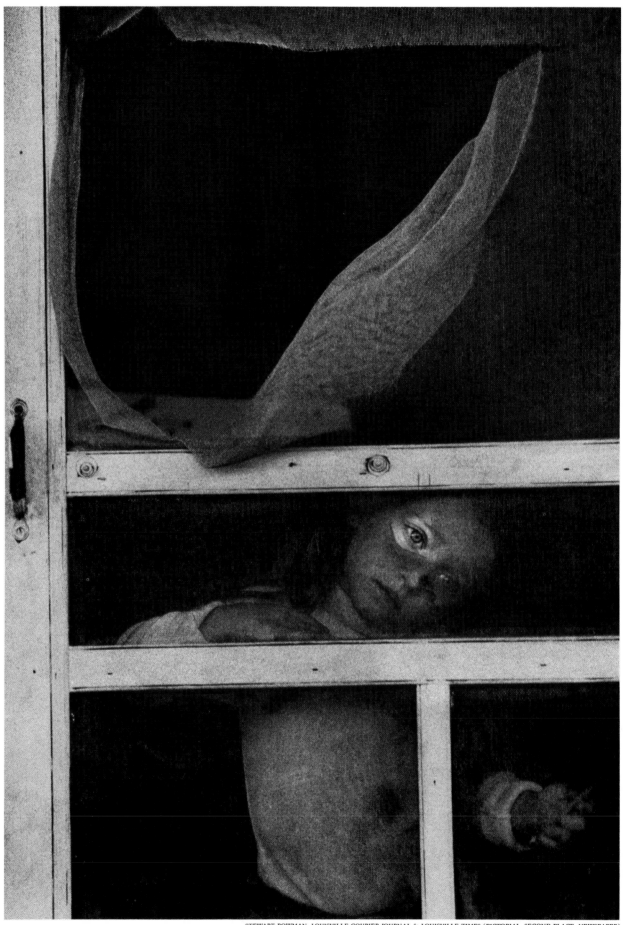

Ten-year-old Tabetha Greer has found a doorway to daydreams as she stares at sidewalk construction going on in front of her family's house in Louisville, Ky.

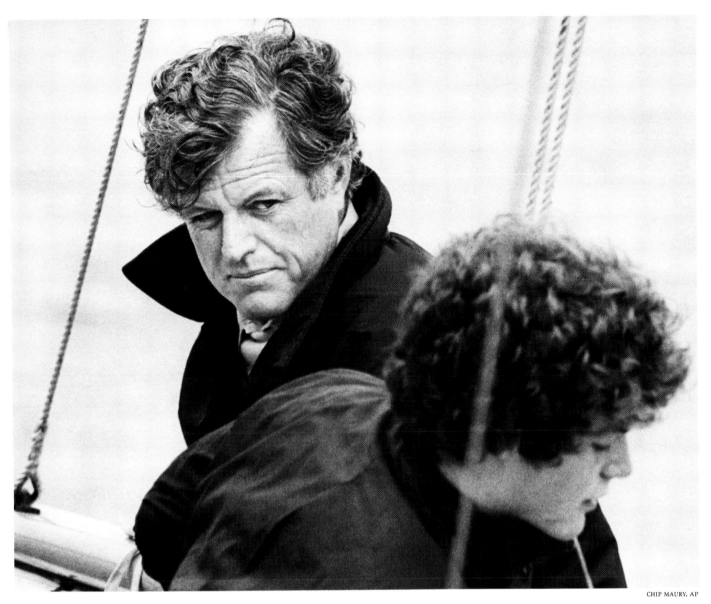

Sen. Edward Kennedy keeps a watchful eye on his oldest son, Teddy, as Teddy maneuvers their sailboat into the pier at the Kennedy family compound in Hyannis Port, Mass.

SOLDIER COMMUNITY
HONOR ROLL

BOB MODERSOHN, DES MOINES REGISTER (FEATURE PICTURE, HONORABLE MENTION, NEWSPAPER)

On Memorial Day in Soldier, Iowa, four veterans from four wars—from the left, Maynard Swensen, Korea; Jerry Blume, Vietnam; Adolph Swensen, the father of Maynard Swensen, World War I; and Fred Briggs, World War II—honor the dead of their community.

Julia Chenault of Denton, Tex., joins in on her favorite instrument as the old folks' kitchen band plays "I'm Forever Blowing Bubbles" during the Denton Senior Olympics.

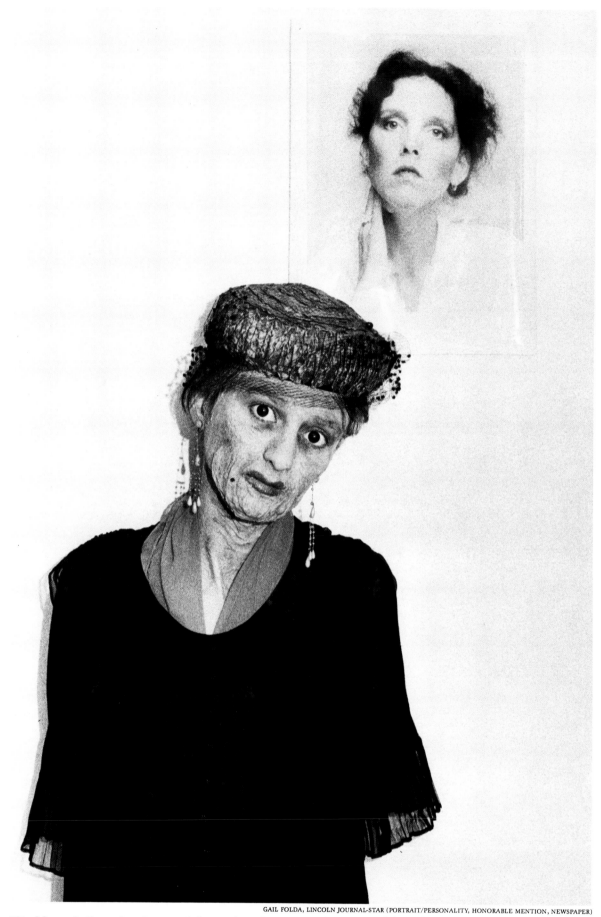

GAIL FOLDA, LINCOLN JOURNAL-STAR (PORTRAIT/PERSONALITY, HONORABLE MENTION, NEWSPAPER)

Would you believe that Joanne Ashmun is only twenty-nine years old? Making a young person look old is one of the hardest tasks facing the makeup artist, but Tim Nelson of Lincoln, Nebr., has done a pretty good job here.

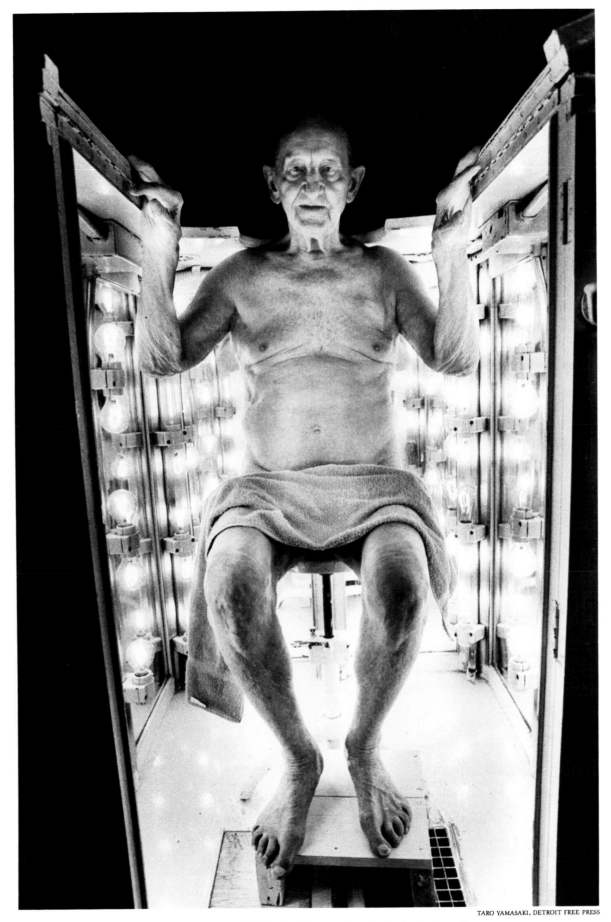

Karl Lynn, at eighty-eight years of age, is the last bath attendant in the last mineral
bathhouse in what was once known as the bath city of America, Mount Clemens,
Mich. He is taking a break from work in a 1930s electric heat cabinet.

BARRON LUDLUM, DENTON RECORD-CHRONICLE

"The Pumpkin Lady," Beulah Tucker, and her son, Jimmy Don, show off some of the pumpkins they have for sale along the roadside in Denton, Tex. Perhaps she swallowed the proverbial pumpkin seed.

238 / People, Portraits, Personalities

Charlie Viars, a janitor at Ridgedale High School in Marion County, Ohio, demonstrates the problems of spray painting a chain-link fence on a windy day. When asked how he liked his new look, Charlie replied, "Ya shouldda seen me yesterday. I was silver from head to toe."

Mike Martin, a high-school biology teacher and avid outdoorsman, tromps toward the flooded grain fields where he will set up a duck blind. Carrying decoys, gun, gloves, waders, and a camouflaged bucket loaded with snacks and calls, Mike has everything he needs—except, of course, the kitchen sink.

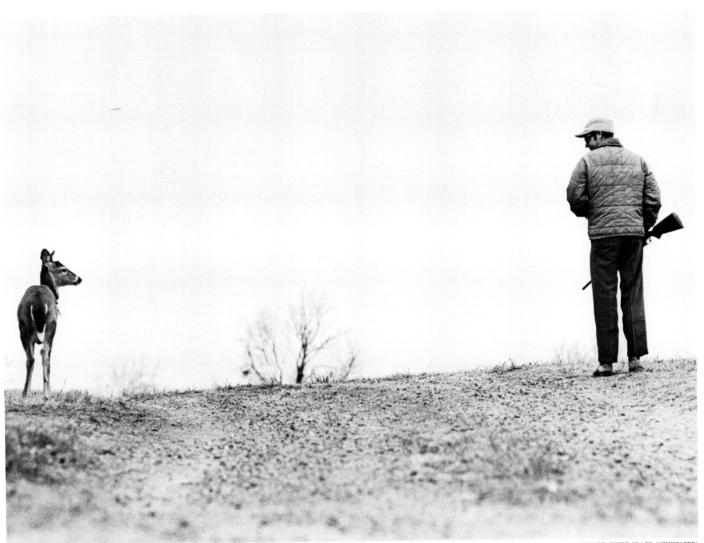

DAVID M. LA BELLE, CHANUTE, KANS., TRIBUNE (FEATURE PICTURE, THIRD PLACE, NEWSPAPER)

The eyes of a young buck deer and those of a hunter lock as the two stop and stare at one another. All is not as it seems, though. The deer, Bambi, was raised by David Burdeau of Urbana, Kans. Although he has been returned to the wild, Bambi still enjoys following Burdeau as a partner and companion.

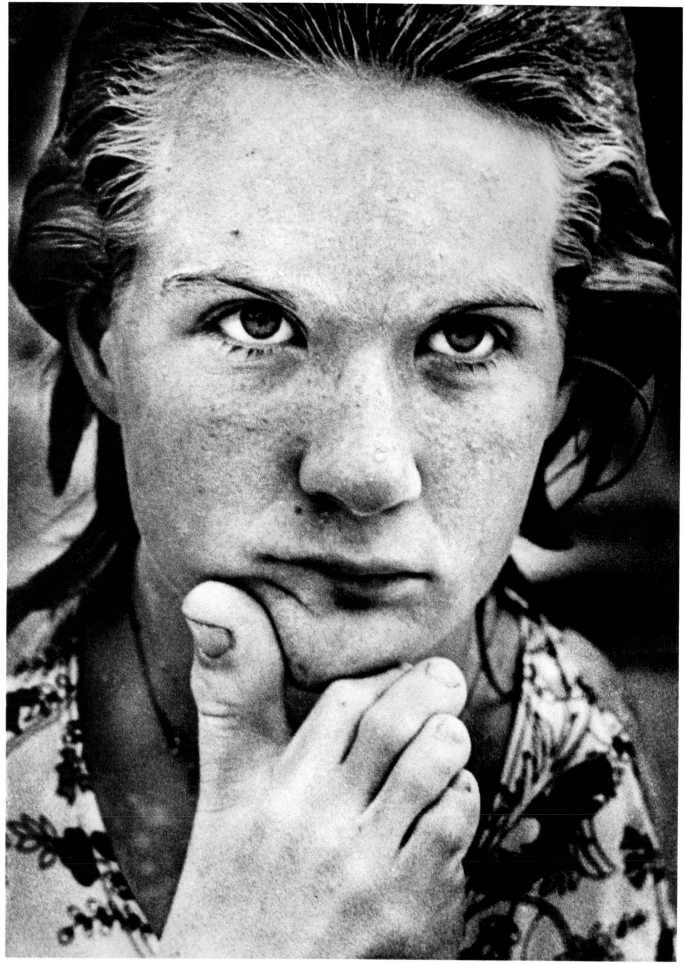

DAVID M. LA BELLE, CHANUTE, KANS., TRIBUNE

Although four seats were taken for this game at the Kansas State Fair in Hutchinson, only three of the contestants had any real chance of winning. The fewer the number of players that compete at this game, the better the chances each person will win.

Wendi Stoeker, the world's only armless competitive diver, sits by the poolside after her daily practice routines in Gainesville, Fla.

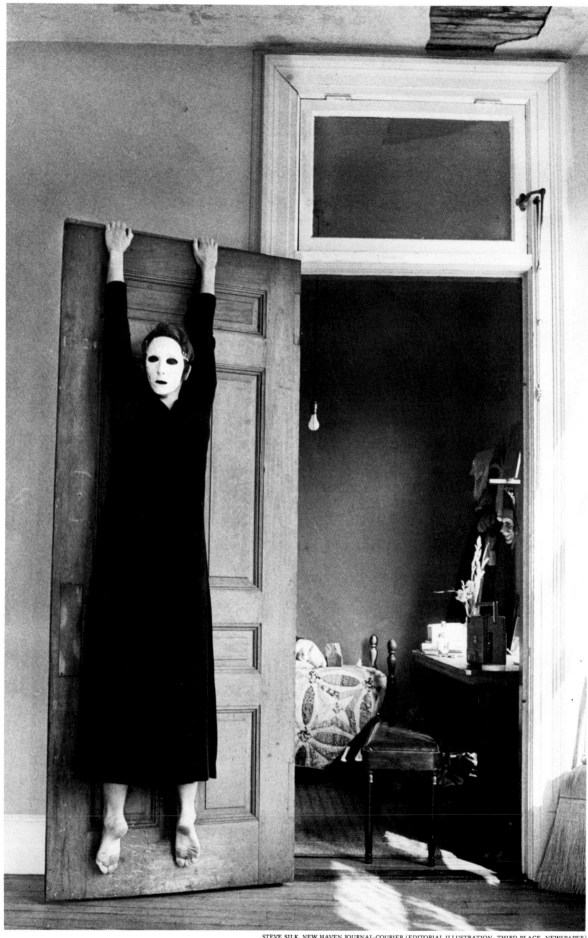

On the morning after, all you can do is put your best face forward.

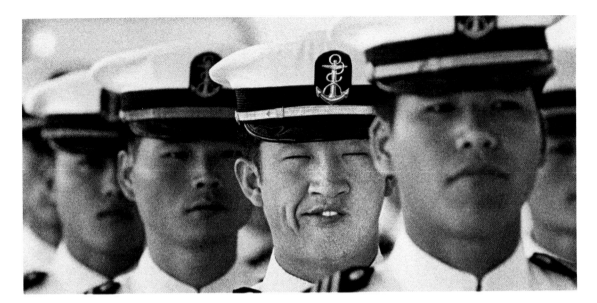

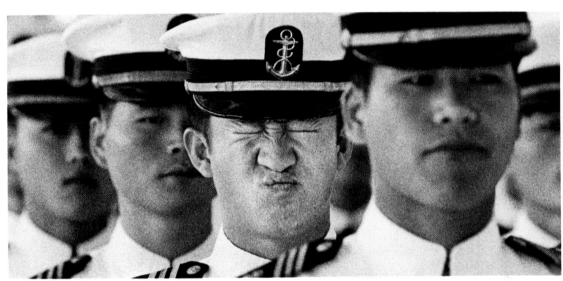

A Korean merchant marine cadet tries hard to avert an imminent sneeze while standing at attention in a formation. The cadet, who was listening to the captain of the ship, was a member of the crew aboard the Korean ship *Hanbada*, which serves as a proving ground for future merchant marine captains. The ship was in Seattle to acquaint the cadets with the harbor and port there.

# The Competition

## The Judging

Judging more than ten thousand photographs, in effect playing a part in determining the standards of excellence for photojournalism, is a demanding task and requires a combination of highly experienced judges and tested procedures. The National Press Photographers Association and the University of Missouri School of Journalism have cooperated during the last thirty-seven years (and have been joined by Nikon, Inc., for the last nine) to develop a combination of just such expert judging and procedures in order to award the best of photographic journalism.

Each of the four judges sees each of the photographs and story boards that are entered into the contest. During the first few rounds of judging, each judge presses a button to vote yes or no for each photograph. When enough photographs are eliminated in this way, the judges discuss each finalist to determine the best in each category. The judging takes at least three days—three very full days. The charge to the judges is to choose pictures that especially meet several criteria. It is the picture, not the event, that is being judged. It will be obvious that photographs that communicate on a local level were just as impressive to the judges as those that depict an event with national significance. Second to the content, the craftsmanship and technical quality were judged.

As in every competition, the panel was chosen to represent photographers, art directors, and editors. A mix such as this may produce the best selection of pictures, but it can also produce volatile and diverse opinions. In the last phase of the judging, lively conversations took place while the judges discussed the relative merits of the finalists.

## The Judges

**Bill Eppridge** is a special contributing photographer to *Sports Illustrated*. He was born in Buenos Aires in 1938 but was raised in the United States. By the time he was fifteen, Wilmington, Del., newspapers were publishing his photographs. He graduated from the University of Missouri School of Journalism in 1960. In 1960, he was the first student photographer to win first prize in a Pictures of the Year competition. Since that time, he has worked for *National Geographic*, *Life*, and *Sports Illustrated*. His work has been widely recognized, and he has covered stories throughout the world. In his position at *Sports Illustrated*, he has concentrated on nonspectator and less popular sports, such as sailing the *Swift Sure* in the straits of British Columbia and hunting poachers in Kenya.

**Eliane Laffont** was born in Burgundy, France, in 1942. She has lived in North Africa and graduated from college in Casablanca. As a journalist for *Elle* and *Paris Match*, she traveled from Argentina to Alaska by car during the year 1964 and wrote articles and essays. She settled in New York in 1968 and started Gamma Agency in 1971. In 1973, she began a second photo agency, called Sygma, and made it one of the biggest agencies in the world. She sold the company in 1978 to work at *Look* as the picture editor and in 1979 was promoted to the position of assistant managing editor there. Since the magazine closed in 1979, she has been working as consultant to Sygma Agency.

**Bernard Quint** has been actively concerned with communications media for many years. As art director of *Life* magazine, he was not only responsible for meeting daily deadlines, but he also participated in the overall editorial planning and design of a wide range of subjects, both current and cultural. His deep interest in photography and photographers, his encouragement of new ideas, and his design concepts all contributed to the development of the photo essay as a form. He was the designer of more than half of the twenty-two essays that appeared in the book *Great Photographic Essays from LIFE*. In the two years since he has left *Life*, Quint has been an active editorial and graphic design consultant for business, government, and publishers. He is now a resident of Rockport, Mass., where he lives and works in a house and studio of his own design.

**Harvey Weber** was born in 1917 in Brooklyn, N.Y., and now resides in Centerport, N.Y. He graduated in 1938 from Wesleyan University with a degree in geology, having worked his way through college as a photographer. After college he photographed for a geological expedition in Montana and provided illustrations for architectural books and magazines. After a stint in the army he worked briefly on the staff of Graphic House before joining *Newsday* as staff photographer in 1948. He has recently retired as director of photography for *LI Mag*, the color Sunday magazine of *Newsday*. He has won numerous awards for his photography, as well as judged major competitions. He remains very active in photography and believes that all photographers who become editors should continue to shoot in order to maintain contact with and knowledgeability of modern photographic problems.

# The Competition—The Winners

**Newspaper Photographer of the Year**

Bill Wax, *Gainesville, Fla., Sun*

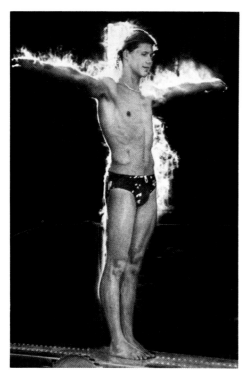

*see p. 170*

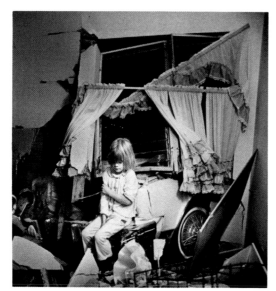

*see p. 211*

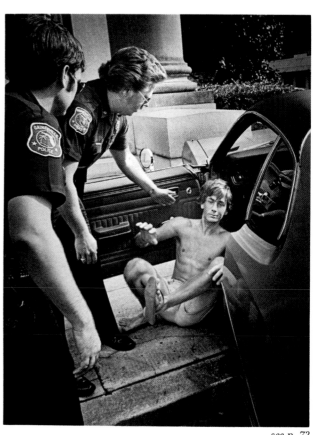

*see p. 72*

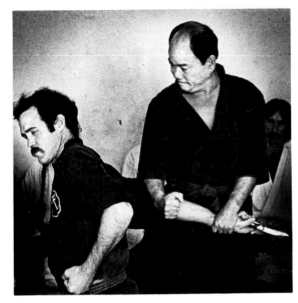
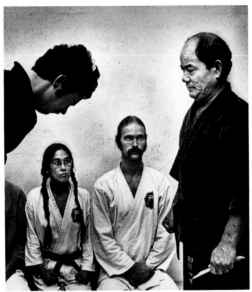

see pp. 200-201

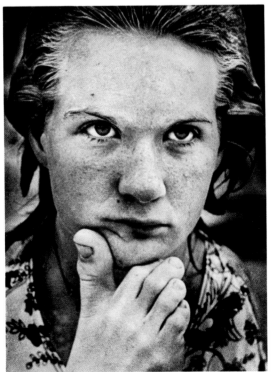

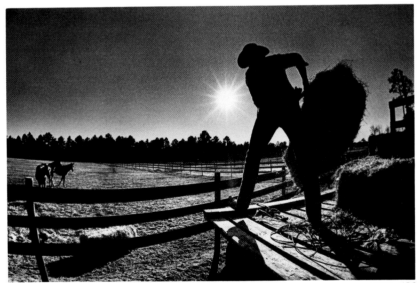

see p. 242

see p. 136

# Magazine Photographer of the Year

David Burnett, Contact Press Images for *Time*

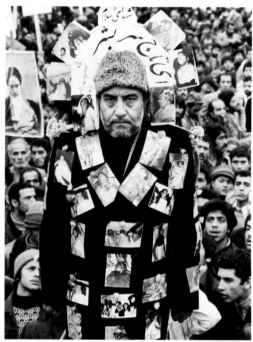

*see p. 18*

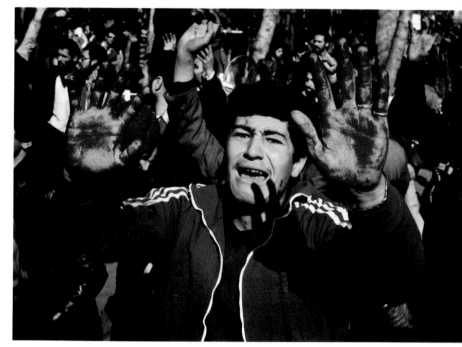

*see p. 34*

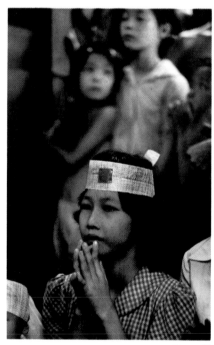

*see p. 33*

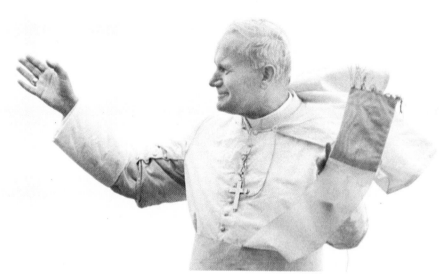

*see p. 82*

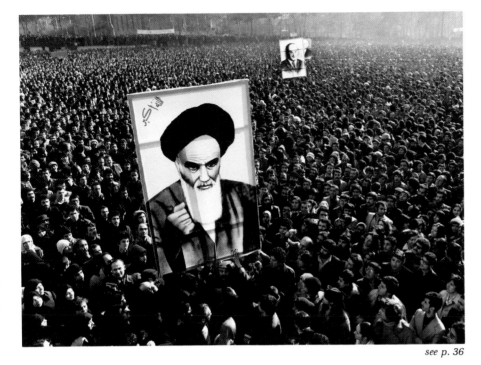

*see p. 36*

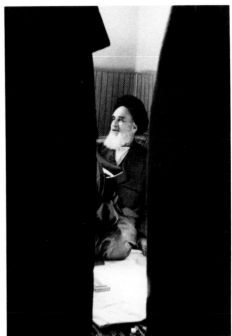

*see p. 20*

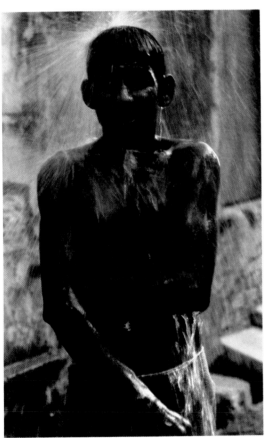

*see p. 43*

*see p. 126*

The Competition / 251

## World Understanding Award

Ethan Hoffman, Freelance, "Washington State Prison"

Judges' Special Recognition, Jean Pierre Laffont, Sygma, "Child Labor"; Michael Wirtz, *Dallas Times Herald*, "Wade Scott, the Comeback Kid"

## Newspaper Division

### Newspaper Photographer of the Year, 2d Place
David M. La Belle, *Chanute, Kans., Tribune*

### Newspaper Photographer of the Year, 3d Place
Bob Modersohn, *Des Moines Register*

## Spot News

1st, Anonymous, UPI, "Firing Squad"

2d, Daniel Neville, *Newsday*, "Gangland Murder"

3d, Charlie Nye, *Eugene, Ore., Register-Guard*, "Sounds of a Dying Whale"

Honorable Mention, Louie Psihoyos, Freelance, "Heated Pool"; Thierry Campion, AP, "Star-Spangled Garbage"; Charles Robinson, AP, "Deadly Bounce"

## General News or Documentary

1st, Larry Downing, UPI, "Marathon Man"

2d, Charlie Nye, *Eugene, Ore., Register-Guard*, "Hi There, Blondie"

3d, Larry Downing, UPI, "Fumbled Diplomacy"

Honorable Mention, David M. La Belle, *Chanute, Kans., Tribune*, "Best of Show"; Ron Mann, *San Bernardino, Calif., Sun*, "Calm Down"

## Feature Picture

1st, Richard A. Chapman, Press Publications, Elmhurst, Ill., "Lady in Waiting"

2d, Erica Berger, *Gainesville, Fla., Sun*, "Male Striptease"

3d, David M. La Belle, *Chanute, Kans., Tribune*, "Fancy Meeting You Here"

Honorable Mention, John McDonnell, *Washington Post*, "Just Another Stupid Cat Picture"; Bob Modersohn, *Des Moines Register*, "Soldier, Iowa"; Louie Psihoyos, *Columbia Missourian*, "Humane Society Sheepdog and Friends"

## Sports Action

1st, Bill Wax, *Gainesville, Fla., Sun*, "Airborne"

2d, Gordon K. Morioka, *Cincinnati Enquirer*, "Precision Diver"

3d, Bruce Bisping, *Minneapolis Tribune*, "The Start"

Honorable Mention, Mark Foley, AP, "Getting Away"; Joe Patronite, *Arizona Daily Star*, Tucson, "Motocrossing in the Mud"; Cary W. Tolman, *Seattle Post-Intelligencer*, "Miss Budweiser Crashes"

## Sports Feature

1st, Steve Dozier, *St. Petersburg Times & Evening Independent*, "Japanese Umpires"

2d, Louie Psihoyos, Freelance, "San Francisco Giants vs. 'Possum"

3d, Brian Smith, British UPI, "Ali Oops"

## Portrait/Personality

1st, Richard Olsenius, *Minneapolis Tribune*, "Cambodian Child"

2d, Michael Hayman, *Flint, Mich., Journal*, "Old MacDonald Wazney"

3d, John McDonnell, *Washington Post*, "Ms. Goldberg of the Zenith Gallery"

Honorable Mention, Gail Folda, *Lincoln, Nebr., Journal & Star*, "Young Woman—Old Woman"; Josie Lundstrom, Freelance, "Back in Uniform"; Jay B. Mather, *Louisville Courier-Journal*, "The Young Equestrienne"

## Pictorial

1st, John Moran, *Gainesville, Fla., Sun*, "Sunset Crossroads"

2d, Stewart Bowman, *Louisville Courier-Journal & Louisville Times*, "Eye to the World"

3d, Bruce Crummy, *The Fargo, N.D., Forum*, "Icy Aftermath"

Honorable Mention, Gerald S. Williams, *Philadelphia Inquirer*, "Want to Neck?"; Charles Cherney, *Arlington Heights, Ill., Daily Herald*, Mackinac Boat Race"

## Editorial Illustration

1st, J. Patrick Downs, *Oceanside, Calif., Blade-Tribune*, "Dressing with Less"

2d, John Danicic, Jr., *Sioux Falls, S.D., Argus Leader*, "Stylish but Obsolete"

3d, Steve Silk, *New Haven Journal-Courier*, "Hangovers"

## Food Illustration

1st, Nick Kelsh, *Columbia, Mo., Daily Tribune*, "Salt and Pepper Shakers"

2d, Scott Braucher, *Arizona Daily Star*, Tucson, "Artichoke"

3d, Gary S. Chapman, *Fort Myers, Fla., News-Press*, "Silverware"

## Fashion Illustration

None chosen by the judges

## News Picture Story

1st, Norman A. Sylvia, *Providence, R.I., Journal*, "A Broken Mind"

2d, Charlie Nye, *Eugene, Ore., Register-Guard*, "The Day the Whales Committed Suicide"

3d, Steve Campbell, *San Antonio Express-News*, "Parade Panic"

Honorable Mention, Charles Robinson, AP, "Cameraman Killed"; Tom Kasser, *San Bernardino, Calif., Sun*, "Summer's Fiery War in Southern California"; Philip B. Stewart, *Running Times*, "President Carter's Collapse"

## Feature Picture Story

1st, John W. McDonough, *Los Angeles Times*, San Diego, "Birkenau-Auschwitz: Death Camps"

2d, Bob Modersohn, *Des Moines Register*, "Horse Power"

3d, Carla Hotvedt-Horne, *Gainesville, Fla., Sun*, "The Crisco Kid"

Honorable Mention, Matt McVay, *Seattle Times*, "A Nasal Battle"; Dan Dry, *Louisville Courier-Journal & Louisville Times*, "A Matter of Race"

## Sports Picture Story

1st, Phil Mascione, *Chicago Tribune*, "And It Came Tumbling Down"

2d, L. Roger Turner, *Wisconsin State Journal*, "Small Triumph in Special Olympics"

3d, Cary W. Tolman, *Seattle Post-Intelligencer*, "Miss Budweiser Crashes"

Honorable Mention, Mark Foley, AP, "Frasson Explodes"; Eric Lars Bakke, *Topeka Capital-Journal*, "Football's Fanatical Fans"; Alison Wachstein, Freelance, no title

## Magazine Division

### Magazine Photographer of the Year, Runner-Up
Jodi Cobb, *National Geographic*

### News or Documentary

1st, David Burnett, Contact Press, "Mother and Child"

2d, Jodi Cobb, *National Geographic*, "Quick Dip"

3d, Neil Leifer, *Time*, "Kennedy Library Ceremony"

Honorable Mention, Gregory Heisler, *Life*, "Three Mile Island"; Olivier Rebbot, *Newsweek*, "Iran's Joyless Revolution"

### Feature Picture

1st, Cotton Coulson, *National Geographic*, "Dressed for the Occasion"

2d, Martin Rogers, *National Geographic*, "Penguin Round-up"

3d, Jodi Cobb, *National Geographic*, "Facelift"

Honorable Mention, Joseph J. Scherschel, *National Geographic*, "Oops"

### Sports Action

None chosen by the judges

### Sports Feature

None chosen by the judges

## Portrait/Personality

1st, Harry Benson, *Life*, "Régine, the Diva of the Disco"

2d, Georg Gerster, *National Geographic*, "Dressed for the Desert"

3d, David Burnett, Contact Press, "Face of Despair"

## Pictorial

1st, Craig Aurness, *National Geographic*, "Grain Elevators"

2d, James A. Sugar, *National Geographic*, "Washington's Big Snow"

3d, Peter Jenkins, *National Geographic*, "Dust Storm"

Honorable Mention, Arnold Zann, Black Star, "Papal Visit to St. Patrick's"

## Editorial Illustration

None chosen by the judges

## News or Documentary Picture Story

1st, Robert Madden, *National Geographic*, "Desperate Moment for Hurricane Evacuee"

2d, Co Rentmeester, *Life*, "The New U.S. Airpower"

3d, Robert A. Cumins, Freelance, "Protocol"

## Feature Picture Story

1st, Jodi Cobb, *National Geographic*, "Why Is Hollywood so Spaced Out?"

2d, Co Rentmeester, *Life*, "Roller Coaster, U.S.A."

3d, Co Rentmeester, *Life*, "The Skaters of Holland"

Honorable Mention, Mark Meyer, *Time*, "Black Bird"; Martin Rogers, *National Geographic*, "Penguin Roundup"; Norman Seeff, *Life*, "The New Rock"

## Editor's Awards

### Best Use of Photographs by a Newspaper

*Columbia, Mo., Daily Tribune*

### Best Use of Photographs by a Magazine

*GEO*

### Newspaper Picture Editor's Award

Susie Eaton Hopper, *Muskegon, Mich., Chronicle*

Judges' Special Recognition, Bill Douthitt, *Longview, Wash., Daily News*

### Magazine Picture Editor's Award

Susanne Walsh, *GEO*

Judges' Special Recognition, Declan Haun, *National Geographic*

### Newspaper Magazine Picture Editor's Award

Rich Shulman, *Panorama Magazine, Everett, Wash., Herald*

# Index of Photographers

The Best of Photojournalism, 5: People, Places, and Events of 1979

Design, University of Missouri Press Staff

Composed in Zapf International by Williams Co., Chattanooga, Tennessee

Color separations by Laser Ltd., Lawrence, Kansas

Black-and-white duotones by Beaumont Graphics Ltd., St. Louis, Missouri

Printed on eighty-pound Warren Lustro Enamel Gloss and bound

by Walsworth, Marceline, Missouri